Digital
Wildlife
Photography

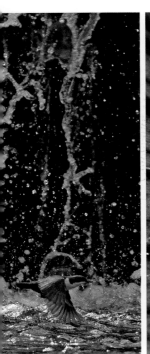

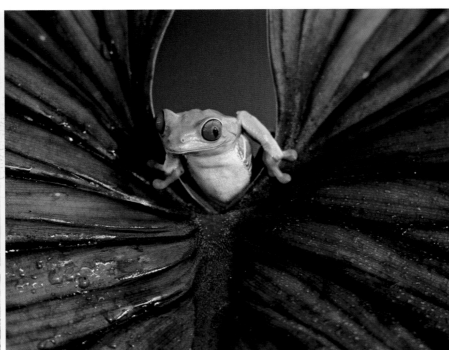

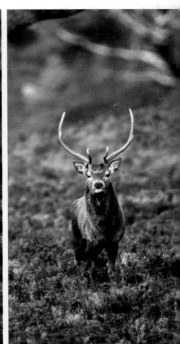

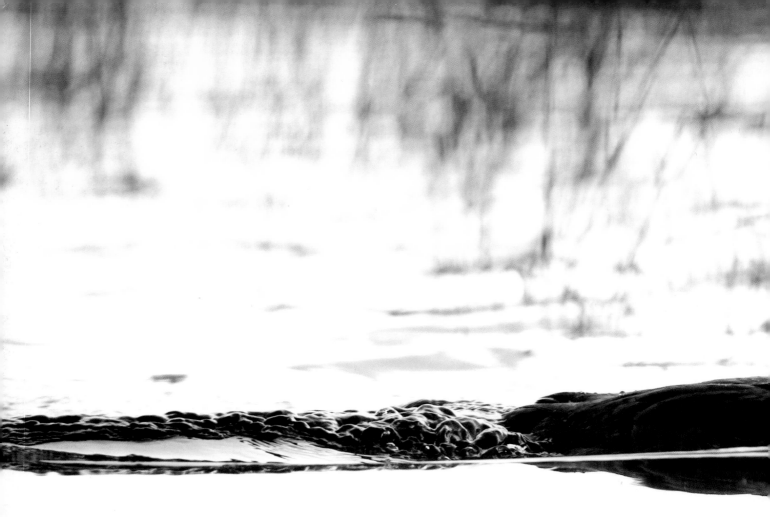

Digital
Wildlife

DAVID TIPLING

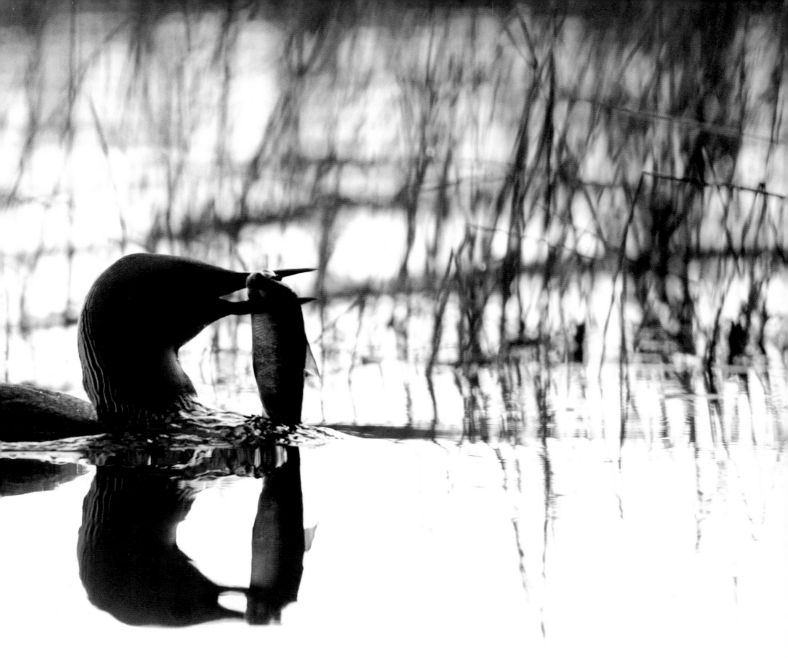

Photography

FIREFLY BOOKS

A FIREFLY BOOK

Published by Firefly Books Ltd. 2007

First printing

Publisher Cataloging-in-Publication Data (U.S.)
Tipling, David, 1965-
 Complete Guide to Digital Wildlife Photography / David Tipling.
[160] p. : col. photos. ; cm.
Includes index.
Summary: A practical guide to all aspects of digital wildlife photography, including equipment, field craft, locations and composition, post-processing and computer manipulation of image, and getting photos published.
ISBN-13: 978-1-55407-305-4 (pbk.)
ISBN-10: 1-55407-305-7 (pbk.)
1. Wildlife photography. 2. Photography—Digital techniques. I. Title.
778.932 dc22 TR727.T575 2007

Library and Archives Canada Cataloguing in Publication
Tipling, David
 Complete guide to digital wildlife photography /
David Tipling. — 1st US ed.
Includes index.
ISBN-13: 978-1-55407-305-4
ISBN-10: 1-55407-305-7
 1. Wildlife photography. 2. Photography—Digital techniques. I. Title.
TR727.T56 2007 778.9'32 C2007-900910-7

Published in the United States by
Firefly Books (U.S.) Inc.
P.O. Box 1338, Ellicott Station
Buffalo, New York 14205

Published in Canada by
Firefly Books Ltd.
66 Leek Crescent
Richmond Hill, Ontario L4B 1H1

This book is produced using paper made from wood grown in managed sustainable forests. It is natural, renewable and recyclable. The logging and manufacturing processes conform to the environmental regulations of the country of origin.

Designed by Rod Teasdale, White Rabbit Editions
Printed in China

Contents

Introduction

Digital photography has evolved rapidly, leading to an exciting revolution in the capture of wildlife images. New technology has inevitably brought new challenges, notably how to extract the best from digital cameras, and how to tackle the steep learning curve associated with processing images once downloaded to a computer. It is the latter process that perhaps challenges most, provoking a common unwillingness to embrace new technology. The fear of change is a human emotion shared by many, and I include myself in this. It took me two years to jump into the digital arena, but when I look back now, that feels like two wasted years.

A poor picture cannot be transformed into a great one. However, a good image can be enhanced to one that really shines. It is worth remembering the popular saying "garbage in, garbage out." Using poor techniques in the field with the attitude that the important part of making great photographs lies in your computer prowess is a recipe for taking pictures that could have been very much better.

The terminology within digital photography of "bits," "bytes," "megabytes," "histograms" and so on can be offputting. In this book, I aim to unravel this jargon and show you what it means, and to present an explanation of what I do alongside the resulting pictures. While the first few chapters explore the technology you will use and the techniques you will commonly employ in taking pictures, the later chapters on processing images on your computer are far more personal; they are written from my own experience, and illustrate what I do, rather than showing the only way to do things. This is important to recognize because in talking to different photographers you will find that no two photographers work with images on the computer in quite the same way. Although the basic processing techniques will be the same, both workflow (editing and processing steps) and adjustments in Adobe Photoshop are likely to differ. The simple fact is that there are both many software programs for editing and many different ways of carrying out the same adjustment in Photoshop. You may have already developed your own way of working; this is good, but you may also learn some different techniques from this book.

The many software programs available for editing images include well-known names such as BreezeBrowser and Capture One. More recently, Adobe has launched Lightroom and Apple has introduced Aperture. Both are designed specifically for photographers, and offer ideal platforms for editing and processing RAW images. I have chosen to illustrate the steps I take in the editing process using Photoshop CS2's Bridge and Adobe Camera Raw. The reason for this is because it is likely at some point that you will have to or want to use Adobe Photoshop when optimizing your images, and no other software application on the market comes close to Photoshop in offering photographers the tools required for doing this. If you are really serious about your photography, it will pay to use the latest version of Photoshop. As mentioned in this book, the tools within Bridge, Adobe Camera Raw and Photoshop are identical or very similar to those found in all other applications. Consequently, even if you use another application, you should still be able to follow my explanations and apply them to your own workflow.

If you are new to digital photography and you are learning how to process your images, you will soon discover the majority of adjustments you make are down to using your judgment, and such adjustments will soon be second nature. By remembering this, the often daunting prospect of remembering various processes will feel less arduous.

The ability to manipulate images, and even the ability to create images, has created quite an animated debate within the wildlife photography world. Some

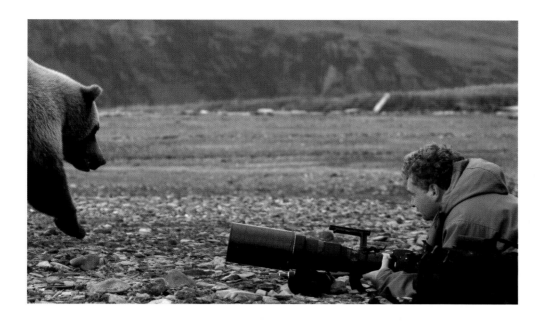

LEFT The author with a grizzly bear in Alaska. This grizzly bear came so close, I could hear its heavy breathing, and perhaps the bear could hear my heart pumping faster and faster! It was a special moment, if not a little unnerving. However, just out of shot a guide was crouched ready with a flare in the event that the bear came any closer.

(Picture courtesy of Anita Stokes)

photographers have emerged who describe themselves as "photographic artists," producing beautiful images that are heavily manipulated, and often the combination of two or more images. On the other side of the fence are the purist photographers who want to stay as true to nature as possible. The problem lies with those that create images and then attempt to pass them off as being true to nature. This generates an atmosphere of distrust, and the viewer becomes confused and cynical about whether a particular image can be believed. While photographers can generally identify these created images, the viewing public may lack the insight required to spot them.

A similar subject exists with regard to captive subjects. For many professionals, the opportunity to photograph a captive animal or one in a controlled environment is a means to an end, and can save many days or weeks in the field. Indeed, most professionals cannot justify extended periods in pursuit of subjects that may at the end of the day fail to repay the time spent in the chase. But purists condemn photographs of captive animals, and most people would always prefer an image of a creature taken in the wild, in its natural surroundings.

Both images of captive animals and those created with a computer have their place, and they can help to enrich the world in which we live with new and exciting pictures. Such images should always be clearly identified as of captive origin or manipulated. Those that publish images, knowing they are not natural but presenting them in a genuine context, are perhaps as much to blame as the photographers themselves. However, I would like to think that the majority of wildlife photographers feel a duty to declare when an image is a montage or when the subject has been photographed in a controlled or captive situation. Of course, context is everything; people generally accept that images used in advertising have no need for such disclosure. It is only important when images are used in an editorial context and passed off falsely as the "real thing." In this book, I have not included such images, with a few notable exceptions where I have given an explanation in the caption.

My main purpose in writing this book has been to show how I go about taking and dealing with digital images, and to try and convey the immense pleasure I derive from being out in the wild, taking pictures. Being so close to a surfacing whale as to be able to smell its breath, and watching in awe as tens of thousands of starlings wheel in unison over a city skyline are two spectacles I have recently enjoyed with camera in hand, and on both occasions I put down the camera in order to soak up the atmosphere. My message is that you should never lose sight of what you are photographing and its welfare, and if you do put your camera down to enjoy that special experience, just make sure you don't miss that exceptional shot!

Getting started

Digital photography is fun, best illustrated by the phenomenal growth in sales of digital cameras worldwide. We no longer have to wait for hours, days or weeks to see our results – they are instant. Not only that, but rather than relying on someone else to develop our film, we can now do it ourselves, and take the image, crop it or correct it if necessary – in short we have total control.

For me, it has revolutionized the way I take pictures; I am taking action sequences now that only a few years ago seemed almost impossible. Couple this with the ease of improving the captured image still further with imaging software, and it finally seems that wildlife photographers have the capability to fully express themselves through their pictures.

If you are about to pick up a camera for the first time, or you are an experienced photographer currently using film, my aim in this chapter is to unravel the mystery surrounding the process of digital capture. Before moving on to the business of choosing a digital camera, it is worth looking at the technology and explaining some of the terms. This background knowledge will help you to decide just which digital camera you need.

Digital capture

Digital cameras look just like their old film counterparts; this may well change as the technology develops. They operate with many of the same controls: a wheel to change the shutter speed, another to change the aperture, and so on. The big difference is how the image is stored once taken, which I will discuss on page 28.

A digital camera has a sensor, which sits in the same place as the film plane (where the film is exposed in a film camera). The sensor is covered with what is known as an "imaging array" – this is simply a computer chip covered in photosensitive detectors (photosensors) – which when struck by light emits an electrical charge. The electrical charge is analyzed and translated into digital image data by a processor. These imaging array chips come in two forms: the complementary metal-oxide semiconductor (CMOS); and the charge-coupled device (CCD). There was a time when there were certain benefits when choosing a camera with either of these chips, but technology has advanced to the point now where there are few advantages or disadvantages with one compared to the other.

RIGHT While talk of bits and bytes and all the other jargon that goes with digital photography seems daunting, in fact it will soon all fall into place once the basic knowledge is acquired. I learn only what I need to; for me, and many other wildlife photographers, the fun part is creating pictures. This one is of a hippo that took an interest in me as I lay on the bank of a pool in the Masai Mara.

500mm lens, ISO 160, 1/125 second at f/5.6 with angled viewfinder

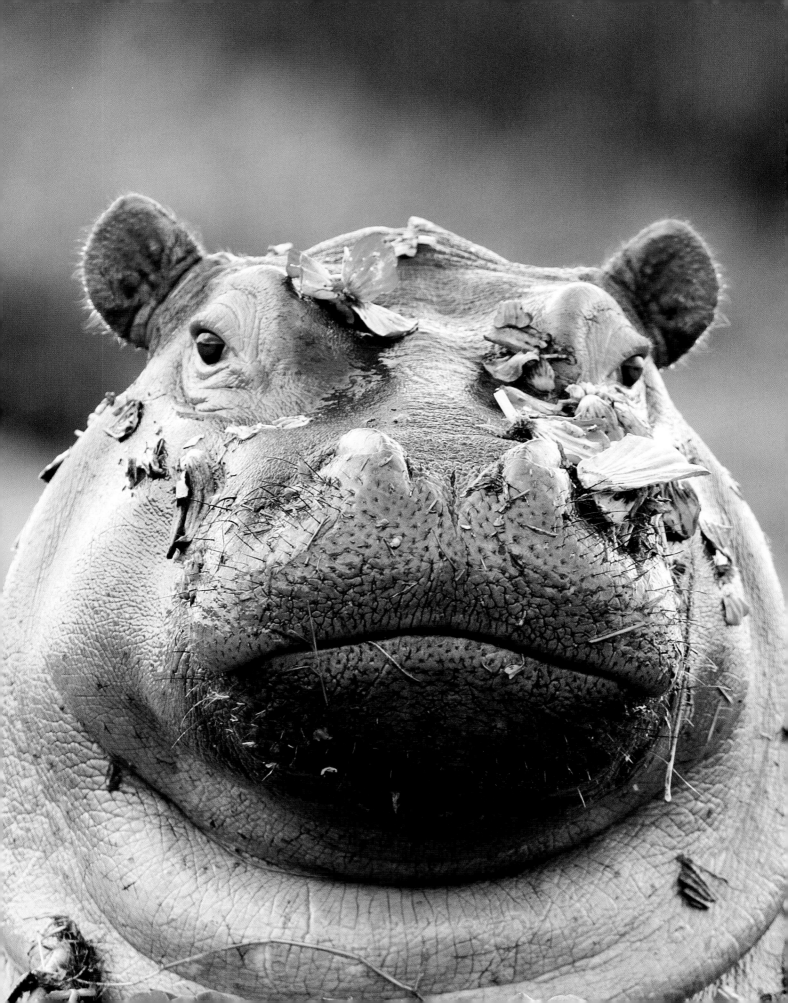

Each photosensor contributes one pixel to the image. The color information for the image is recorded by each photosensor having one of the primary colors as a filter. Twice as many green filters are used as red or blue due to our eyes being most sensitive to green light.

Apart from the CMOS and CCD sensors there is one other type of sensor used in Sigma cameras, this is the Foveon, which differs in having three layers of photosensors on the same chip: the top sensor captures blue lightwaves; the middle, green waves; while the longest red waves reach the bottom layer. The benefit of this chip is that it captures full color information for each pixel. I could write an entire book on how the technology works, but you really don't need to know any more than this.

Once all the captured data is processed, it is sent to a storage card that you have placed in the camera; this is commonly referred to as "digital film," or "removable storage media." Once the card is full, it can be removed and the pictures transferred to your computer; this process is explained later in the chapter (see page 28).

A digital single-lens reflex (DSLR) camera (ABOVE). DSLRs look almost identical to film cameras, and are far more versatile than compact cameras (RIGHT). Compacts are in effect complete units with built-in lenses; they fit in a pocket, which makes them ideal for family photos and holiday pictures, but they fall short on delivering picture quality and on the ability to use long telephoto lenses for photographing wildlife.

What type of camera do I need?

Cameras come in two basic types: the compact that most nonphotographers will own for family and holiday photos; and the digital single-lens reflex (DSLR) camera. Compact cameras are great for quick shots of the family, but their capabilities pretty much end here (except for macro photography – see page 17 – and digiscoping – see page 24). For wildlife photography, you often need long telephoto lenses and the ability to change your lens; this is where the DSLR comes into its own, providing versatility.

There is a vast choice of DSLRs on the market and, if you are new to photography, choosing one may seem a complex exercise. However, if you are armed with a little knowledge, and you can perhaps talk to other photographers, choosing the right camera becomes easier. One thing to remember is that you can take great pictures with the most basic of cameras – it is the person behind the camera, not the camera itself, who will be taking the picture.

Most current DSLRs are packed with technology that you may never use. Below I have given a few pointers to look for when choosing a camera body.

DSLRs range in how many pixels they offer, from camera bodies with 4 megapixels (4 million pixels) to 16 megapixels currently. Another complication when choosing a camera body is that camera photosensors come in different sizes. Some offer what is known as a

"full frame"; in other words, the picture covers the same area as a piece of 35mm film. The majority have smaller sensors: the picture area is cropped typically by up to 1.6x, so making a 500mm lens in effect a 750mm lens. This cropping is a great advantage for wildlife photographers, particularly as the cameras offer excellent picture quality, and are generally cheaper than their full-frame counterparts.

The sidebar at right gives a few examples of how cropped frame sensors alter the effective focal length of a lens.

FULL FRAME	CROPPED FRAME AT 1.3x	CROPPED FRAME AT 1.6x
20mm	26mm	32mm
105mm	137mm	168mm
300mm	390mm	480mm
500mm	650mm	800mm

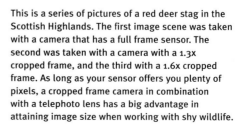

This is a series of pictures of a red deer stag in the Scottish Highlands. The first image scene was taken with a camera that has a full frame sensor. The second was taken with a camera with a 1.3x cropped frame, and the third with a 1.6x cropped frame. As long as your sensor offers you plenty of pixels, a cropped frame camera in combination with a telephoto lens has a big advantage in attaining image size when working with shy wildlife.

TOP TIPS FOR CHOOSING A DSLR BODY

1 Select a body that is supported by a good range of interchangeable lenses. This means sticking with one of the main manufacturers such as Canon, Nikon or Olympus. Just about 99 percent of professionals use either Canon or Nikon. These two are ahead of the rest in digital technology and offer the best range of lenses – if you can afford it, choose a camera from one of these manufacturers.

2 Choose the latest model because digital technology is racing along. Within a few months, or a year or two, a more advanced version will be on sale. Most professionals are changing their digital bodies at least once every two to three years.

3 Go for a body that offers a good number of frames per second; this will be important for taking action sequences. The number of frames per second is called the "burst rate."

DSLRs have an internal memory known as the "buffer," which stores image data before being processed and transferred to the storage card in your camera. This allows a number of frames to be taken in quick succession without the camera locking up and not working until the pictures' data has been processed and transferred. The number of frames a camera can take before its buffer becomes full and it stops you from taking any more is known as the "burst depth." Burst depth is not the issue it once was with early DSLRs, but it is worth looking at when choosing a camera because there is nothing more frustrating than missing shots because your camera is playing catch-up.

4 Select a camera that offers enough pixels for the desired use of the pictures you will produce. For example, a 4 megapixel camera will not offer the same possibilities as an 8 megapixel camera (see page 13).

5 Make sure your body has a depth of field preview button, a feature often missing on cheaper models. When focused on a subject, this allows you to assess the zone of sharpness from the front to the back of the picture, and enables you to judge whether you need a bigger or shallower depth of field for the effect you wish to create. You will need this because you will usually look through the lens when it is open at its widest aperture, which allows plenty of light into the viewfinder, but this may not be the aperture you have selected (the lens automatically reverts to the set aperture when you take the picture). If you have selected a smaller aperture, by using this preview you will see exactly what will be recorded by your sensor.

6 Finally, handle the body with a telephoto lens on the end before purchasing. Make sure it feels comfortable and that all the controls you feel you will use are well laid out and easily accessible. Your camera and lens will eventually become an extension of your arm.

Feeling relaxed and comfortable using your gear will free up your mind for taking pictures. This might sound like a silly sentiment if you are new to photography, but imagine driving a car where the controls for the radio are in the trunk and the gear shift is just out of arm's reach – it would be frustrating, as it can be with poorly designed camera bodies.

HOW MANY PIXELS DO I NEED?

This has to be one of the most frequently argued questions in digital photography. There is a school of thought that says the number of pixels you have is not so important as the quality, size and shape of the pixels on the sensor. For instance, you can buy compact cameras that have 8 million pixels, yet the picture quality is poorer than a 4 million pixel DSLR, and often it is not as good as a 4 million pixel compact camera of similar design. More important is the quality of the sensor and how the camera processes that captured information.

You will find when you are taking pictures that there is often a desire to crop and reframe once you have the image on your computer screen. Remember that when you crop you are reducing the file size of the picture, and so it is important to have enough pixels in the first place to be able to crop and still use the picture in the way you intended. There is a process called "interpolation" that will stretch a picture's size, but more of that later in the book (see page 122).

The number of pixels in an image is expressed as the "resolution" – the more pixels in an image, the bigger the image can be printed without showing any pixels (pixellating). The resolution is expressed in megapixels, and as a grid. For example, a 13.5 megapixel camera captures 4,500 by 3,000 pixels.

If you wish to print up to 10 x 13 in size, then a 5 megapixel camera will be adequate. If you wish to have your work published and you want to produce prints of 16 x 20 or larger, ideally you need a minimum of an 8 megapixel body in order to get decent results that show plenty of detail in the print.

Batteries

Digital cameras and big autofocus lenses have a healthy appetite for batteries, particularly in cold weather. The top range DSLRs come with their own rechargeable power packs, which are always preferable to using standard batteries. Nevertheless, if you are not using a power pack, you need to carry plenty of spare batteries. There is nothing worse than being in a prime position to photograph a subject and running out of power.

While alkaline batteries are the popular cheap choice for most appliances, it is worth investing in lithium batteries for your camera. These come with a higher price tag but they last much longer and perform better in cold weather than alkalines. In cold weather, keep spare batteries in a warm pocket; cold is a real battery killer, and by keeping the batteries warm, you will help to retain their performance for when they are needed.

RIGHT Lion cubs playing with their mother. Working your camera will soon become second nature, freeing your mind to enable you to concentrate on photographing and enjoying moments such as this.

500mm lens, ISO 200, 1/250 second at f/6.3

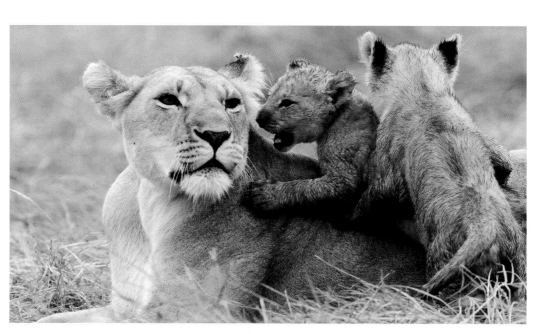

Lens choice

If you are working on a limited budget, don't worry too much about buying an expensive camera body – it is better to point your resources at the best lenses you can afford. With optics, you get what you pay for, and quality comes at a price.

The different camera and lens manufacturers offer similar or identical lens specifications. Your lens choice may be dictated by which camera brand you buy – if you go for one of the main manufacturers' bodies such as Canon or Nikon, you are likely to want to stick to their lenses too.

Lenses come in lengths ranging from around 10mm to over 1,000mm. To give you the versatility you need for general wildlife photography, a good focal range would stretch from a wide angle of around 17mm to 500mm. My camera bag contains the following lenses:

- 12–24mm zoom lens

- 70–200mm zoom lens

- 500mm telephoto lens

- 1.7x teleconverter.

I find the above combinations cover just about all of my needs, and they all fit comfortably into a camera bag I can easily carry. I do have a few extra specialized lenses that I use when needed, including a 70–180 mm macro lens.

You might think that a professional with just three lenses in his bag is a surprise. Yet I make these lenses work for me – they are all frequently used and they match the needs of my style of photography. This includes concentrating on birds and mammals and occasionally plants and landscapes. If your main interest lies in photographing insects, such as butterflies and maybe small mammals or plants, then a different lens combination is probably necessary. However, you don't need to worry about having an arsenal of lenses of every focal length imaginable; a couple of well-chosen zooms and a long telephoto are the tools that most professionals use 99 percent of the time.

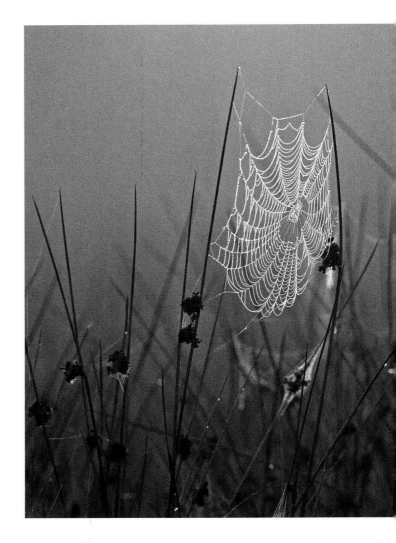

ABOVE When choosing lenses, make sure that you cover most focal lengths from wide angle to telephoto. If you are keen on photographing all wildlife, your subject matter is likely to be diverse. I was out photographing rutting red deer at dawn one autumn when I could not resist photographing this dew-laden cobweb. I like the monochromatic nature of this image and its simplicity.

135mm lens, ISO 200, 1/125 second at f/4

ABOVE The 300mm f/2.8 lens is a beautiful lens to use, but it comes at a price in both its cost and weight.

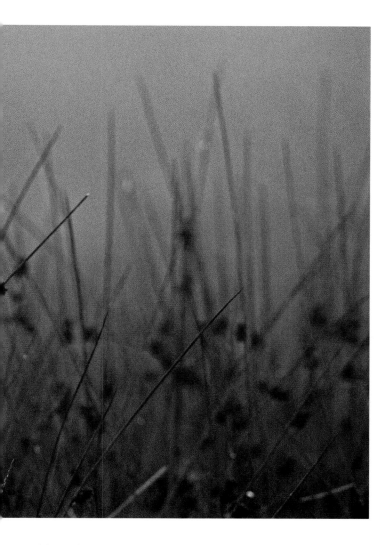

When choosing a lens there are various features to look out for. Here are my top tips:

1 Lenses include image stabilization also known as "vibration reduction," found now in many medium zooms and telephoto lenses. This technology helps to reduce or eliminate camera shake (a blurring of the image). In effect, it allows you to use lower shutter speeds. This is very useful if you are using a very long telephoto lens, where camera shake may be an issue, or if handholding for more versatility when photographing action as opposed to mounting the lens on a tripod. Although not essential, having an image-stabilized lens is very helpful. Nonetheless, you will still need a fast enough shutter speed to freeze movement; image stabilization only helps to reduce the effect of camera shake induced by you, or by a wobbly tripod.

2 The maximum aperture of a lens, particularly in long telephotos, is an important consideration when photographing wildlife. The aperture is the control within the lens that allows in varying amounts of light. The range of apertures marked on a lens is known as "f-stop numbers." Maximum apertures start at around f/2.8, which will let lots of light enter the camera, allowing use in low-light situations. The downside is a large lump of glass in the end of the lens, which ultimately makes it large and heavy. At f/32, the lens has only a small opening allowing little light in.

Speed comes at a price; a 300mm f/2.8 lens is likely to be twice and maybe three times the cost of its f/4 equivalent, and will be at least twice as heavy. A maximum aperture of f/4 is ideal for a long telephoto because it gives plenty of versatility. My everyday wildlife photography lens, meaning the one I use the most, is an f/4, 500mm lens. It is not light, nor cheap to buy, but it does the job admirably. In the past, I have owned a 300mm f/2.8, and enjoyed using it. I changed back to a 500mm because I missed the reach of the 500mm, particularly for photographing birds where a close approach is not always an option.

3 Teleconverters or "converters" as they are commonly called, are optics that fit between the camera and lens, and range from 1.4x to 2x. They are a great way of extending the reach of your lens, but come with a cost. A 1.4x converter will halve the amount of light hitting your sensor; for example, an aperture of f/5.6 will be f/8, while a 2x loses you two stops of light. That said, in bright conditions they work well, especially on image-stabilized lenses, which help with the increased camera shake resulting from a large increase in focal length. The golden rule with teleconverters is to always use the recommended manufacturers' converters with the lens you are using.

4 When choosing midrange zoom lenses and long telephoto lenses, make sure the lens has a tripod collar; you are likely to need to use the lens mounted on a tripod for many of the images you take.

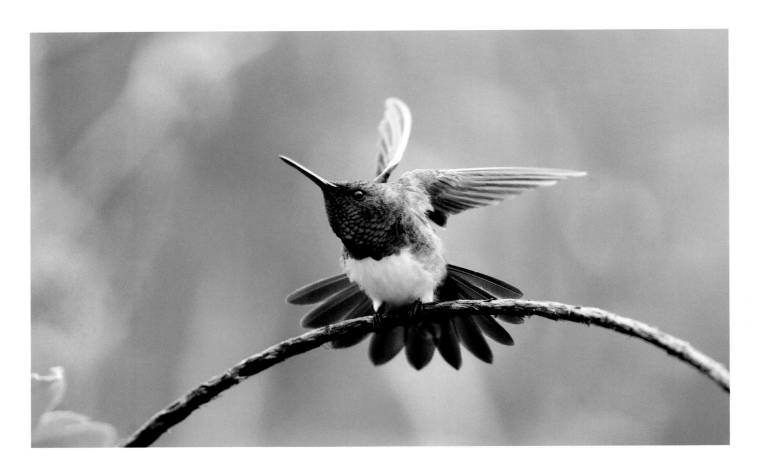

ABOVE If birds are your big interest, then to avoid frustration a long telephoto lens such as a 500mm is a must. This snowy-bellied hummingbird photographed in Central America, even with my 500mm lens and a cropped sensor camera making it 700mm, still required an approach to within 18 feet (5.5 m) to obtain a reasonable image size.

500mm lens, ISO 200, 1/125 second at f/5.6

5 While most wildlife photography requires a long lens, don't ignore ultra wide-angle lenses in the 12–17mm range. For ridiculously tame subjects, these are great for getting up close and personal, and creating some eye-catching images. How close your wide-angle lens focuses will be an issue. The closest focusing models (my 17 mm lens focuses to within 2 inches/5 cm) do cost a lot of money, but the closer the lens focuses, the better for creating worthwhile effects. These lenses are also good for placing your subject within the landscape, and I will discuss this technique in more detail later (see Chapter 4).

6 You might read and hear sometimes that midrange zoom lenses do not offer the quality of fixed-length lenses. This can pretty much be ignored these days;

optical quality is no longer the issue it once was with zooms. The vast majority of zoom lenses will give no discernible difference to picture quality when compared to a fixed focal-length lens.

7 Autofocus has been a boon for capturing exciting images depicting action. The fastest autofocusing lenses are those that have a wide maximum aperture such as the 300mm f/2.8. The drawback is that these lenses are bigger than their slower counterparts and more expensive. However, don't get hung up on using autofocus all the time; if your eyes are good, manually focusing frees up a greater ability to compose more quickly and far more creatively on static subjects. See Chapter 4 for more on composing creatively.

In summary, lens choice is ultimately down to personal preference, your style of photography, and the subjects that most interest you. My philosophy has always been to not weigh myself down with too much gear, and then the whole process of taking pictures remains enjoyable out in the field.

Macrophotography

To cover macrophotography in any thorough way would almost involve writing another book. As a result, and because there are already excellent books on the subject, I will mention just some of the general points that should be considered.

WHAT IS A MACRO LENS?
Simply, a macro lens is a short telephoto lens that focuses much closer than a telephoto. A true macro lens will focus close enough to offer at least a 1:2 or one-half life-size magnification; this is known as the "reproduction ratio." Some of the best macro lenses focus to 1:1 or life-size.

Macro lenses for DSLRs typically range from around 55mm to 200mm. Macro zoom lenses can be very useful; I use a 70–180mm zoom, which is particularly good when photographing active mammals in a studio setup. Which length you go for is likely to be determined by the sort of subjects you intend photographing. If you are looking for a lens that will cover all eventualities, you cannot go too wrong with a 90mm or 100mm macro lens. The advantage of using long macro lenses (anything up to 200mm) is that they give you a greater working distance from your subject, and so you are less likely to disturb your subject. This is particularly true of insects such as dragonflies and butterflies. The longer length also provides you with a narrower field of view and consequently less background clutter, with more emphasis placed on the subject.

ALTERNATIVES TO MACRO LENSES
If you don't wish to purchase a macro lens, but you want a macro capability with the lenses you have, you can focus closer than the minimum focus on a lens by using extension tubes. Extension tubes are hollow cylinders that are attached between camera and lens, and are available in varying lengths that can be used alone or stacked together. The drawback is that extension tubes lose you light, and you will need to adjust your aperture or use a slower shutter speed to ensure a correct exposure. A 50mm tube loses around one stop of light. Another gadget is the closeup lens, which can be screwed on to the objective lens like a filter; this has the effect of increasing magnification, and is worth experimenting with.

Nikon's AF-S VR Micro-Nikkor 105mm f/2.8G IF-ED

DEPTH OF FIELD PROBLEMS
Big magnifications and working in close proximity to a subject create depth of field issues. Working with a typical aperture of f/16 is not unusual, and this can lead to lighting problems, which is why many photographers who like macro work use a flash. The big camera manufacturers, such as Canon and Nikon, have developed a sophisticated macro flash that fixes to the end of the lens, and these are excellent. Alternatively, you can use a standard flash gun, ideally mounted off camera with a bracket. You will need to experiment with settings and angles, and for this it is worth consulting the books that are dedicated to macrophotography.

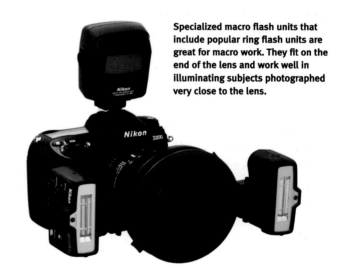

Specialized macro flash units that include popular ring flash units are great for macro work. They fit on the end of the lens and work well in illuminating subjects photographed very close to the lens.

MACRO MODE ON COMPACTS
Finally, many compact cameras have a macro mode, allowing very close focusing. These cameras are very popular with insect photographers because the insects can be quickly photographed for identification later. They are suitable for butterflies and other decent sized insects that can be approached within a reasonable range.

RIGHT For small reptiles, amphibians and insects, you will want a macro lens — one that focuses very close, allowing a decent image size. There are some excellent zooms on the market that do just this. I use one with a 70–180mm range, which allows most subjects to be photographed with ease. These are Panamanian golden frogs; the male is clinging to the female's back during a marathon 90-day mating ritual. Although I do little macro work, as reflected in this book, I always travel with my macro lens to be ready for unexpected opportunities such as this.

70–180mm macro lens,
1/60 second at f/9

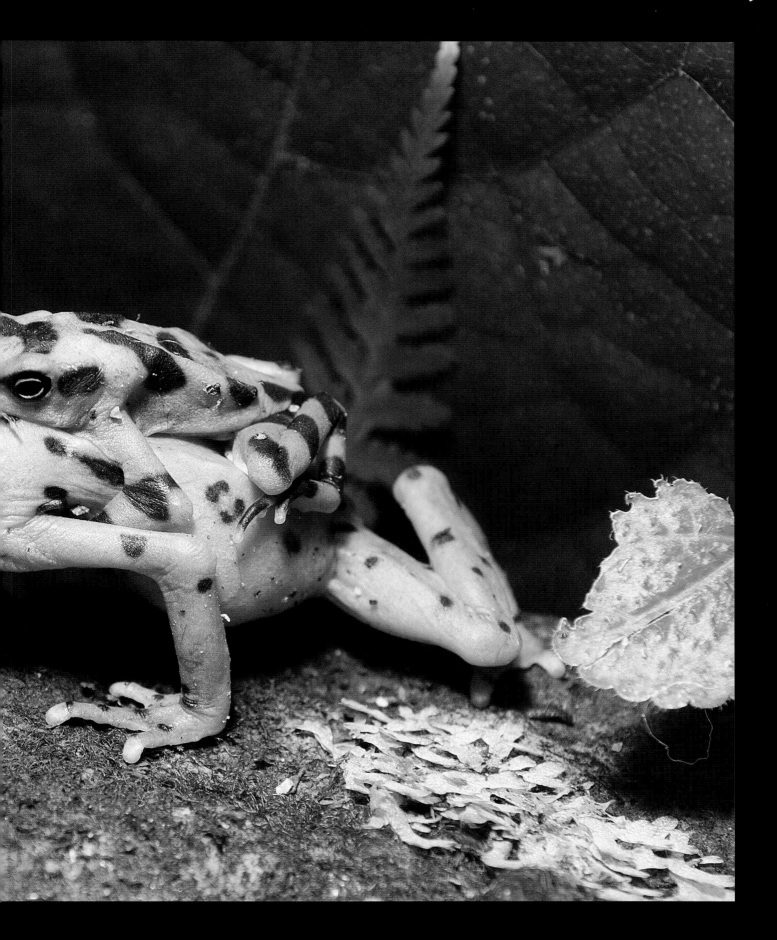

Tripods and heads

You can spend a lot of money on cameras and lenses, but if you then place them on top of a cheap, wobbly tripod the money can be wasted. Rather like buying a chair with three legs, it is simply false economy. A less than sturdy support will inevitably lead to camera shake, and even with an image-stabilized lens there are likely to be times when you are photographing a subject on the very edge of your equipment's capabilities in poor light. I know, because I have had many images spoiled by camera shake, often unrepeatable shots of rarely seen behavior that has occurred in poor light at the start or end of a day.

I see many people in my workshops attempting to handhold telephoto lenses when they should be placed firmly on a tripod. An old well-used rule of thumb, and one worth remembering, is that to consistently get sharp handheld images, you need a shutter speed to match the focal length of your lens. This means that if you are handholding a 500mm lens, you need a shutter speed of at least 1/500 second to guarantee a sharp picture. If you then start restricting yourself to fast shutter speeds, you will lose out on depth of field (see page 42), and so your picture composition suffers. My advice is to always use a tripod when practical.

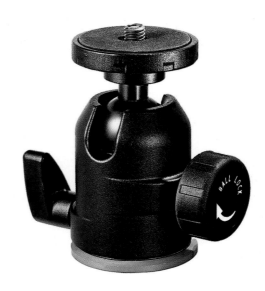

ABOVE Ball heads are very popular with wildlife photographers and, although they can take a bit of getting used to, once mastered they are universally suited to a range of lenses. If you will be mounting a large telephoto lens, it is sensible to opt for a larger model. It is also worth trying to avoid buying a cheap ball and socket head; the advantages of the more expensive models are the fine adjustment controls, which are vital when using these heads to their best advantage.

There are many cheap and awful tripods around, and you should not shy away from investing in something decent, especially as the cheap, wobbly versions will probably need replacing before too long.

First, I would suggest buying a set of tripod legs that can be splayed at right angles if necessary. This is a great advantage if you are on uneven ground, perhaps sitting on a river bank or the side of a hill. A second consideration is to obtain a tripod that has no central column – by raising a central column you immediately lose some stability and the column becomes superfluous. With a model that allows its legs to be splayed, coupled with no central column, you have an excellent support for lying on the ground and taking low-level shots.

Tripod legs come in either metal or carbon fiber. The latter are very popular as they are around 30 percent lighter than their metal counterparts; the drawback is that they are much more expensive. If weight is an issue with you, a carbon fiber model is likely to be a good investment. There are various makes; however, for performance and longevity, the majority of professionals use Gitzo or Manfrotto tripods.

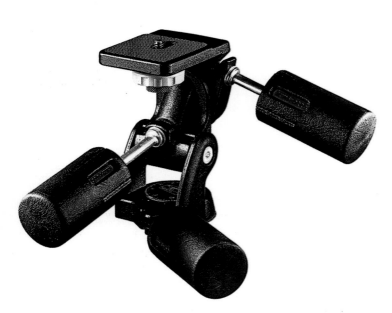

ABOVE This is a three-way pan-tilt head. These are fine with short lenses, but have limitations when it comes to using long, heavy telephotos mounted on them; they then become more difficult to control.

Once you have your tripod legs, you need a head. There are various options for which head to buy and these are discussed below.

1 The Wimberley and the Dietmar Nill heads are known as "gimbal-type" heads. They allow long telephoto lenses to pivot and move both in the horizontal and vertical axes with no resistance. They are good pieces of gear for long, heavy telephoto lenses in the 500–800mm range, allowing flying birds and running animals to be tracked with ease.

2 An alternative to the Wimberley is the Sidekick, a scaled down version that attaches to a ball and socket head, and allows the same fluidity of movement.

3 The ball and socket head takes some practice to use effectively. Unlike the Wimberley, it is very versatile, allowing short as well as long lenses to be used, and it is relatively small and light. Another advantage of it is that the Sidekick can be attached, giving added help for shooting action.

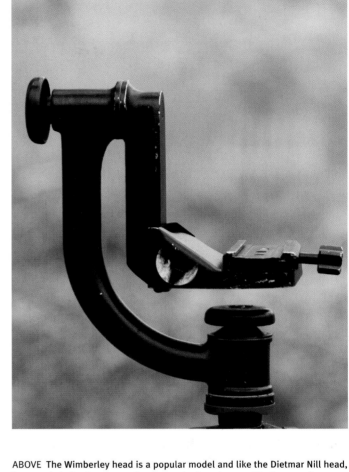

ABOVE The Wimberley head is a popular model and like the Dietmar Nill head, is a good choice for supporting long telephoto lenses. The lens works on a pivot and allows resistance-free panning. The downside of the Wimberley is that it is designed primarily for long lenses, not short focal lengths, so it lacks a little versatility.

LEFT Currently my head of choice, the Dietmar Nill tripod head. It works on a pivot, and is jerk- and vibration-free, allowing panning at slow shutter speeds and superb stability. It is shown here with a camera and macro lens, but it comes into its own when using the longest telephoto lenses.

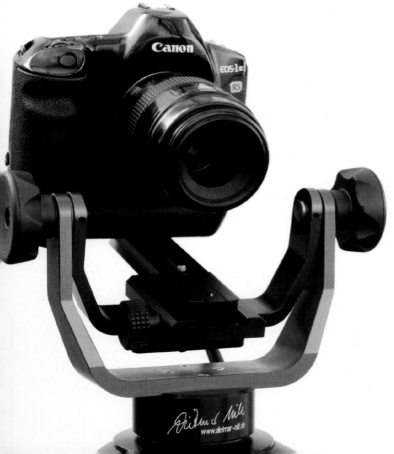

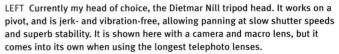

4 Pan-tilt heads do what they say on the box: they allow smooth panning and tilting of the lens. These are not as popular as they once were with wildlife photographers, but they do the job well nevertheless. A series of knobs control the adjustments.

5 Fluid or video heads are like pan-tilt heads but they have some built-in resistance that gives them extra stability. For this reason, they are popular with filmmakers. Their drawback is their price.

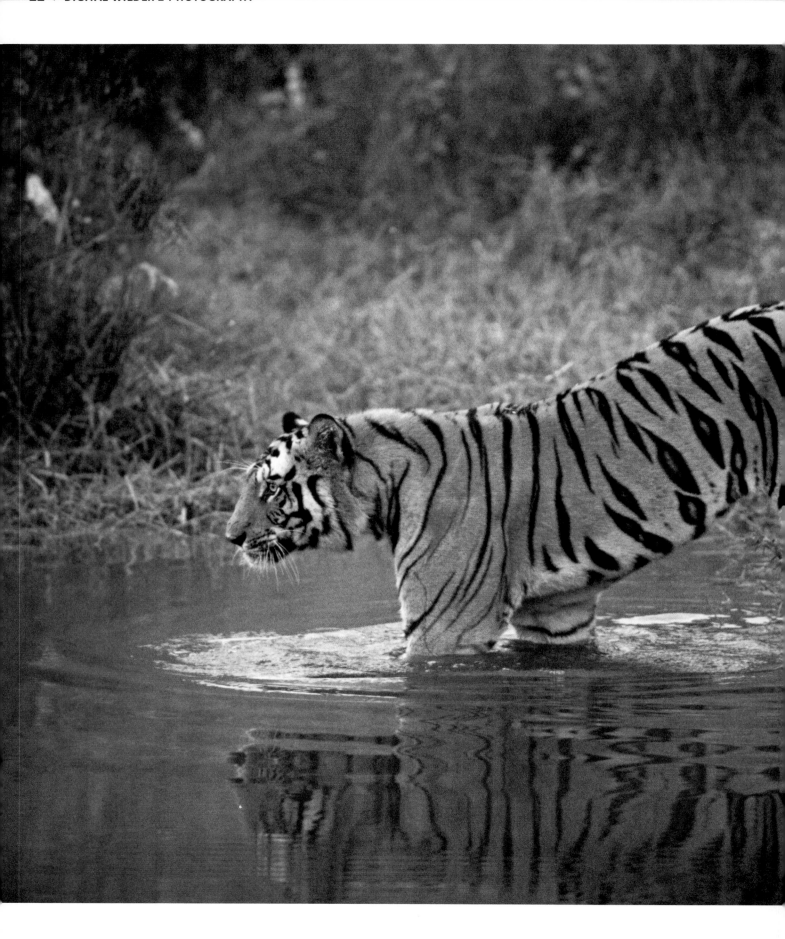

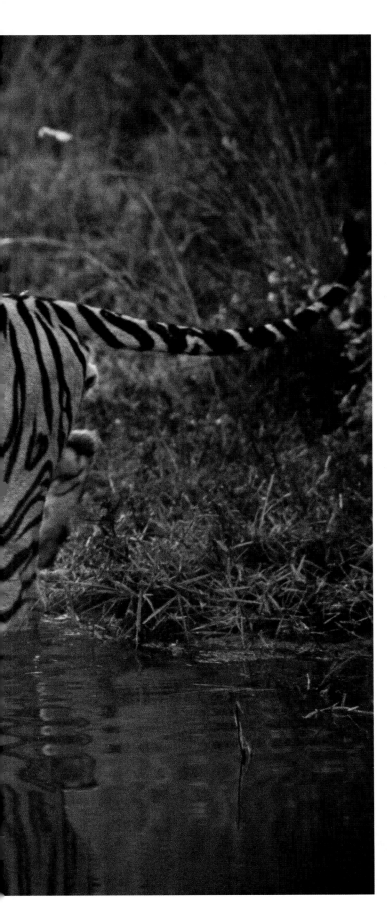

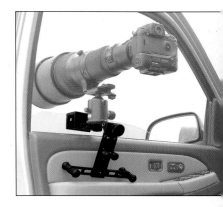

LEFT I photographed this wild Bengal tiger in India from the back of a jeep, just before sunrise. There was very little light but, by resting my long lens on a beanbag, I had a solid support, allowing a slow shutter speed to be used without worrying about camera shake.

200mm lens, ISO 400, 1/15 second at f/4

RIGHT The Kirk Window Mount – a useful accessory if you take a lot of photos from vehicles.

Choosing a tripod head is a little like choosing a car; you need to try out the different models to see which suits you best. I always use quick-release plates on my tripod head. This is a device where one part is permanently attached to the lens, the other to the tripod head. The lens can then be clipped or slid on or off quickly, and this is far more convenient than having to screw the lens on to the tripod head each time you mount it.

The monopod is an alternative to a tripod that can be handy in certain situations, particularly if stalking a mammal in thick undergrowth, for example. They can also come in handy as shoulder stocks for photographing action. However, a monopod will not have the same stability as a good tripod.

One other essential piece of gear for keeping the camera steady is the beanbag. Quite simply, this is a cloth bag, with a zipper at one end, that you can fill with rice or dried beans; it can be used for supporting lenses on car windows, the ground, walls, blind windows and so on. It is very versatile and a stable support. When traveling overseas, I take my empty beanbag and fill it with rice at the place where I am staying.

You can buy custom-built camera mounts and brackets for use in vehicles and public blinds. These offer good support, especially if you use a vehicle as a mobile blind for much of your photography. There is a range of models and, as with tripods, it pays to go for as sturdy a looking setup as possible. If you want a good window mount, the Kirk Window Mount made by Kirk Enterprises is one of the best on the market. The cheap and easy alternative to this is the beanbag.

Digiscoping

Digiscoping is an increasingly popular way of capturing wildlife images without the need for a DSLR and long lens; it is simply the marriage of a compact digital camera with a telescope. The high magnifications achieved with such a combination and the need for the minimum of equipment have made it a favorite of birdwatchers.

To go digiscoping, you need a compact camera, a telescope and a tripod on which to mount your gear. Although you can hold a compact camera up to the eyepiece of a telescope and snap away, for the best results you need to attach your compact camera to your eyepiece by way of an adaptor. Some camera manufacturers, such as Nikon, produce custom-made eyepieces and camera adaptors for digiscoping, while there are other independently manufactured adaptors available for a range of telescopes and compact cameras. Indeed, Nikon produces an adaptor to which you can shoot with a DSLR attached to a telescope.

When selecting an eyepiece, the lower magnification eyepieces will produce a brighter image and will allow the subject to be found and followed more easily; anything between 20–30x is ideal. The choice of telescope for digiscoping is very important, and generally a bigger objective lens is better. The more light that is allowed into your camera, the faster your shutter speed will be, which increases your strike rate for achieving sharp pictures. Models that have an objective lens of 77mm and up are ideal, but of course they do come with a higher price tag than the 60mm models, which are also adequate.

Choosing a compact camera to go digiscoping might at first seem daunting because there are so many on the market. Traditionally, Nikon led the field in this arena with its Coolpix range of cameras. However, this is not necessarily the case now, and many other manufacturers, including Sony and Canon, offer compacts that can do the job. Nikon scores in its custom range of telescope eyepieces and adaptors, and it offers telescopes with large objective lenses. When choosing a compact camera, make sure it has a decent size LCD screen on the back — go for optical zoom rather than digital zoom as the latter

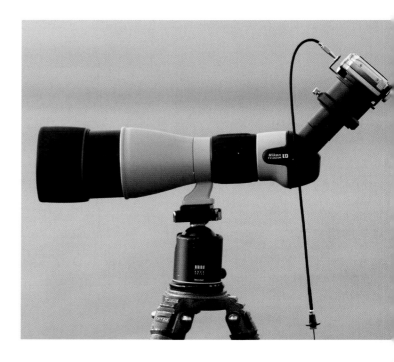

ABOVE Digiscoping has introduced many people to wildlife photography. This is a typical setup: the compact digital camera is attached to a telescope by means of an adaptor. A cable release is an essential accessory when digiscoping to reduce the problems of shake that can lead to blurry pictures.

only zooms in on the picture, sacrificing your pixels, while the optical zoom is a true telephoto zoom and you won't lose any picture quality. Moreover, make sure that the objective lens of your compact is smaller than the telescope's eyepiece so that vignetting (darkening of the edges of the picture) is avoided. Having said this, vignetting can easily be cropped out once your picture is on the computer screen and, by zooming in slightly on your subject, vignetting can normally be eliminated.

As mentioned above, you can mount DSLRs to telescopes, and you may think that this is a great way to obtain super telephoto images of hard-to-approach subjects. On the face of it, the better picture quality likely to be obtained from a DSLR compared to a compact makes this an attractive option. Nonetheless, be aware that your picture quality will always be compromised by the quality of glass in the optics that you use; glass in objective lenses of telescopes do not match up to the glass in telephoto lenses, and lead to poorer quality images. In addition, one of the big attractions of digiscoping is the lack of weight in your setup — add a DSLR, and suddenly you are carrying around more equipment.

PROBLEMS WITH DIGISCOPING

There are serious limitations to digiscoping. Light levels are important in achieving good, sharp pictures with a digiscope and, therefore, bright sunny days are best for digiscoping. Tracking moving subjects with a digiscope can be a challenge, making action shots and pictures of running mammals and flying birds very difficult.

When in the field with your digiscoping gear, be aware of camera shake. Camera shake is easily overlooked but it is likely to be the cause of more ruined images than anything else. Having a sturdy tripod helps, as does using a cable release when low shutter speeds are used. If it is windy, try to hide behind a shelter, a wall or car door. Crouching low and not extending your tripod are other techniques. Take as many pictures as you can; the more you take, the better the chance you have of having at least a few sharp pictures. Try and resist the temptation to delete pictures in the field; it is very tempting to scroll through your photos on the cameras LCD screen and delete the blurred ones, but this is sometimes difficult to judge accurately, and so it is better to do one edit at home. Reviewing and deleting also uses up battery power quickly; having a big enough capacity Secure Digital (SD) card or Compact Flash card will help with this.

Having said all of the above, if your prime aim is to achieve a pictorial record of an animal or bird with the minimum of gear, then digiscoping could be for you.

With digiscoping, the same issues, such as focusing, camera shake and image processing, are shared with conventional digital photography and are covered in the following chapters.

Mobile phones

A recent craze is the use of cameras on mobile phones to take pictures of birds through a scope. In effect, this is digiscoping, although the term "phonescoping" has been used. Currently, cameras in mobile phones offer poor quality and are of very limited use for wildlife photography. However, this may change as technology develops, and phonescoping may become as popular as digiscoping, particularly among birdwatchers.

LEFT A typical digiscoping setup. The compact camera is held in a bracket and attached to an adaptor that fits over the eyepiece of the telescope. A cable release is attached to help avoid camera shake.

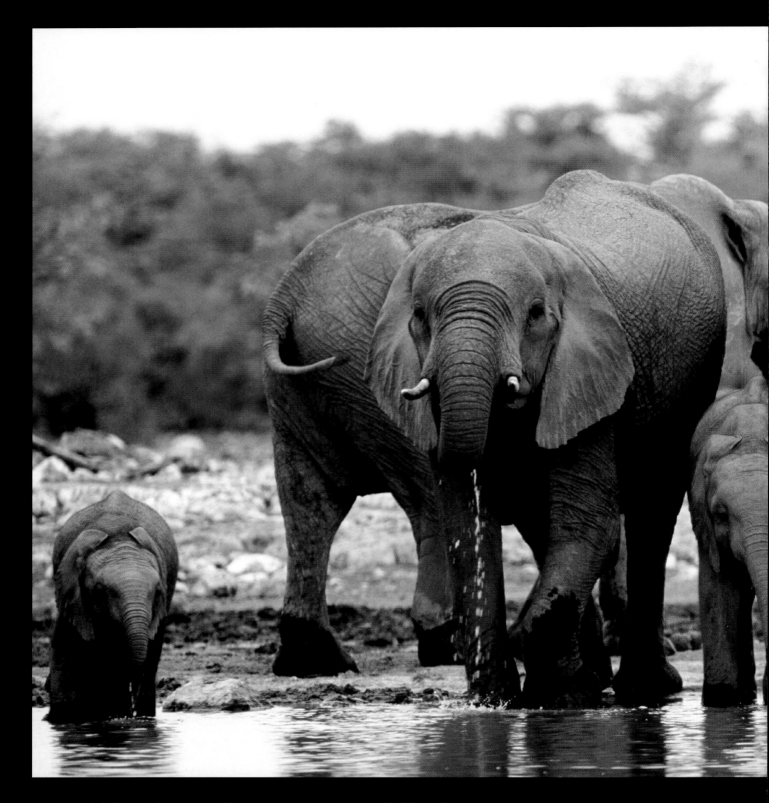

ABOVE A herd of African elephants come to drink at a waterhole in Etosha National Park in Namibia. Etosha becomes a giant dust bowl in the dry season, so I meticulously cleaned my sensor at the end of each day to cut down on cleaning images during post-processing on the computer. I have cropped this image to remove some of the featureless white sky that detracted a little from the elephants and was superfluous to the aesthetics of the picture.

500mm lens, ISO 100, 1/250 second at f/11

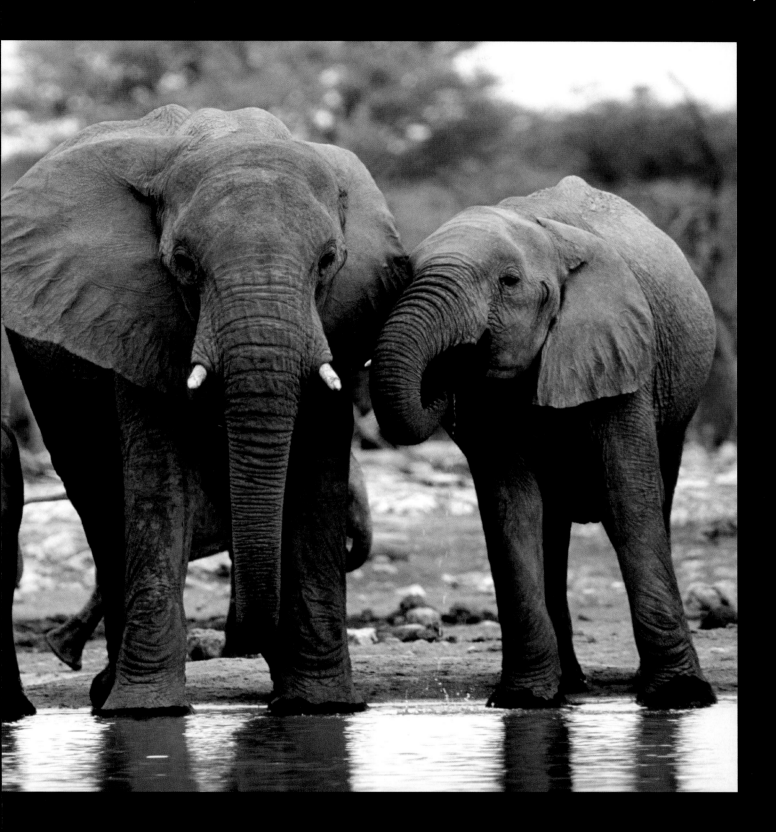

Digital film

Once you have taken your pictures, they need to be stored somewhere on the camera. The camera processes the information and sends the data to whatever storage media (digital film) you are using, from where you can eventually download the pictures to your computer.

Digital film comes in a variety of formats, including IBM Microdrives, Compact Flash cards and SD cards. For wildlife photography, the majority of cameras in which you are likely to be interested take Compact Flash cards.

Compact Flash cards come with varying storage capacities, and the capacity of the card dictates the price. I currently use 4GB (gigabyte) cards, which can take around 200 pictures when I am shooting in RAW (see Chapter 2 for an explanation of RAW). If I were to shoot in basic JPEG mode (see Chapter 2), then 2,000 images would fit on the card. Therefore, the size of card you need may be dictated by the mode in which you decide to shoot.

Cards have what is known as a "write speed." This is the speed at which the card accepts and stores the information being fed to it from your camera. The faster the write speed, the better the processing speed of your camera as it is freeing up more space more quickly.

The transfer of pictures from card to computer can be made by using one of the following options.

ABOVE A Compact Flash card being placed into a universal card reader for downloading images.

RIGHT The PC card adapter is used to download images to your computer by inserting your Compact Flash card in the slot, and slotting this into your computer.

1 **PC card adapter. These enable** Compact Flash, SD and IBM Microdrives (with an adapter) to be inserted **into a personal computer (PC) card slot on a laptop or into a PC card reader.** The PC card shows up as a drive on your computer desktop, and the image files can be dragged and dropped into a folder from this.

2 **Card reader.** This is my preferred option. I am a Mac (Apple Macintosh) user and I use a universal card reader. Simply, this is a device (see photo below) into which you insert your card, and it plugs into your computer. The card reader then shows up on your desktop as another drive, and you simply drag and drop the files from it into a folder on your hard drive.

 If using a Mac, you can take advantage of a system-level application called "image capture," which allows you to decide where the files are to go, and gives you a quick preview to aid in deleting obvious reject images, and so saving time when downloading.

3 **Camera to computer.** Most cameras are sold with a cable that attaches directly from the camera to the computer in order to download images. This is much slower and more laborious than using one of the devices listed above, and should be considered only as a last resort.

Once you have downloaded the images, to use the card again you need to erase it or reformat it. I format my cards each time I go to use them again. If you inadvertently erase all the images on a card by mistake before downloading them, don't despair. It is often possible to retrieve all or a number of the images by using retrieval software. SanDisk offers CD software for their cards, while Lexar Compact Flash cards come with Image Rescue loaded on the card. There are many sites on the internet offering such software.

Computers

As this is a book about photography, I don't want to go into too much detail about how to choose a computer. Much has been written about the various merits of either owning a PC or Mac. There was a time when, if your computer was to be used for digital imaging, having a Mac was advantageous. This is not really the case now, and the choice is down to personal preference. Although Microsoft Windows is by far the most common operating system, the Apple Macintosh system is more widely used by imaging professionals. I have used both systems and currently use Macs; I do find them extremely easy to use. Whatever system you decide, Adobe Photoshop, the imaging software you are likely to use, works equally well on either platform.

Adobe Photoshop CS2 brings significant advantages to photographers using DSLRs due to the vastly improved Adobe Camera Raw (ACR) and Bridge (see Chapters 6 and 7 for a detailed look at these features).

When choosing a computer for digital imaging, the following points should be considered.

1 RAM (random access memory) and processing speed measured in megahertz (MHz) or gigahertz (GHz) are the two key factors that will determine the speed at which you can open and manipulate images. Speed is the main determining factor in the price of a machine, but when dealing with photos, the faster the better.

RAM is temporary storage used to run programs required to undergo tasks. This is where your picture data goes to be viewed or manipulated. It is relatively easy to add more RAM to a computer. Computers come with enough RAM for most imaging work, but it is always worth adding more, as imaging work is memory-hungry. It is worth starting with at least 1 GB of RAM, as the cost will be recouped in both time and stability.

Moreover, when choosing a computer, ensure that you have a big enough hard drive for some storage. In the region of 250 GB with an 8 MB (megabyte) disc cache gives both speed and capacity, and is a good start. Operating systems take up more and more space, and so having a second drive is a good investment.

2 Choosing the right monitor on which to view your images is an important decision because you will use the monitor to make critical adjustments to improve the image. There are two types to consider: the cathode ray tube (CRT) and the flat-screen liquid crystal display (LCD). However, it is going to become harder and harder to find a good CRT screen because they are produced less now, and the choice may in fact disappear.

An attraction of LCDs is their size and weight compared to the much more bulky CRT monitors. If space is at a premium on your desktop, this may be an issue, but with the smaller, sleeker designs of LCDs there comes a higher price tag. Nonetheless, they do last longer than CRTs and stay true in rendering color for much longer. Consequently, the higher price may not be representative of their true value when compared with a CRT.

There are many other differences between the two types of monitors but most of these should not really affect your decision. For either kind of display, I would suggest you buy as large a screen as you can fit into your space or that you can afford, certainly a minimum of a 17-inch (43-cm) screen is desirable for digital imaging. Remember that when you have an image up on screen you will also have various palettes and controls relating to your imaging software displayed, taking up space.

Laptop computers are useful tools when traveling, yet their screens can be limiting with many models. It can be difficult to make accurate judgements when optimizing an image, and the screens do have a narrower accurate angle of view.

Digital storage

Pictures take up a lot of room on a hard drive, and you will soon find that your computer's hard drive is groaning under the sheer number of images that has accumulated. There are two common options to solve this space issue. You can either copy your pictures to CD or, better still, DVD. Alternatively, and in my view a far more effective solution, purchase external hard drives that connect to your computer, and on which your images can be stored.

DIGITAL STORAGE IN THE FIELD

If you are away from home taking pictures, or shooting so many pictures in a day that you do not have enough Compact Flash cards, then you need a way of storing your images in the field. Of course, you can travel with a laptop, and many photographers do, but by downloading all your images on to this, you are putting all your eggs in one basket. You need to think about what would happen if your laptop breaks or if it is stolen. Not only is it worth traveling with a backup, but it is handy to be able to carry something small in the field on which to download images. This is where the portable hard drive comes in. These fit in the palm of your hand and typically range from offering 20–80 GB of storage space.

Portable hard drives work by having a slot for the Compact Flash card, from which the images can then be transferred. Some, such as the Epson range, have very good screens from which you can delete images, while others are simply a hard drive with few bells and whistles. Another option or another means of backup is to travel with a portable CD or DVD writer, which can burn images directly from your memory card. For more on storage options, see Chapter 8, Storage and backup.

RIGHT **Small portable hard drives that fit in your pocket can be very useful. This is the Epson P4000.**

Taking care of your equipment

Cameras and lenses are delicate pieces of equipment and so need some care, especially when transporting them around. The very nature of wildlife photography – being out in often rough terrain or in adverse weather – means that a good waterproof camera bag is an essential. Camera bags come in all shapes and sizes. If you travel overseas, it is worth choosing a model that fits the dimensions required by airlines for carry-on luggage because no airline will insure your equipment for transport in the aircraft's hold, and many insurance policies exclude cover for equipment placed in an aircraft hold.

RIGHT **When the weather gets rough, don't put your camera away; protect it from the snow or rain and keep shooting as great images can still be taken. Extreme weather provides opportunities for some extreme pictures. This is an eider flying through a blizzard.**

500mm lens, ISO 400,
1/350 second at f/4

Adverse weather can produce great opportunities for wildlife pictures. Scenarios might include heavy falling snow or rain. Custom-made rain covers for lenses and cameras are very useful in such circumstances, and can be purchased from a variety of sources selling photographic accessories (see the list at the back of this book). Of course, you can always use small garbage bags; and shower caps are also popular accessories for keeping cameras dry.

The digital photographer's biggest challenge is dust. Getting too much dust on your sensor will result in you having to remove its effects from your pictures with image editing software, which can be time consuming. Regular sensor cleaning is good practice. There are many ways of doing this, and some of the big camera manufacturers offer sensor cleaning services. I use a large bulb blower made by Giotto, that is squeezed by hand, which I find works very well. However, some photographers frown at this method, suggesting the dust will be pushed into inaccessible areas. To avoid this, I always hold my camera up, with the interior facing the ground, so that the dust is given a chance to fall out when disturbed by the blower.

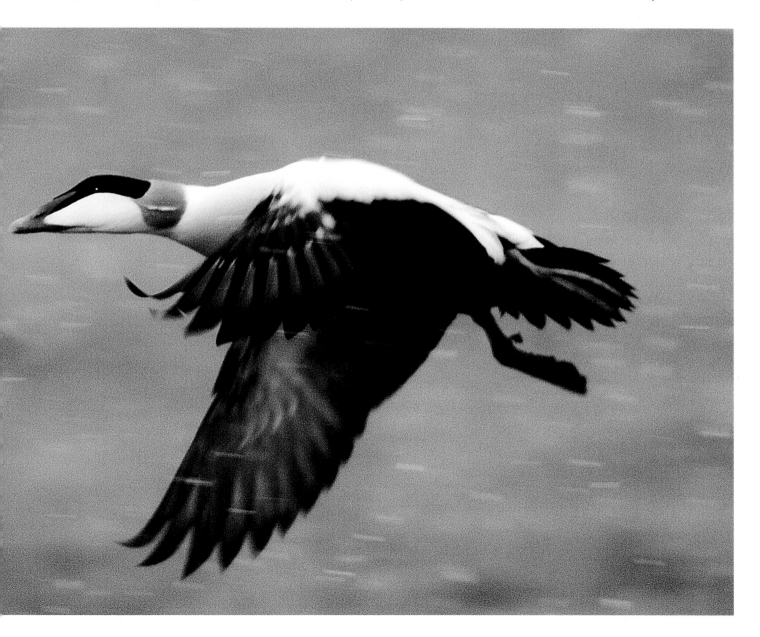

It is possible to buy sensor cleaning brushes, and these range in price from very little to a substantial investment for a top-of-the-line set. Many photographers swear by the brush method, while others use both brushes and specially purchased swabs. Which method you choose comes down to personal choice. However, never use canned air because, although tempting, if you squirt a drop or two of liquid from the can onto the sensor, removing this will be a problem.

To keep your sensor clean:

• Always keep the camera's body cap on when there is no lens attached.

• It is not always possible, but try to avoid changing lenses in dusty conditions.

• Mount your lens before switching the camera on. Once the sensor has a charge, it attracts dust far more easily.

• Avoid using compressed air when cleaning your sensor.

• If particularly stubborn dust spots persist, take the camera to an authorized repair center for cleaning.

• Regularly view images on the computer at 100 percent to check for possible dust. You can take a picture of the sky with the lens set at an aperture of f/22, and this will effectively show how dirty your sensor is because dust spots will be far more visible than when shooting with the lens wide open.

RIGHT Hot and dusty environments are obvious danger zones for getting your sensor dirty, yet this can happen in more unlikely places too. This baby emperor penguin chick, just like the thousands of other birds in the colony, was producing guano, which was freezing and creating a layer of blowing particles. This made changing lenses difficult without dirtying the sensor. Whenever you change lenses, you should take as much care as possible to avoid getting dust into your camera and, on any trip, clean the inside regularly. The last thing you want is to return home with hundreds of images that need time-consuming retouching work to get rid of dust spots.

300mm lens, ISO 100, 1/250 second at f/8

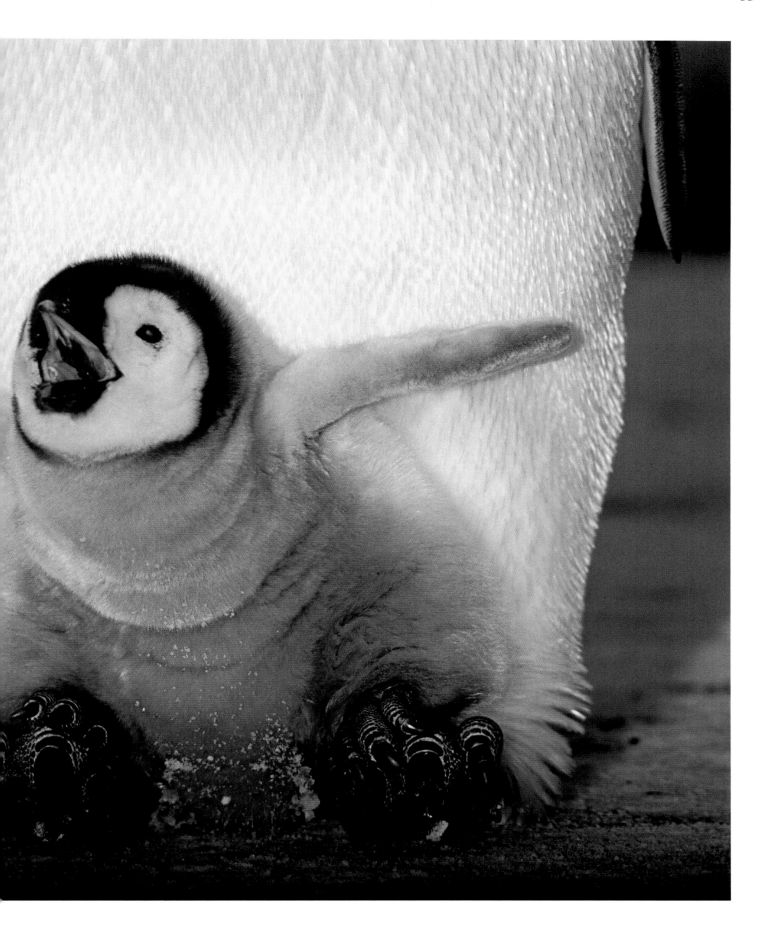

CHAPTER 2

Taking pictures

Before running loose into the field with your DSLR, there are a few shooting parameters that need to be understood. These include: formats to shoot in, white balance, color temperature, color space, level of sharpening, (sensor speed) ISO, noise reduction, and file numbering.

These are all relevant to how your pictures will look and to how they will be managed, and so it is worth taking time to acquaint yourself with what these terms mean and how they affect your pictures and workflow.

Setting up the DSLR

FORMATS

Which format should I shoot in? This question is often asked during my wildlife photography workshops and holiday shoots. There are basically two choices: either JPEG or RAW.

Depending on how sophisticated your DSLR is, you will find a variety of choices for image quality on the scrollable menu on the camera. You need to choose one of these, which are variously described as RAW, JPEG or TIFF, with JPEG likely to have a variety of options (basic, normal and fine, with fine being the highest quality JPEG). Confusingly different camera manufacturers give their cameras' RAW files different names. For example, Nikon calls the RAW files their cameras produce NEF files, which stands for Nikon Electronic Format, and the letters NEF appear as a suffix on the image number. Whereas the suffix that Canon uses is CRW. To help select the best setting for you, I have detailed what the choices all mean below.

JPEG

JPEG stands for Joint Photographic Experts Group, and it is basically a compression method developed by this group. Thus, a JPEG is a way of storing a picture at a much smaller size – in other words, all the data is squeezed into a smaller space. This has its drawbacks because the JPEG is known simply as a "lossy" format. By compressing this data, information is lost, although this may not be discernible to the human eye if the highest quality settings are used. However, it certainly will be noticeable if you decide to work on the image and resave it a number of times. Your camera will allow you to set different JPEG settings from basic through to fine. JPEGs have undergone some processing by the camera, according to parameters which you, the photographer, can set. For example, the amount of sharpening you desire, white balance and so on.

RIGHT You have no way of telling whether I shot this hazel dormouse in RAW or as a JPEG. There is often no discernible difference if you get your exposure, white balance and other parameters right when shooting in the JPEG format. It does, however, make sense to shoot in RAW if you have no compelling reason for taking JPEGs because the added control you have when processing your images will help you to produce the image as you want it, taken in a controlled setup.

70–180mm macro lens, ISO 160, 1/250 second at f/16

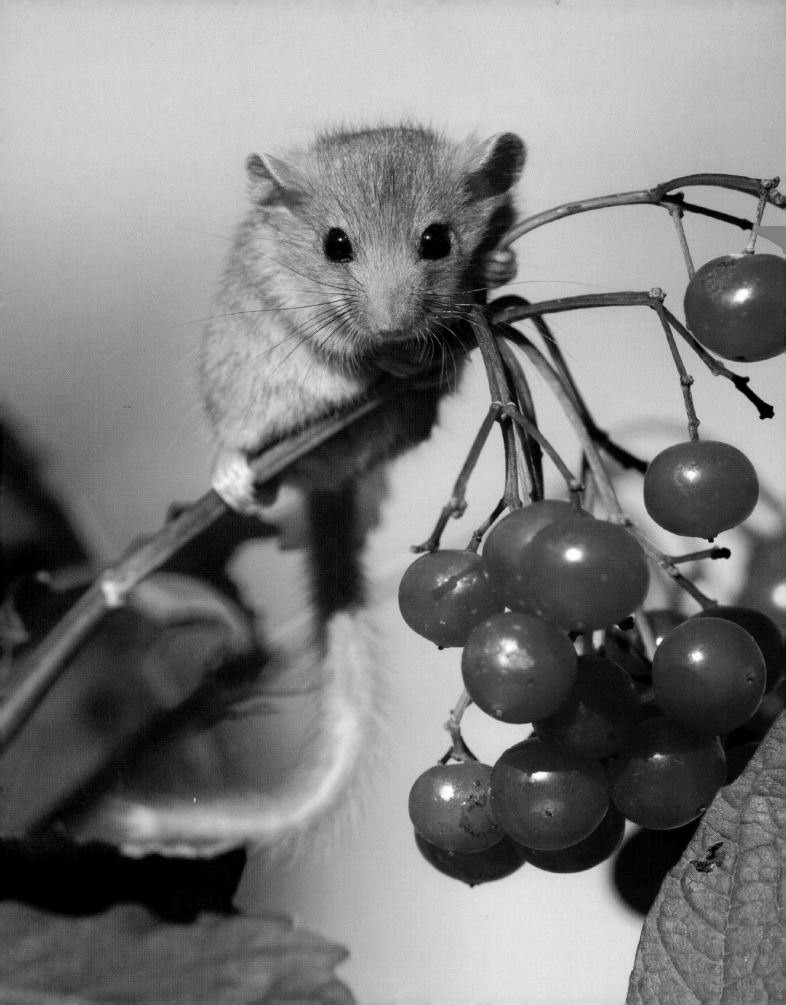

One last point to remember about a JPEG is that it is captured as an 8-bit image. But what is a bit? To keep it simple, a bit is the basic unit of computing and it has two states: either on or off. This means either black or white. Eight bits make a byte and, as each bit has two states, one byte has a possible 256 combinations; that is to say, 256 values from black to white. An RGB image has three channels (colors are created by mixing red, green and blue, hence RGB) and, because there are 8 bits per channel, if you multiply each channel by 256 you get a staggering 16.7 million colors. Most DSLRs capture RAW images in 12 or 14 bits, giving even more possible colors. Rather than converting to 8 bits when editing our RAW images, by converting to 16 bits we retain the integrity of that color information.

You may be wondering how the human eye could ever discern the difference between 8- and 16-bit images. A higher bit depth gives smoother and more graduated tones. At times, if an 8-bit image has been adjusted too much in Adobe Photoshop, the transition in tones starts to show, and this is known as "banding." Furthermore, if an image is to be interpolated (enlarged by adding more pixels) or manipulated heavily, then 8-bit images will not hold their quality as well as the larger 16-bit file.

RAW

The RAW image format is as it sounds: it is the raw image data captured by your digital sensor with no processing applied by the camera – you could compare it to an undeveloped piece of film. The parameters set in the camera, such as white balance, saturation, contrast, sharpening and so on, are recorded as metadata which is not applied to the image in the camera, and so at the time of conversion these can be adjusted in the way you desire. The obvious advantage to RAW is a greater flexibility in the finished quality of the image.

TIFF

TIFF stands for tagged image file format. This is the common format used to convert a RAW file into one that can be read across platforms, and used for a variety of end uses such as printing. There is no real reason to use this setting in your digital camera, not least because TIFF files take up far more room on your Compact Flash card. They also take considerably longer for the camera to process because the image is not compressed and it is having various parameters applied to it as it is processed. RAW files are converted to TIFF files later in the workflow, as it is both cross-platform and can be compressed "losslessly" using ZIP compression. Chapter 6 explains this in more detail.

Now that these formats have been explained, you can see that the basic choice is between shooting in RAW or in JPEG.

RAW VERSUS JPEG

Much debate surrounds the pros and cons of choosing one of these formats over another. Wrongly, in my opinion, many assume that the RAW format is the domain of the professional and the JPEG the domain of the amateur. Yet many sports photographers shoot JPEGs exclusively because it gives them performance benefits both in terms of the camera and in the delivery of images to their picture desks, from which the pictures are edited and chosen.

Another misconception is that an image shot as a JPEG is far inferior to one shot in RAW that has been converted to a RGB TIFF. This may be true on the bits and bytes level, but whether a difference is discernible to the human eye can be another matter entirely, especially if the JPEG is on the finest setting. Which format you use really depends on what you want to do with your images, and how much control you wish to have over the finished picture.

A JPEG is ready to be printed as soon as it is out of the camera; no further work is needed. Nevertheless, the settings in the camera are applied as the image is taken. These include saturation, white balance, contrast and, perhaps crucially, sharpening. Although some of these can be changed in Adobe Photoshop, sharpening cannot be reduced and, if an image is oversharpened, it can ruin it. Therefore, if shooting in JPEG, it is more important to get the picture right in every aspect. It is worth remembering that you can make a JPEG file from a RAW capture, but you cannot make a RAW file from a JPEG capture.

If shooting in RAW, you can easily change many parameters without having much effect on the final quality of the image. You should bear in mind that the RAW image data will have as much as 50 per cent more color information (tonal range) than a JPEG, but as mentioned, whether a difference can be assessed is another matter.

Listed below are the benefits of using each format:

JPEG

1 If you have correctly set your white balance and other parameters to render the image how you wish it to look, JPEG images need little or no extra work done to them once captured by the camera.

2 JPEGs take up less space. For example, a camera producing a 31 MB RAW file will produce a 4 MB JPEG file – you can fit more pictures on your Compact Flash card, and they will take up less space on your hard drive.

3 All photo-editing and image browsing programs can open JPEG images, whereas a special "plug-in" (software add-on) may be needed to open the RAW files of some camera models.

4 If you decide JPEG is the format for you, then shoot only at the best quality setting of JPEG (fine) and set the image to the largest resolution. If your camera gives you a small (S), medium (M) or large (L) quality setting, then always go for large. Medium and small settings are always going to give inferior picture quality. The only advantage of selecting a lower setting would be that it would use up less space on your Compact Flash or SD Card.

RAW

1 RAW capture offers you greater flexibility in terms of how the finished picture will look. Unlike a RAW image, every time a JPEG is worked on and saved, data is lost, degrading the image further. This may not be that noticeable in the highest quality settings if done once or twice, but it will show if the image is resaved multiple times. As mentioned already you can convert a RAW file into a JPEG or TIFF.

2 A well-worked RAW image – one that has had care taken over it to ensure it is of the highest quality – when converted to a RGB TIFF will, in theory, give better reproduction, particularly if the picture is reproduced to a large size. This is especially true of color information that may be lost in the JPEG format, but this may be debatable if a JPEG has been captured at the finest setting.

3 White balance and sharpening can be experimented with in a RAW image until the desired effect is attained. RAW images can also be revisited years later because imaging software improves – it is likely that in years to come we will be able to revisit our RAW images and improve their quality still further. Unfortunately, with a JPEG there is no opportunity to go back and improve upon the result.

4 Adobe has introduced the Digital Negative (DNG). With an Adobe DNG converter you can translate RAW files from any camera into this one DNG format. This means that all the different RAW formats can be united into one format, which can be opened in years to come, and so the images are protected for posterity.

You can see there are pros and cons to both JPEG and RAW and, ultimately, the choice of which format to use is up to you. If you are not a professional but shoot for enjoyment – perhaps contributing to a camera club and occasionally seeing your work in print – then shooting in JPEG mode should pose few problems. However, you will be missing the flexibility that the RAW option gives you, and so inhibiting your creative control over the final result.

If, on the other hand, you have ambitions to become widely published – perhaps you want to produce large poster prints – and you have the creative urge and time to get the best from your images, shooting in RAW is the only way to go. The post-processing time (when you optimize your images on the computer) needed to deal with RAW files is easily outweighed by the knowledge that you are doing all you can to produce the highest quality image.

RIGHT Because I captured this shot of a leopard leaving an acacia tree at dusk in the RAW format, I was able to enhance the warm glow of the setting sun and sky by increasing the color temperature in my RAW converter. If I had been shooting in the JPEG format, however, I could have done the same thing within my camera at the time of shooting, and I could have adjusted the white balance to bring as warm a feel as possible to the image.

200mm lens, ISO 100, 1/250 second at f/8, cropped to a panoramic

WHITE BALANCE

The color of a subject varies depending on the color of the light source. For instance, if you take a white piece of paper and hold it out in the midday sun under a cloudless sky, it will appear white. Place that paper at the same time of day in the same lighting conditions but in the shade, and it will take on a blue cast. Moreover, hold the paper out in direct sunlight at sunrise or sunset and it will take on a warm glow. Nonetheless, our brain is able to adapt to changes in the color of the light source, and will still identify the card as white.

The digital camera's solution to overcoming these color casts is the white balance (WB) function. This has a number of settings, which include cloudy, shade, fluorescent, flash, auto and so on. By setting the white balance to shade, and then photographing the paper in shade, the camera will compensate for the blue cast. However, do be wary of creating neutral-looking images. While a studio photographer might strive for lighting that appears white, this is not the case with wildlife photographers. Most wildlife photographers will want to take advantage of the beautiful warm glow you get soon after dawn and before dusk, and other such nuances in the light. Consequently, using the WB effectively will help to control the mood of the image.

For the vast majority of situations encountered when photographing wildlife, having the white balance set to

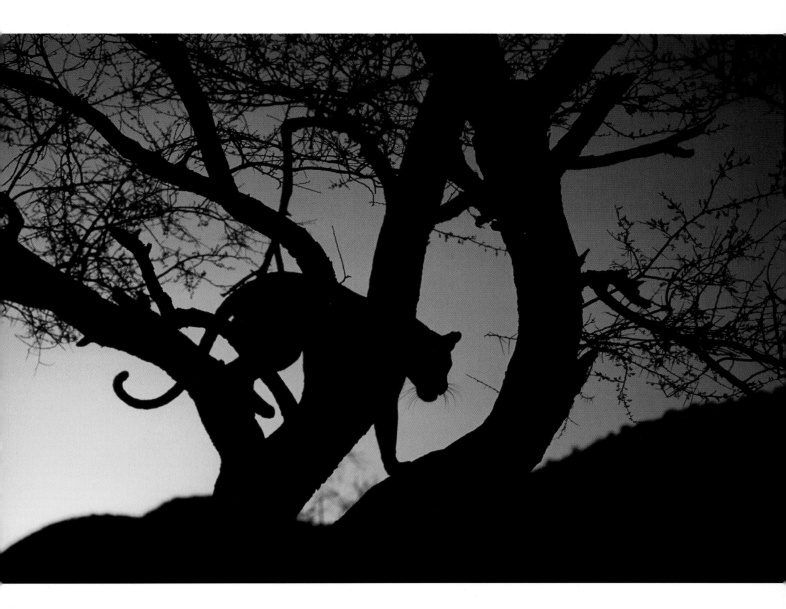

automatic (auto) will give you a good, balanced result. In any case, if you are shooting in RAW, you can easily change the setting after the picture has been captured. If shooting JPEGs, you might want to experiment with your camera in different lighting conditions in order to gain experience in choosing settings, and for seeing which is best as an all-around setting. Getting it really wrong could ruin an image.

Many JPEG shooters prefer shooting in the shade setting for most situations rather than in auto. As always, it is down to personal preference when viewing the results. In short, you need to experiment.

COLOR TEMPERATURE

In addition to the white balance control, many of the advanced DSLRs have the option to choose color temperature settings. You can use the color temperature settings instead of the white balance option in certain circumstances. I only ever use the color temperature adjustment on my camera when silhouetting subjects against a sunset or sunrise. By boosting the temperature, you increase the reddish cast and make the picture more dramatic. If shooting in RAW, this can of course be done equally effectively at the processing stage. For most of the time you can ignore color temperature unless you want to create a specific effect and you are shooting JPEGs.

COLOR SPACE

The color space determines the range of colors available for color reproduction. Color management is a big issue, and I will be covering this in more detail in Chapter 5. We all perceive color according to how good our eyes are, and this depends on age among many factors. Indeed, some people are color-blind but are not aware of it. My view is that if the colors in an image look right, then it is right.

International Colour Consortium (ICC) profiles are universally adopted measures that ensure that if a color calibrated device is used, the colors in any particular profile will look the same viewed by anyone, anywhere in the world. This is important when pictures are used in print because color accuracy is vital.

Two color workspace profiles are common: sRGB and Adobe RGB (1998), often shortened to Adobe RGB or ARGB. I use Adobe RGB (1998) as this is the industry standard used by all my clients. The advantage with this profile is that it has a large color range and latitude. An sRGB file contains less color than an Adobe RGB because it is incapable of defining some cyans and yellows or rich blues.

SHARPENING

Your DSLR will offer a range of sharpening levels. If you are shooting in the RAW format, you should leave the sharpening turned off or at the lowest setting. This is because images can be sharpened using a variety of sharpening tools in either Adobe Camera Raw (ACR) or Photoshop, such as "Smart sharpen" or "Unsharp mask"

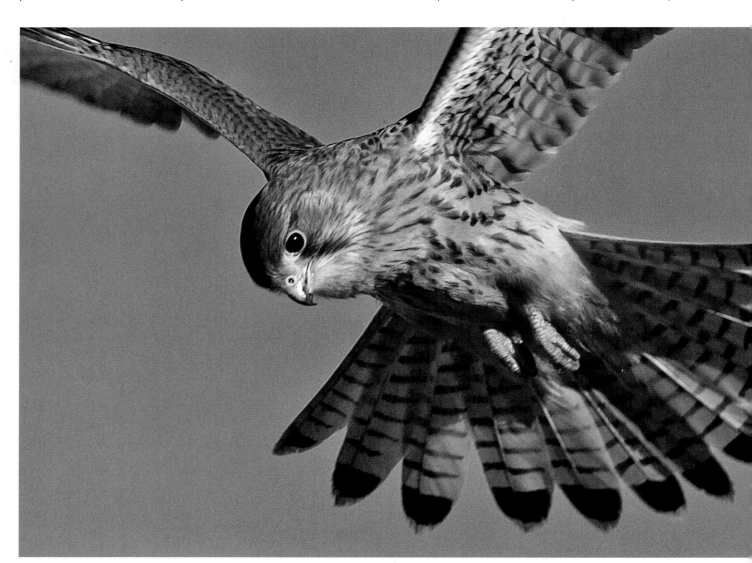

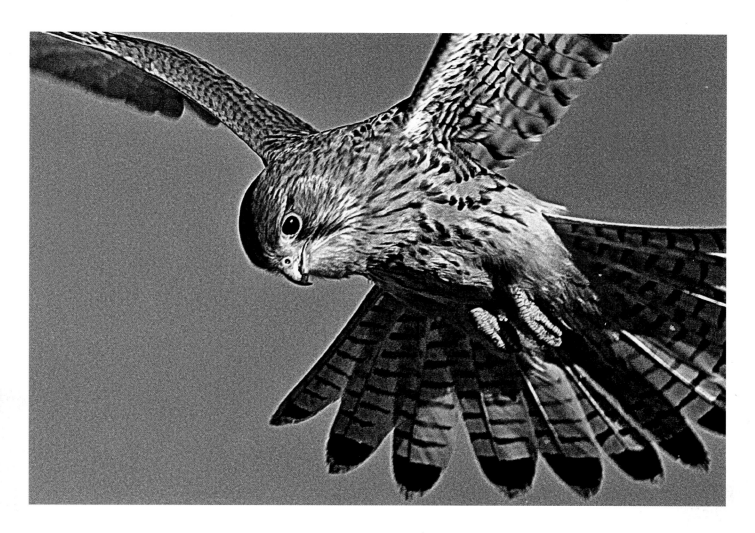

LEFT AND ABOVE This hovering kestrel is illustrated in the first image having undergone a correct amount of sharpening. The second image shows what happens if too much sharpening is applied. Note the halo effect around the edge of the bird; noise is also increased, and the detail in the bird suffers.

500mm lens, ISO 200, 1/1000 sec at f/8

(see Chapter 7). The danger of sharpening an image at capture stage is that if you then manipulate and/or interpolate, the sharpening effect will be accentuated and the look of the picture will suffer. For this reason, if your images are destined for publication or will be sent to a photo library, they should definitely not undergo any sharpening.

If, however, you are shooting in the JPEG format, it may be desirable to apply some sharpening in the camera. Nevertheless, remember that you can always sharpen in Adobe Photoshop. Ideally, any sharpening should always be at the end of your workflow, once any adjustments have been made. The danger when shooting JPEGs is to oversharpen at capture stage, and then this cannot be reversed.

NOISE REDUCTION

Signal noise – the occurrence of random unrelated pixels – as with film grain, is often an unwanted feature of a picture taken in poor light when a high ISO (see page 45) is used. There are obviously occasions when noise can enhance the mood of an image. Many cameras have a noise reduction facility that activates when the camera deems it necessary, usually when high ISO speeds are used. The other main causes of noise are long exposures, and again the noise reduction may then kick in. Some cameras have noise reduction settings that should only be set if using ISO values above 400, or when taking a picture with a long exposure, normally for one second or more. For shooting in normal conditions, you should have any noise reduction settings switched off. There are some good noise reduction software applications available by searching on the internet.

f-stops and shutter speeds: understanding exposure

Explaining the theory of exposure can get very complicated. However, understanding how to expose correctly is not too difficult, and digital cameras have histograms that make getting it right a fairly straightforward procedure.

Every subject at which you point your camera has a range of tones, and the key to a correctly exposed image is to record these tones in the way you desire, while keeping important detail in the brightest or darkest areas.

Three things work in conjunction with each other to determine which exposure you use. These are: the lens aperture; the camera's shutter speed; and sensor sensitivity, expressed as an ISO value. You will hear photographers talking in "stops" when discussing exposure. A stop is simply the term used to describe an increment of the aperture opening, whether it be increasing or decreasing the amount of light let through a lens.

THE LENS APERTURE

The range of apertures marked on a lens is known as "f-stop numbers." On a short focal length lens, these generally range from f/2.8 to f/32. At f/2.8, the aperture on the lens is wide open, allowing the maximum amount of light to reach the camera's sensor. At f/32, the lens aperture has a small opening, allowing little light in. When we want to let more light in, we use the term "opening up." When we want to decrease the amount of light coming in, we are "stopping down." Each increase or decrease in the range either doubles or halves the amount of light let through to your camera's sensor. For a lens with a typically large f-stop of f/2.8, the series would be f/2.8, f/4, f/5.6, f/8, f/11, f/16, f/22, f/32. These are standard one-stop increments. As you move up the scale, you are halving the amount of light traveling through the lens by adjusting the size of the hole – the aperture.

The aperture's role in the creativity of a photograph is to control the depth of field. The depth of field of a photo is the area, from near to far, that *is* in focus; in most photos,

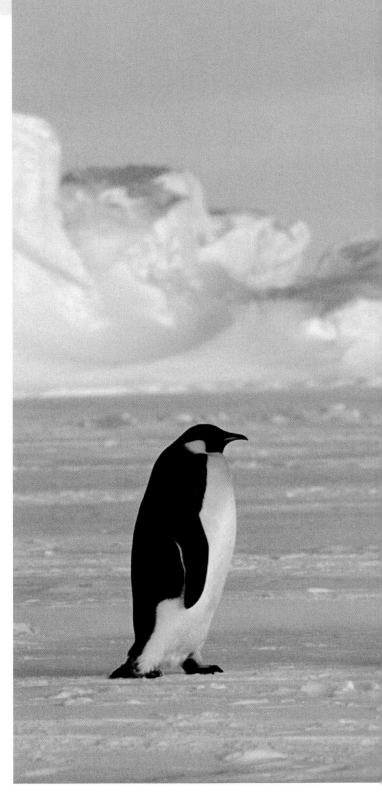

some other areas of background or foreground will be out of focus. At f/2.8, the depth of field is very shallow, so your subject will be isolated from its background. Whereas at f/22, the background to the subject is likely to be in reasonable focus. Therefore, the aperture that you choose has a big effect on the overall look of the picture.

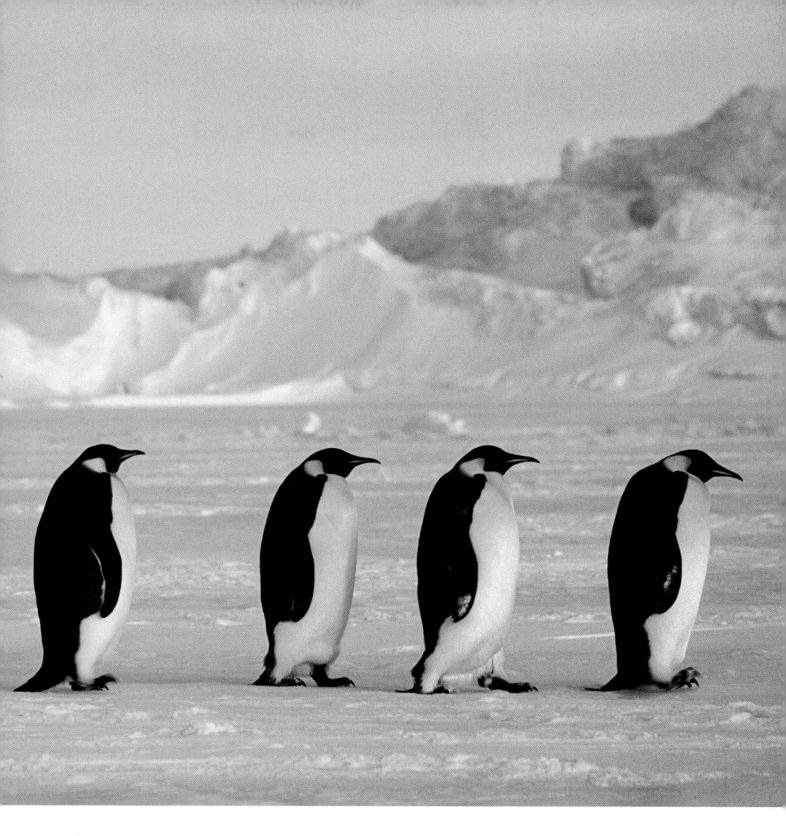

ABOVE A line of emperor penguins march in single file across the sea ice of the Weddell Sea en route back to their colony from the open sea. I used a 300mm f/2.8 lens to take this image with a shallow depth of field to put the icy backdrop into soft focus and place more emphasis on the penguins.

300mm lens, ISO 100, f/2.8 at 1/250 sec

THE CAMERA'S SHUTTER SPEED

Now you have an understanding of apertures and f- stops, shutter speeds are easy to come to grips with. The shutter in your camera normally opens for a fraction of a second and, as with f-stops, either halves or doubles the amount of light hitting the camera's sensor, depending on which way you go with the scale. As with most lenses, cameras allow you to measure in one-third stop increments. In a typical camera, these increments range from 30 seconds or longer, if you wish, to 1/4,000 or even 1/8,000 second. As with the aperture, your choice of shutter speed greatly affects the look of your subject in the picture if it is in motion. To freeze the action of, say, a flying bird, you are likely to need at least a shutter speed of 1/500 second. Conversely, you may want to show motion in your image and create blur, for example, of a running zebra. Then you may want to use a slow shutter speed, perhaps in the region of 1/30 second.

SENSOR SENSITIVITY

The ISO value is the final piece in the exposure jigsaw. ISO traditionally described film speeds, but with a DSLR the ISO dictates the speed of your sensor.

Generally, DSLRs range from ISO 100 to 3,200 – the higher the rating, the more sensitive the sensor is to light. Consequently, higher ISO settings mean less light is needed to make a picture, enabling images to be taken in poor light conditions or with higher shutter speeds and smaller apertures. The ISO rating you

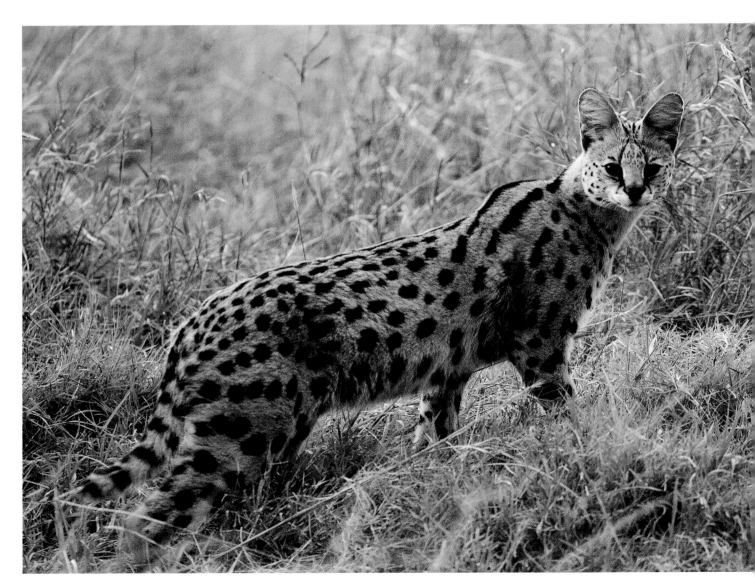

choose acts as the basis for your exposure. With the higher ISO values in DSLRs, there are disadvantages in the form of increased signal noise. Although not the same as grain in film, it has a similar effect in that the image is somewhat degraded.

Signal noise normally starts to become apparent with ISO values of 400 and above, but in poor light a picture may only be possible with a high ISO. The picture of a serval below was taken at an ISO setting of 800 because it was getting dark, sunset having happened a few minutes earlier. Nonetheless, in most situations an ISO of between 100 and 200 is recommended. At these low settings, signal noise will not be discernible, giving you a better quality result.

LEFT **This image of a serval was taken well after sunset; indeed, we had to have our vehicle lights on to find our way along the track. Yet this digital image makes it look like full daylight. Even at an ISO of 800 there is remarkably little signal noise in the image.**

500mm lens, ISO 800, 1/15 second at f/4

Once your ISO value is set, the shutter speed and aperture are linked: alter the value of one and the value of the other has to be changed to provide the same exposure. There is only ever one correct exposure, but many different combinations of shutter speed and aperture. This is known as "exposure ratio." For instance, if your camera's meter tells you that the correct exposure is 1/250 second at f/8, and you then decide that you need a faster shutter speed of 1/500 second, you are halving the amount of light coming into the lens to retain the correct exposure, and so the aperture needs to be opened up one stop to f/5.6, thereby allowing the same amount of light to hit your camera's sensor. When creating a picture, you can see that a balance has to be struck between choosing the right aperture for the effect you wish, along with a high or low enough shutter speed.

At this point, if I were writing a book about film photography, I would launch into how to spot a midtone and how to use this as the basis of your exposure. However, exposure with DSLRs does not work like this: it is much simpler. Yet, as with film photography, it is important to be as accurate as possible. If highlight details critical to a picture's composition, such as white snow or a white front to a bird, are overexposed (known as "blown highlights"), then returning detail to these areas using imaging software such as Adobe Photoshop will be impossible. It is better to have a full exposure, but if there is a danger of blown highlights with whites or other critical highlight areas, it is better to lean toward underexposing the image so that the detail can be retrieved.

By underexposing an image too much, be aware that signal noise can then appear – both in shadow and mid-tone areas – so creating more problems. Thus, as mentioned above, your aim is to set your exposure as accurately as possible. It is a common fault to believe that powerful image processing software can repair any large exposure errors, but unfortunately the software cannot work miracles. A full exposure, one where it is leaning toward overexposure but not with blown highlights, will better retain detail as more bytes define data in the highlights than in the shadows; underexposing as a matter of course is not good practice.

HISTOGRAMS

The only way to be sure of the accuracy of your exposure is to use the information provided by your camera's histogram. Note that the histogram is based upon a JPEG image and the settings for that, even though you may not be saving your image as a JPEG.

Although the LCD screen showing the image you have taken is great for checking composition, lighting and sharpness, it cannot be relied upon to show a correct exposure. For this level of detail, it is best to use the histogram. When first confronted with a histogram, it may seem daunting, but it is in fact remarkably simple to read. The histogram maps out the brightness values in an image. The darkest pixels are on the left, gray in the middle, the lightest on the right (use the phrase 'light is right' to remember this). The vertical axis of the histogram shows the number of pixels for each level.

In a good well-exposed image, the range of brightness levels stretches across the histogram. If the histogram is bunched up to the left, it is likely that the image is underexposed. If it is bunched up to the right, it is overexposed, unless the scene is "high key" (light). If you have a very tall spike at either end of the histogram, you are seeing under- and overexposure, or "clipping," occurring. The examples shown here should give you a feel for how the histogram represents different images.

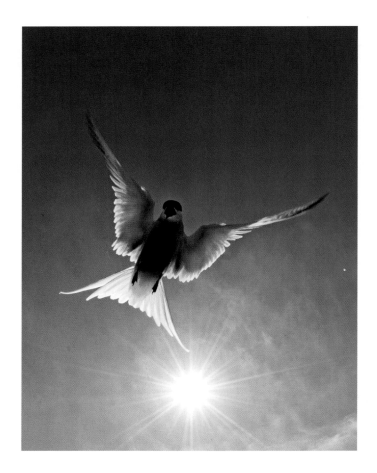

ABOVE AND BELOW An Arctic tern hovers above me on the Farne Islands. This histogram shows a good contrasted image, with peaks and troughs denoting dark and light. The sun is what is known as a "specular highlight," a highlight that has to be blown out with no detail by its very nature; this is shown on the histogram by a small spike at the right-hand side. At the opposite end, for the dark tones, there is a little clipping – blacks that have no detail – however, this is minor and not a problem.

17–35mm lens at 25mm, ISO 100, 1/1600 second at f/6.3

For correct exposure, consider the following points:

1 If you are shooting JPEGs, your margin for error in getting the exposure right is less than if shooting in RAW.

2 When checking a histogram, if possible, make sure that you are not clipping data on either end of the histogram. To avoid signal noise, it is better to have a histogram showing the pixels leaning toward the right, but not clipped, rather than being bunched to the left, indicating underexposure. If the image is underexposed by any large degree, signal noise can become an issue. Nevertheless, note that whites are difficult to render with digital photography compared

with using film – highlights are far easier to blow out. Therefore, with subjects that may be dark with light or white areas, you might find that you need to underexpose to avoid blowing the highlights. You can always rescue detail from underexposed areas, but never from blown highlight areas in an image.

RIGHT AND BELOW This shot, of two bottlenose dolphins taken underwater in the Caribbean, is perfectly exposed. The accompanying histogram shows a good spread of pixels, with the peak in the middle, which represents some of the darker water and the dolphins' gray bodies (midtones), and leaning to the right, which denotes the light blue water.

Compact camera with Sea & Sea housing, ISO 200, 1/60 second at f/11

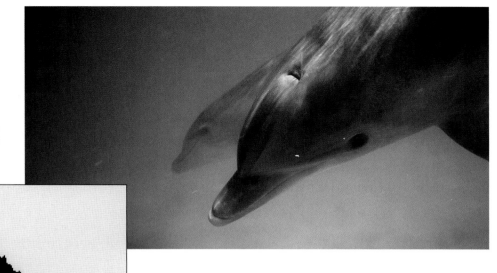

RIGHT AND BELOW Here we have a histogram showing a high key image (one with lots of light tones). Obviously the snow and breasts of these emperor penguins mean that the pixels are bunched toward the right, but note the lack of clipping on the right-hand side, which means detail has been left in the whites, making this a good exposure.

135mm lens, ISO 100, 1/750 second at f/8

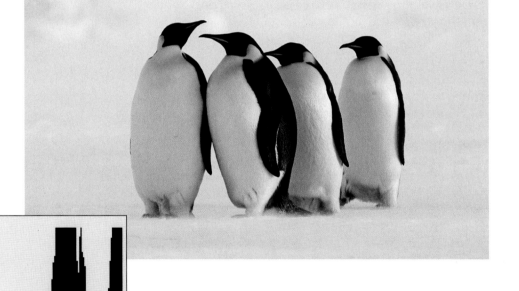

3 When checking for blown-out highlights, use the blinker function on your LCD screen – when switched on this enables those areas that are blown out to blink. Naturally, the sun or other features in a picture will have to be blown, but vital areas such as fur, feathers or light backgrounds should not be.

4 It can be difficult to view histograms in bright conditions in the field. To help, you can buy little bellows units that fasten over the screen to shield it from the light. For a long time, I used a cardboard toilet paper roll for this purpose – nice and cheap and available wherever you may be in the world!

Using your camera's different light metering modes

Most digital cameras come with a choice of three light metering modes: center weighted, usually an area in the center of the frame and marked out in the viewfinder; the more precise spot meter, which is a very small spot that sits in the middle of the frame; and finally matrix metering, commonly found in most DSLRs.

Matrix metering, otherwise known as "multi-pattern metering," is the most sophisticated method to use. It takes information from all over the frame to give a reading. However, it is occasionally fooled, and it is never my first choice. I tend to stick to center weighted metering, using this for 95 percent of my shooting; it is more accurate for gaining the effect that you want with your subject. Spot metering can be very useful for evaluating an exposure for a small area of the picture, but you should not use it for run of the mill work because readings will vary widely depending on which part of the picture the meter is pointed at. In any event, whichever metering mode you prefer, always remember to use your histogram to determine the correct exposure.

ABOVE AND RIGHT This panther chameleon is properly exposed, but on the histogram the pixels are bunched to the left, reflecting the many dark tones in the image, notably in the background, but also in some markings on the reptile. However, there is no clipping evident, and so detail is retained in the darkest areas, giving a good exposure.

70–180mm macro zoom lens at 105mm, ISO 200, 1/90 second at f/11

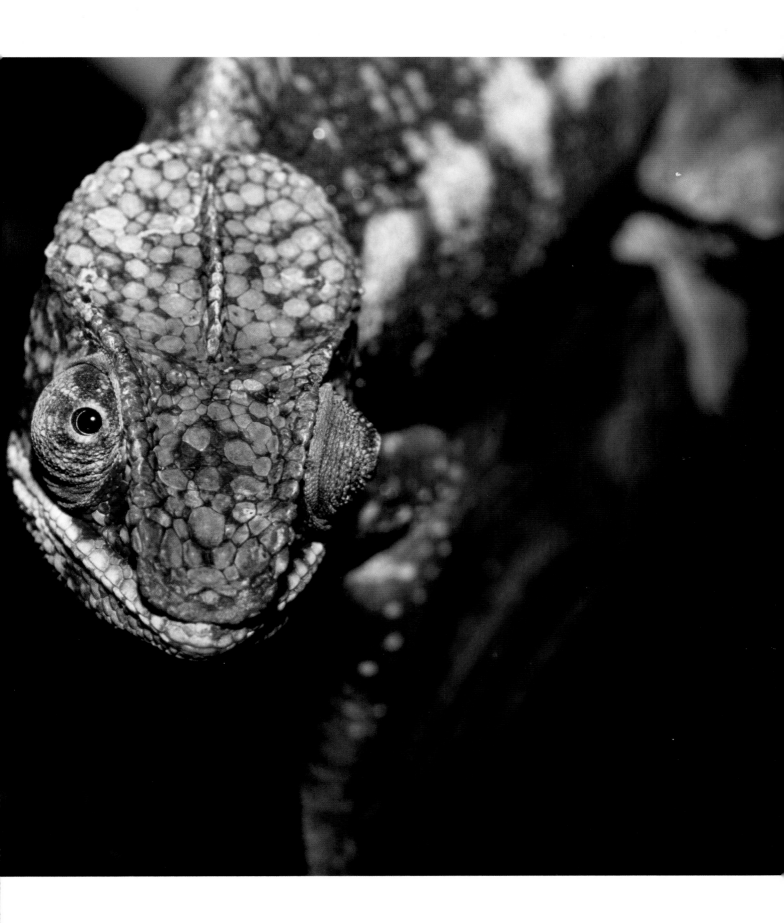

Flash

For some wildlife photographers, flash is likely to be a well-used tool. For others, flash photography may be an occasional foray. Flash can be used in two ways. First, it can be a supplementary source of light to daylight; we call this "fill-in flash." The extra light is used to fill some shadows and to help enhance detail that may be lost in too much shadow. How much flash you use in such situations is very much down to personal choice. Its second use is as the main source of illumination, for example, photographing bats at a roost or raccoons foraging at night. In such circumstances, with the absence of any daylight, the flash becomes the only light source. If using full flash you might want to consider using more than one flash gun as a source of illumination. This will help reduce what could appear as a very flat picture and your lighting of the subject will be far more creative.

I use fill-in flash quite frequently, especially at times when the light may be flat, or during the middle of the day if the sun is high in the sky and the light is harsh. Fill-in flash can help to soften shadows. During low light, it can give a

little extra illumination and lift the image. Used well, the viewer, in my opinion, should not be able to detect that fill-in flash has been used.

To use fill-in flash, choose one of your flash gun's daylight balancing modes. The fill-in flash level will fall between two-thirds and one stop below the ambient light reading taken by your camera. However, for my taste, with digital cameras and digitally compatible flash guns, simply shooting away in this mode produces an "overflashed" effect. In the days of using film, I used to dial a −1.7EV (flash output level) compensation into my flash gun to retain a natural look. When using digital, it is my experience that it is worth aiming for an around −3 compensation to retain some shadow detail and a more natural look.

The same is true when using full flash; you may find that the subject looks "overflashed." By underexposing on your camera or dialing in minus values on your flash gun, a more natural effect can be achieved. The ability to check histograms and to look at the picture on the camera's LCD screen mean that you can experiment a little until the desired result is achieved, although it is better to do this before you aim the camera at your subject!

There will be some situations where it may be advantageous to use more than one flash gun. If a nocturnal animal is regularly returning to a baited site, for instance, two or three flash units can be set up to both illuminate some background and to prevent dark shadows across the animal from light that is too directional. To fire more than one gun at a time, a simple device called a slave unit can be attached to the extra flash guns. Some experimentation may be needed to get the exposures and flash settings balanced.

FLASH ACCESSORIES

There are various flash accessories that are extremely useful. The flash extender is a simple device that attaches to the head of the flash gun and, with the use of a fresnel screen, concentrates the light and so enables the flash to reach further. This prevents the light from scattering over a much wider area than the picture area and, because of

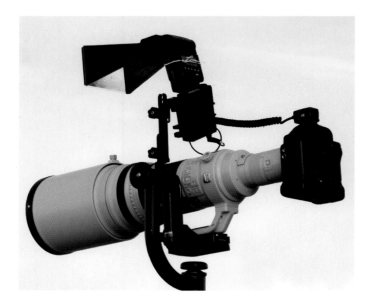

ABOVE This is a typical telephoto lens and flash setup, incorporating a flash extender to focus the light emitted by the flash gun more efficiently. A power pack is attached for fast recycling times for the flash gun, and the flash is mounted on a bracket. This kind of setup is particularly useful in a rainforest, where light is at a premium and flash is used either as the main source of light or as fill-in flash.

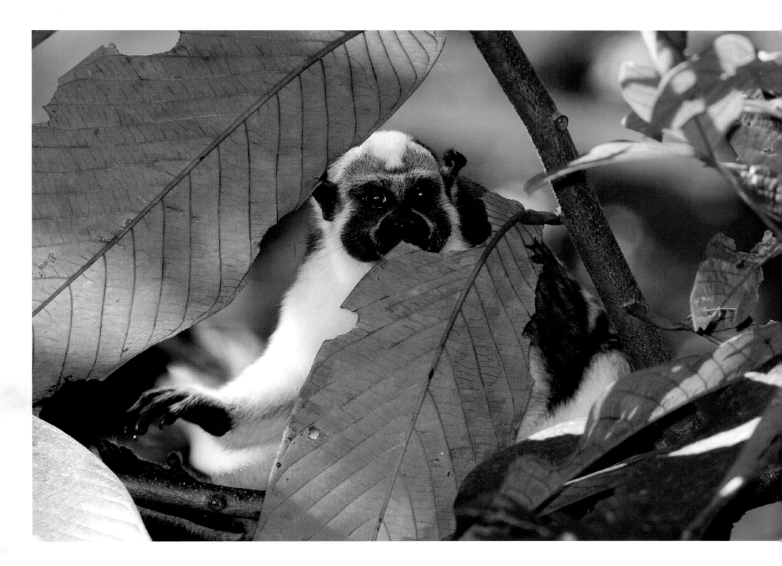

ABOVE I have used fill-in flash to help illuminate this Geoffroy's tamarin that was sitting in heavy shade.

500mm lens, ISO 100, 1/60 second at f/8

the power saving, the flash recycles (recharges) faster too. Flash extenders are very useful in rainforests and other dark habitats; I have used flash extenders to great effect in the rainforests of the Amazon.

A number of different makes are sold commercially, but by far the most popular are those that fold away flat, and so are easy to slip into a camera bag.

One drawback of using the flash with the extender mounted on the camera's hot shoe is the possibility of red-eye or eye shine. This is caused by light reflecting on the lining of your subject's retina, and is often most apparent with owls that have yellow retinas and with subjects that have small eyes that reflect the light of the flash. Such problems can be rectified in Adobe Photoshop at a later date (see Chapter 7), but it is better to avoid this in the first place. It helps to place the flash away from the axis of the lens, perhaps on a bracket or you can use a extension cord and hold the flash away from the camera.

Recycling times can be frustratingly long if your flash has to work hard and pump out a lot of power. Too long and vital shots can be lost. The solution is to use a power pack such as the Quantum battery pack. These are large rechargeable batteries that will fit on your belt, but which will give instant recycling in most situations. They enable shots that might otherwise have slipped through your fingers.

CHAPTER 3

Field techniques

If only animals could talk. Imagine if we could ask the leader of a pride of dozing lions at what time they intended hunting that day. Although they may not be able to talk, many animals often communicate signals to one another that can warn us of some impending behavior, and can alert the photographer to have a camera ready. There are thousands of signs in the natural world. Take a family of whooper swans, for instance. They signal their intent to take off by bobbing their heads, giving just enough warning to the photographer to be prepared when the action begins.

Research

GETTING TO KNOW YOUR SUBJECT

Gaining knowledge of animal behavior and learning the signals that may lead to interesting behavior are big weapons in a wildlife photographer's armory. It also helps to be in the right place at the right time. This does not have to be simply down to luck; there are a multitude of information sources from everything about behavior and locations, through photograph-specific subjects, to the best times of the day and year. The internet offers a mass of information, but perhaps the best resources to tap into are other wildlife photographers. In my experience, most photographers are only too willing to impart information, and there are some excellent nature photography forums on the internet that allow you to ask questions. This can lead to useful replies and potentially good contacts with other like-minded people.

Being able to second-guess an animal or know what a subtle piece of behavior means comes with experience. However, reading up as often as you can, and generally arming yourself with as much knowledge as possible, will help you to capture those special pictures. Naturally, it also heightens your enjoyment when you have an understanding of what you are photographing.

RIGHT Being able to second-guess an animal's behavior by watching what it does can go a long way to attaining a successful image of the subject. This black-necked grebe, photographed on a bitterly cold day on Bulgaria's Black Sea coast, was feeding close inshore in rough seas. After a few minutes, I was soon able to recognize its favored feeding area, and so I sat quietly close by, and before long it was performing in front of the camera for me.

500mm lens, ISO 200, 1/1,000 second at f/4

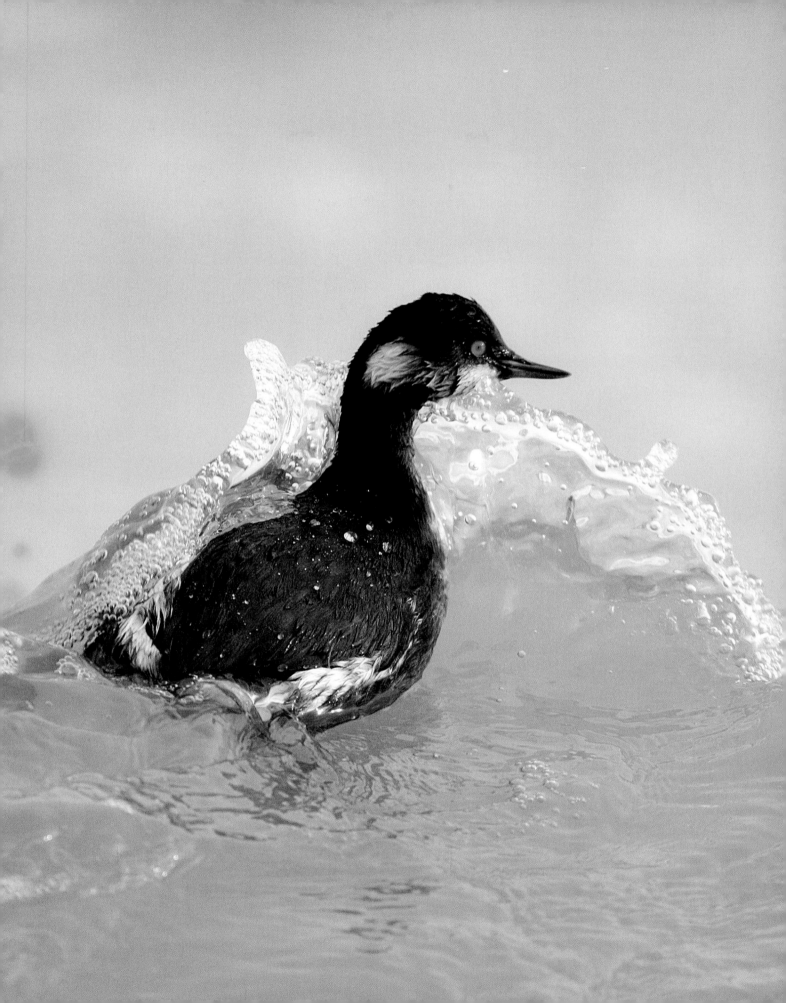

WILDLIFE TOURS

Over the years, I have filled a filing cabinet with examples of published work from brochures and magazines, which are filed under subjects and locations. This acts as a useful library when I am planning a trip. There are some very good wildlife photography tour operators, providing trips to photographic hot spots around the globe. Many of these are led by professional photographers and provide excellent opportunities that would be too expensive to organize alone.

If photography is your main goal, it is often worth steering clear of general wildlife watching holidays because these can lead to frustration if other participants want to constantly move on to see the next spectacle. Not only that, many are happy to be out in the heat of the day when the sun is high and the photography poor, leading to further frustration. It is far better to pay a little more for a custom-made tour for photographers.

When choosing a tour, try and speak to someone who has taken the tour before and glean as much information from them as you can. You should quiz the tour leader on the likely opportunities and, above all, make sure they have experience of the tour's location. It is surprising how many tours are led by someone who is visiting a destination for the first time: a recipe for disappointment.

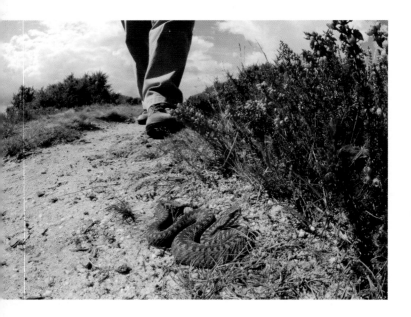

Getting close

APPROACHING ON FOOT

Reading the signs given by an animal when you are moving in close may be the difference between success and failure. If you are stalking a grazing deer and it suddenly looks up in your direction, and after a few seconds it resumes feeding, you may feel you can move in closer. Yet if it retains its stare and changes its posture, this tells you that it feels you could be a potential threat; any closer and it may disappear in a cloud of dust.

In the natural world, some of the easiest signals to read are given by birds. When stalking a large bird such as a heron or bird of prey, if you get too close and it decides to fly, the chances are that it will defecate and ruffle its feathers before taking off. These are all signs that you will learn to recognize with experience. You will get a feel for what an animal will do once you have been taking pictures for a while.

Gaining an animal's trust is an uplifting experience. Nonetheless, showing that you do not present a threat is not likely to be possible with every subject, and it generally depends on both the subject and where in the world you are. For example, there is a place in India inhabited by a tribe of people that has for centuries revered all forms of life, and they are vegetarians. As a result, the tribe has never posed a threat to the local wildlife, and the animals here are almost fearless of humans, with some species of deer willing to be approached within a distance of a few yards. Contrast this with a Scottish estate, where for centuries the deer have been hunted. In such a situation, you may be unable to approach on foot within a mile of them. These same deer, however, might be approached in a vehicle from only a few yards away because they associate danger with people on foot.

All animals will have a safety zone, an invisible line that if crossed will start to cause alarm. This zone can often be shrunk by spending time close by, and by allowing the animal to accept you into its environment. I have regularly done this with deer, approaching to a distance at which the animal starts to show signs of being wary, then

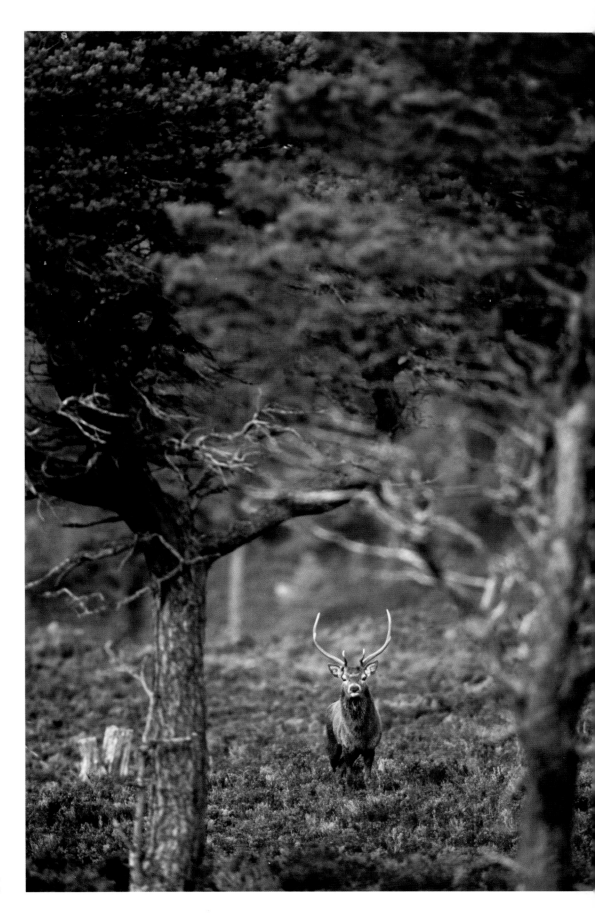

RIGHT Mammals can be very difficult to approach on foot. Deer are most easily photographed in deer parks where they are used to people. I put all of my stalking skills to the test when I approached this magnificent red deer stag during the rut. Photographed in the Caledonian Pine Forest in the Scottish Highlands, I wanted to convey the habitat in which the deer live, and so I purposely framed the stag between the two trunks of the pines. The deep heather was difficult to move through, and to be more maneuverable I mounted my lens on a monopod. By keeping downwind of the deer and moving low and slow, I was able to make a reasonably close approach.

300mm lens, ISO 100,
1/250 second at f/4

LEFT I worked with a snake handler to get this image of an adder on a heathland path. The adder was caught not far from the path and placed here before being put back exactly where it was found. I placed the adder close to some flowering heather to add color to the image, while the walker on the path helps tell a story. A wide angle lens was used to help show the habitat.

10.5mm fisheye lens,
ISO 100, 1/250 second at f/11

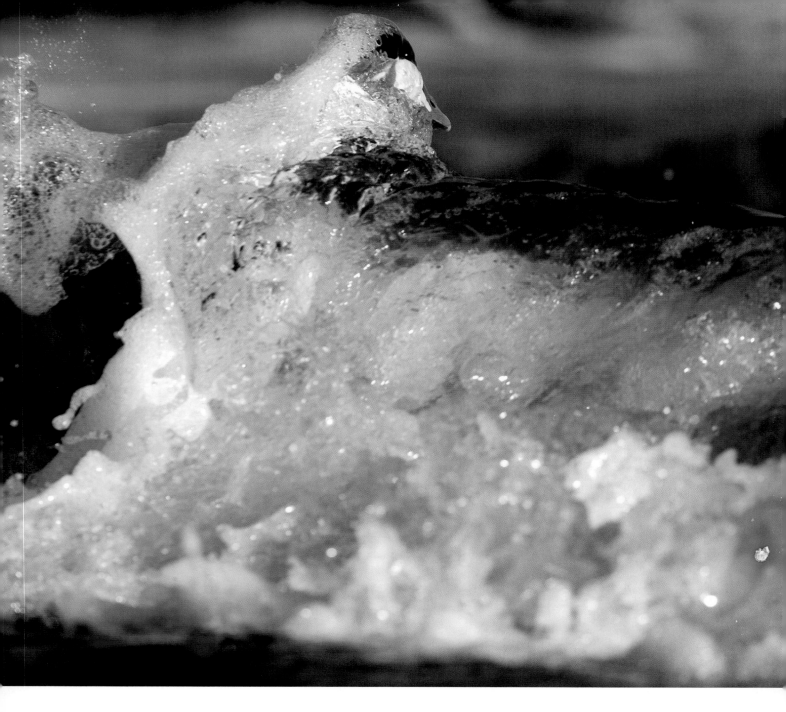

backing off a little to allow the deer to resume whatever it is doing. By simply sticking with it, slowly the animal accepts my presence, to the point where a closer approach can then be made.

For me, stalking an animal on foot is the most satisfying form of photography. Perhaps some long-buried primeval hunting instinct is being satisfied, but I have found gaining an animal's trust to be a very gratifying experience. Stalking on foot is where your field craft will be tested to the fullest. Many of my stalks are often spectacular failures; they do not always work.

Animals are always alert to danger, and so crawling or crouching toward your subject in a manner that may be imitating a predator is not usually a good idea. Standing and slowly walking directly toward your subject may also cause some alarm. It is often a good idea to gain distance by approaching slowly at an angle, stopping regularly to allow the animal to relax. By approaching in a zigzag, you will pose less of a threat. If you are stalking a wary animal with a good sense of smell, you need to approach downwind; many animals have poor eyesight but great hearing and sense of smell. This is where prior knowledge of your subject comes in handy.

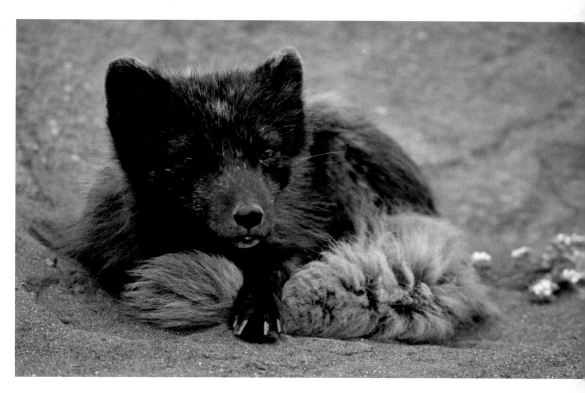

LEFT I have spent many hours and days photographing eiders on the coast in winter, close to where I live. This image is my favorite of the hundreds I have taken, and was shot on a day with stormy seas. To get close to the birds, I slowly edged my way down the beach and stood quietly in the surf. Initially the eiders moved away, but after a few minutes they drifted back inshore and resumed feeding and surfing through the waves. By staying still and quiet, animals will often accept you into their environment, once they have decided you pose no threat.

I have purposely placed the bird close to the top of the frame and to one side to accentuate the effect of the wave in the picture. By placing the bird toward the left, when you first view the picture your eye travels along the wave into the picture until you reach the bird.

500mm lens, ISO 160, 1/1,000 second at f/4

ABOVE This Arctic fox would regularly come and sit close to me on the cliff top on St. Paul in Alaska's Pribilof Islands in the Bering Sea.

135mm lens, ISO 160, 1/1,250 second at f/8

If you are stalking a grazing animal or feeding bird, try to wait until the subject is feeding before moving, and then when it looks up, stop and allow it to relax for a while and resume feeding before you move again. The idea is not to cause fear but to try and communicate to the animal or bird that you are not a threat.

WAIT AND SEE

There are often situations where just sitting quietly on the ground or on a stool will be enough for an animal to gradually come closer. Some years ago, I discovered an Arctic fox den close to a cliff top on the Pribilof Islands in the Bering Sea. The foxes were relatively relaxed in my presence and, by sitting quietly several feet from the entrance to the den, they took little notice of me. Indeed, the mother was so trusting that she would often come and lie beside me; I made an excellent windbreak!

This can be a very productive technique for photographing birds. There is a place close to where I live on the edge of an estuary, where I can sit nestled below the sea wall. As the tide comes in, it pushes feeding waders closer and closer. Because I am sitting still and not perceived to be a

RIGHT Years before taking this picture I had fleetingly watched a deer cross a woodland track ahead of me at dawn. It had been silhouetted, as in this image, and at the time I regretted missing a great shot. Years later I came across this fallow deer at dawn in the New Forest in similar circumstances; it lingered just long enough for me to get this image, which is one of my all-time favorite deer images.

I have used the large oak trees as a key part of the composition, framing the subject with both the trunks and the foliage above.

500mm lens, ISO 100, 1/250 second at f/8

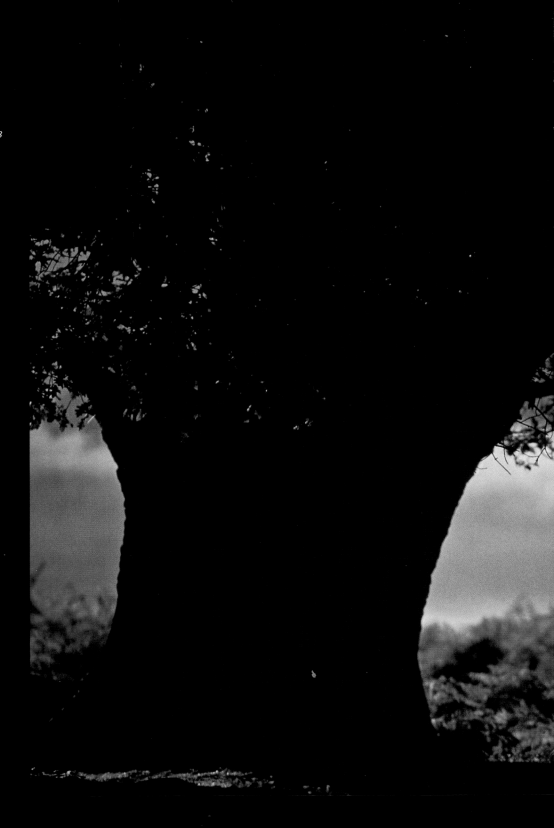

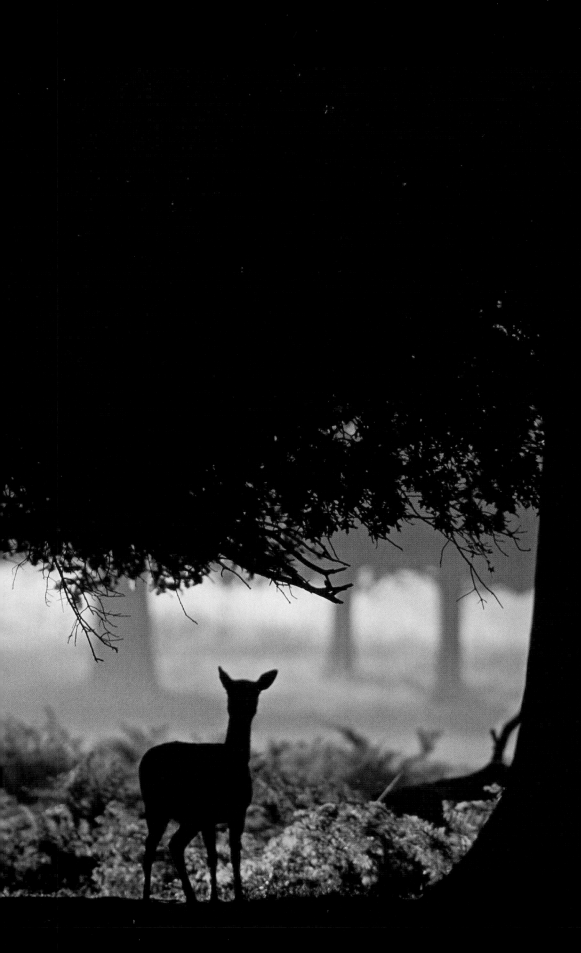

threat, the birds come within range for some excellent pictures. Sitting close to water or feeding sites visited regularly by birds can be very productive too, and I cover this later in the chapter (see Feeding Sites, on this page, and Water Attractions, on page 63).

USING A VEHICLE AS A MOBILE BLIND

Vehicles make great mobile blinds. Many forms of wildlife do not seem to associate danger with a car, yet if you get out of the car, they can be off in a flash. There is still a technique to be learned when using a vehicle, and placing it for the light, not too close and not too far, are important considerations. For shy subjects, it is sometimes best to go for broke and drive to within optimum range, rather than stopping at a perceived safe distance and then starting the engine to move in closer. When moving in on a subject, be ready – once you switch the engine off you want to be able to shoot immediately. Some animals may not hang around for you to check the light or decide that you need to change a lens.

Supporting the camera and lens can be done by using a beanbag (see page 23) rested on the door frame; this is the easiest method. Alternatively, you can buy door clamps and mount the camera on a tripod head if you so desire. I always use a beanbag, not least for their stability. If traveling, you can fill the beanbag up at your destination with dried beans or rice.

When shooting through the window of a car, many photographers swear by camouflage netting as concealment. This can be advantageous; however, it is often not necessary, particularly with birds as most do not associate a car with danger.

When working in Africa, I have regularly used a vehicle – normally a Land Rover or Toyota Land Cruiser – to lie under in order to shoot animals from a low angle. The advantage is that the vehicle helps to break up my outline. I, of course, do not do this with potentially dangerous subjects, such as lions, but rather with animals that do not pose a threat.

If you are on a vacation, one final point to remember when renting a vehicle is to check, if there are two of you, that the rear windows roll all the way down. Many vehicles have an annoying feature of rear windows that open only two-thirds of the way down. This can be really frustrating as you wrestle like a contortionist to get your lens at the right angle to photograph.

FEEDING SITES

Few animals are likely to pass off the chance of a free meal. There are plenty of well-known sites where food is put out, enabling large numbers of people to enjoy close encounters with wildlife. Many are set up for birds and, in North America, there are also feeding sites set up to attract larger wildlife, including deer and brown bears.

Around the world there are thousands of similar locations where wild animals are attracted to food, providing great photo opportunities. Often the hardest part is finding out about the locations; the easy part can be taking the picture.

There are likely to be occasions when you want to create your own feeding station to lure an animal. Patience is a virtue when establishing a site. It may take a while, perhaps days and sometimes weeks, for a site to work well, depending on the animal you are trying to entice. If you look upon a feeding station as a long-term project, it may eventually be possible for the animal to trust you enough to accept food from your hand. I have done this successfully with birds, squirrels and even a water vole that readily took chunks of apple from my hand.

Birds are the easiest subjects to attract to food, whether in northern latitudes or in the tropics. In general, the more feeders you have, the more birds you attract, whether in your garden or out in the countryside.

A garden is a great place to bait for wildlife. If you live in an urban environment, provided you take care with the amount of food you put out to avoid a rat infestation, even animals such as foxes will readily visit and may become tame.

Food choice is important, and there are some foods that seem to be almost universally liked. For example, peanut butter smeared on a tree trunk is a big attraction for squirrels, and foxes enjoy peanut butter sandwiches too!

RIGHT Attracting animals to a baited site allows a degree of creative control. This nuthatch has been tempted to land on a garden fork by placing a nut feeder just to the right out of shot. A bird feeding station in the garden lends itself to using any number of props as suitable perches. With this prop, I have been careful to place it so that there is a nice smooth background with no distracting out-of-focus elements.

If you live in a rich area for birds, often the more feeders you put out, the more birds come to feed. This is useful because when you come to take pictures, if you then remove all the feeders except for one or two, you create a "lineup" as birds wait to get at the food; this can help to make individual birds perch on your props for longer as they wait. The bigger variety of food you put out, the bigger variety of birds you are likely to attract.

300mm lens, ISO 160, 1/500 second at f/4

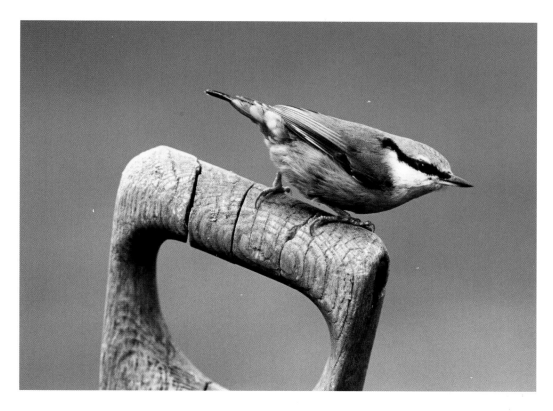

RIGHT Apart from baiting for shy animals and using a blind as concealment, there are plenty of opportunities for luring tame animals in places where they see lots of people. Town and city parks are good examples, where urban wildlife such as this gray squirrel can be tempted close with food. In fact, you may want to illustrate the animal in its urban environment, as I have done here, by using a short focal length lens and including the park railings in the picture.

17–35mm zoom lens, ISO 160, 1/125 second at f/8

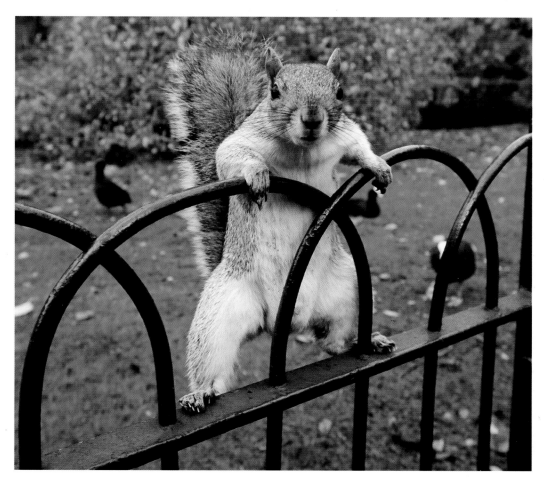

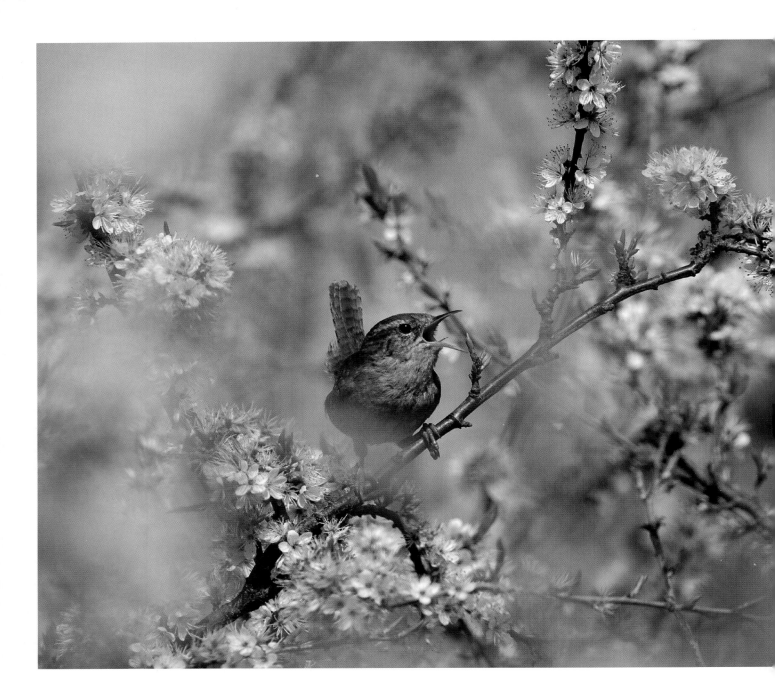

ABOVE Tape-luring birds is a very effective way of photographing individuals on territory in spring. Care needs to be taken not to overdo this technique; if an immediate response is not forthcoming, you should move on. Often, however, a bird will respond to the sound of its own song. The trick is to stand in position in front of your desired perch, and hope that as it comes close to investigate, the bird will perch in the desired spot.

This wren was singing from deep inside a hawthorn bush, which was in flower, making it impossible to see. I taped the wren singing, then played back a quick burst. The wren immediately popped on to the outside of the bush in response, and I got my shot. If you have a specific perch in mind, you can use a speaker with a lead, place the speaker by your perch, then play the song and hope the bird will come to the perch to investigate. While I use the playback technique of recording a singing bird then playing the song back, many photographers use prerecorded songs that can be bought on CD. These can be loaded onto an MP3 player, played on CD players or prerecorded onto tapes.

500mm lens, ISO 100, 1/400 second at f/5.6

Rabbits and many other small furry animals enjoy apples, while nuts are a big attraction to a chipmunk. Different seeds and fruits will lure different species of birds; for example, niger seed is a big hit with goldfinches, while mealworms are loved by thrushes such as robins. There are many sources of information, both published in books and on the internet, to guide you in choice of food.

Animals that live in urban environments can become quite tame, so do not ignore your local park. For instance, most public parks are great places in which to photograph gray squirrels; they will come right up to you if a nut is offered. Parks provide good locations for luring birds with food too, whether there are ducks on a pond or garden species that come for bread or seeds.

WATER ATTRACTIONS

Water is a good lure for animals, particularly in dry habitats, as mammals and birds need to drink, and many need to bathe too.

Well-established water holes or seasonal ponds will be well known by the local wildlife and regularly visited. There may be occasions when you visit an area and it is opportune to build your own water attraction. This can be done by using a number of methods. Quite simply, a shallow bowl or dish can be placed in the ground. However, it is possibly more effective to use a pond liner, which can be bought at most garden centers. A small makeshift pond can be built and landscaped, making sure the plastic edges are hidden with moss, top soil or some other natural material, so that your pictures look natural.

Drinking pools work best for birds. In dry areas they are quickly found, then visited regularly. By placing a perch by the pool, you can control where the bird will land and so optimize your photograph's background. A technique often employed to tempt birds such as warblers is to create a drip. This is a water container, that drips water, positioned above the pool, and it can act as a strong attractor.

TAPE-LURING AND USING NOISES

Using a recording to simulate birds' song in order to lure an individual to the camera is often used by bird photographers, and using sounds for mammals can work effectively as well.

Playing the song of one bird to attract another is a method that needs to be used judiciously; if a couple of bursts do not have the desired result, it is best to move on. Subjecting a bird to distress is unacceptable. The most effective method I have found is to tape a singing bird. To do this, I use a directional microphone attached to a small tape recorder that has loud, built-in speakers. By playing a bird's own song back, you usually get a more positive response than with a prerecording, although using the latter can often be effective.

Mammals will react to and come close to sounds. For example, the squealing sound of a distressed rabbit can lure a fox to come and have a look, and a similar simple squeaking sound can attract weasels. I am not, however, suggesting you play the tape of a roaring tiger or lion, which could be deemed both irresponsible and foolish. Nevertheless, small animals can react, and the important consideration is to use sounds in moderation. Your aim is to photograph, not to cause distress.

BEING INVISIBLE

Some animals will not tolerate human presence, and you will need to think about making yourself invisible. Many animals have poor eyesight but great hearing and sense of smell, while others rely on vision rather than other, less well-developed, senses. Deer, for instance, have superb senses of smell and sight. Therefore, if a shy roe deer is your intended target, not only do you need to be concealed, but probably downwind too, to avoid being detected.

There are a number of methods you can use to conceal yourself. As already discussed, a vehicle can make a good mobile blind. Otherwise, you need to conceal yourself in either a specially prepared blind (see page 65) or you should break up your outline with camouflage. Many animals identify the outline shape of a human as danger. Camouflage clothing breaks up the human form, but you have to go the whole way and cover legs, hands and face. It will be far less effective if you only wear a camouflage jacket and normal dark jeans, although this is better than nothing.

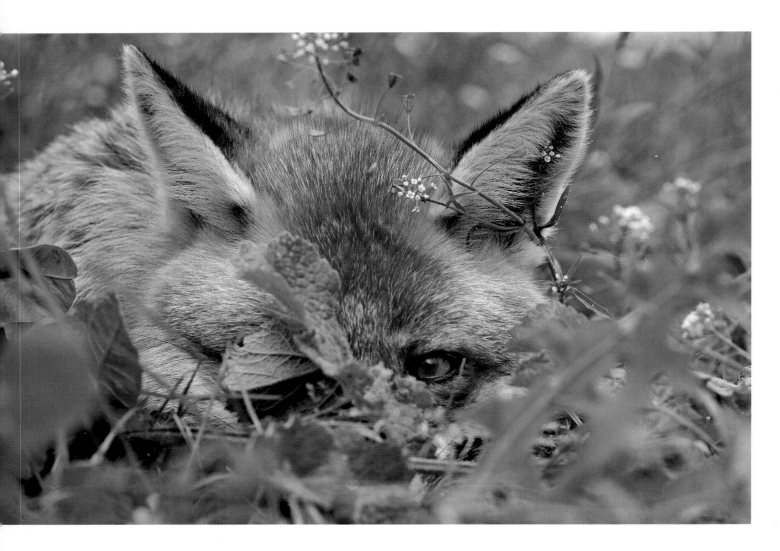

When using camouflage, don't forget your lens. Many Canon telephoto lenses come in white, a beacon for any animal looking for danger. Using camouflage tape, which can be found in army supply stores, will help. Nikon lenses come in black, which is less important to conceal. I use a lens sock on my long lenses as an alternative to tape; these are made from elasticized camouflage cloth that fits snugly over the lens hood.

Naturally, there are many animals where camouflage is not needed. All the same, you should always avoid bright colors even around tame wildlife. Dark clothes are always a good idea, whether greens or browns. On one occasion, I was photographing grizzly bears in Alaska when a person in a bright orange jacket appeared. The bears were used to humans, but as soon as this person appeared, the bears reacted by moving away.

ABOVE The focal point of this picture of a resting fox is its one visible open eye, so I used a long lens to isolate the head of the animal and provide focus on the eye.

500mm lens, ISO 100, 1/250 second at f/11

Dark clothes are fine for many animals that have poor eyesight, otters being a good example. I have spent many weeks in the company of otters. They have poor sight but acute senses of smell and hearing, so it is always important to position yourself downwind, and to be quiet. I have regularly had individuals approach to within a few feet, quite unaware of my presence. I wear no special clothing for this other than a green jacket and dark pants.

One of the things that often gives people away to animals sensitive to noise is the rustle of clothing, particularly waterproof pants. It pays to invest in clothing that does not have the rustle factor.

Blinds

SETTING UP BLINDS (HIDES)

Blinds (also known as hides) allow complete concealment. Many reserves and wildlife hot spots have permanent blinds. Set up for viewing wildlife, these blinds are mainly on bird reserves, and they can provide some great opportunities. Yet they can be frustrating places too; some are often placed so that they face into the light, while others can suffer from noisy visitors who make the wildlife wary of the blind.

There are some definite "don'ts" when using blinds, which are worth repeating here:

- Never stick your hand or head out of the viewing windows; this will give the game away instantly.

- Try to keep noise to a minimum.

- If you need to stick your telephoto lens out a long way, be slow and cautious when you move it; swinging it around like a baseball bat will soon alert your subject to potential danger.

Having criticized the location of some public blinds, there are many that are perfectly situated for taking pictures. Nonetheless, you cannot beat building your own blind.

This can be made quite easily or, if you are like me and completely hopeless at such practicalities, blinds are easily purchased from specialized retailers. There are dome-shaped blinds, which can be erected in seconds and easily moved, and there are more traditional-style canvas blinds, comprising a stretch of canvas pulled over a tubular framework; these can be left in place for long periods.

Dome-shaped blinds are ideal for situations where you might want to move a hide halfway through the day because of changing light direction, or when you want to erect a blind quickly. They are the most convenient blinds to use, and most fold down so you can transport them easily.

Once a blind is in place, depending on how wary your subject is, you may want to increase its camouflage by placing the local vegetation around or over it, to blend it into the environment. Generally, a blind needs a few days left alone for the local wildlife to get used to it, although this depends on the subject. I have erected blinds for certain birds such as waders, and had them feeding around the blind within minutes of putting it up.

If you regularly attract mammals or birds into your garden, you may want to utilize your garden shed, or perhaps even shoot from a window of your house. This is

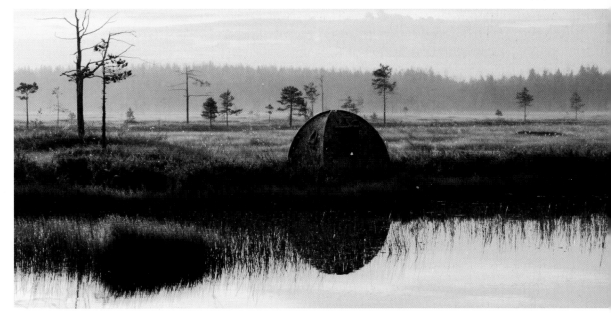

RIGHT The use of a blind allowing full concealment can provide a fascinating window into the private life of your subject. Photographers are often privileged in viewing behavior rarely observed by others. This is a dome-shaped blind that I erected at a pool being used by a pair of breeding red-throated divers in Finland. Dome blinds are very adaptable and can be erected in seconds, making them a good choice for impromptu use or when a blind does not need to be left in situ for too many days.

easily done, and some camouflage netting draped across a window will often provide sufficient cover.

When placing a blind, make sure it is at the correct distance from where your subject is likely to be. This may seem obvious, but it is easy to place a blind too close or slightly too far for the intended length of lens; this is particularly true when photographing small birds. Make sure the hide is also well placed for the best light.

USING THE BLIND

Approaching and entering the blind needs to be done with care. Scaring off a shy mammal or bird may mean that it will take a long time to return, and when it does it may be more nervous than usual. If you are able to scan the site with binoculars from a reasonable distance, this situation can be avoided. It is better to be patient and to wait for the animal to move off in a calm manner, and if you are feeding it, it is likely to come back before too long.

For some subjects, it may be advantageous to arrive in the dark and to leave in the dark; this approach is especially appropriate for eagles and large birds, such as great bustards, which may be watching you from a distance. If arriving in daylight, it is sometimes advantageous to go into a blind with a friend; many animals are unable to count effectively, and if they see two people arrive and one leave they may think the danger has gone away.

Once inside, if you need to move your lens, make gentle, slow movements. Sharp movements will draw attention to you. When your subject arrives, it is tempting to start taking pictures right away. Although difficult to do, you should deny that temptation and wait a few minutes to allow the animal to relax. If frightened, it may never return.

A final piece of advice: make sure that you have a comfortable chair to sit on. There is nothing worse than spending 10 hours perched precariously on a wooden crate or worse. Being uncomfortable will affect your concentration when it comes to taking pictures.

RIGHT **Some subjects can only be photographed effectively by using a blind, and even then they may prove a challenge. This is the case with the great bustard that, as one of Europe's most sought after birds by photographers, is one of the continent's most challenging to photograph. I spent 15 hours a day for many days in order to successfully photograph this species. One of the challenges was to have the blind placed in just the right position to maximize my chances. This is true in most situations when deciding where to place a blind — you should plan carefully, particularly if you intend spending full days in the blind because then light and backgrounds for varying views from the blind become important. If waiting for an elusive subject that may appear once every few hours, it may be possible to set up a secondary opportunity, although you do not want to do anything that might compromise your main goal.**

500mm lens, ISO 100,
1/750 second at f/5.6

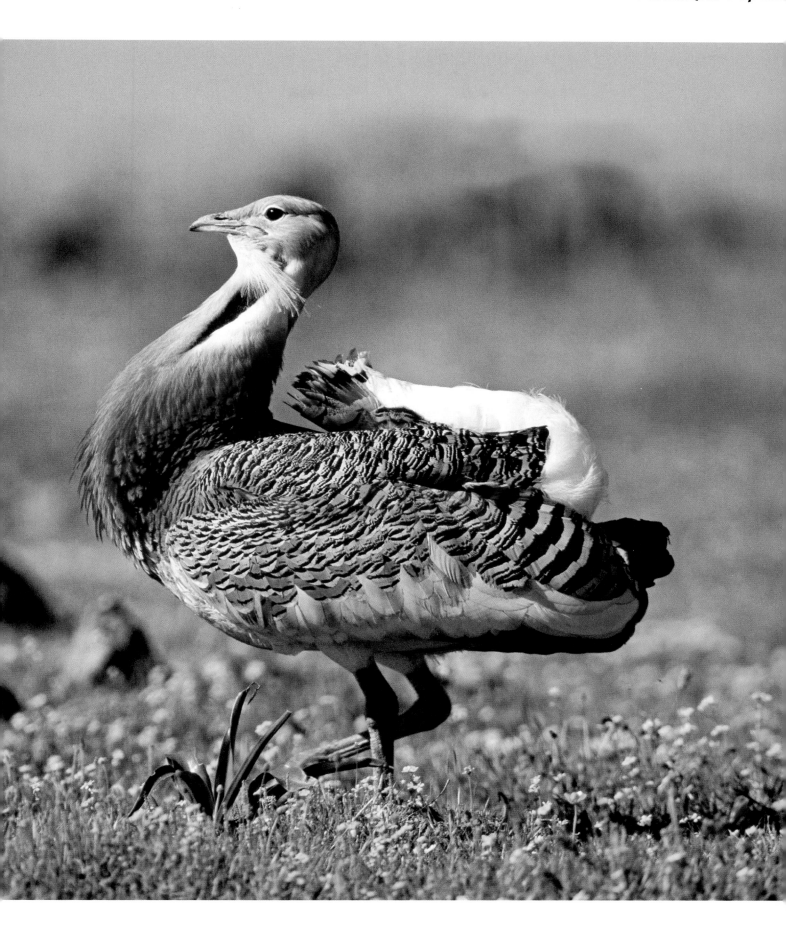

Photographing captive wildlife

There are many wildlife photographers around today who spend more time photographing captive animals than they do their wild cousins. These include the pictures you see of tigers running through the snow, leaping snow leopards and howling wolves, to name just three.

I have nothing against this as long as the photographers are honest about how such images are taken. In fact, it is sometimes the only way to capture creative images of animals that might take many months of work in the wild. For me, it is a means to an end, although I get little satisfaction from it and rarely do it. The exception, however, is when I photograph birds of prey.

BIRDS OF PREY

There are many falconers who are often only too willing to provide their birds for photography, and usually an eagle, falcon, hawk or owl will sit quietly on any perch you provide. Some beautiful images can be made that would be extremely difficult to capture in nature.

Most falconers are reluctant to remove the paraphernalia attached to a captive bird's ankles, and so steps need to be taken to ensure that you hide this equipment when shooting. The use of out-of-focus foregrounds, such as a sprig of leaves, is one way of doing this. Shooting from an angle can help in this process, and if you have a bird feeding on prey, you might be able to place the offending leg behind the prey item.

RIGHT A red-eyed tree frog peers at the camera from between some leaves. This image was taken in a controlled setup; the frog was from a rainforest collection in the U.K. Reptiles and amphibians lend themselves to this type of photography, where props, lighting and the animal itself can be manipulated. With this setup, I simply placed a large potted plant with attractive leaves on a table, in a greenhouse. The leaves were sprayed with water, and the frog introduced to the position in the leaves that is pictured. I used a couple of large plants with big leaves to create the out-of-focus green background, and only natural light was used. I was not bothered about the provenance of the plant's leaves — whether the plant was native to the frog's native habitat — because the image was aimed at advertising buyers. However, this is a point worth considering when building sets for captive animals, particularly if you are attempting to produce scientifically correct pictures. Images of red-eyed tree frogs are very popular with advertisers, and this image has sold well for a range of advertisements and editorial uses.

90mm macro lens, ISO 160, 1/125 second at f/8

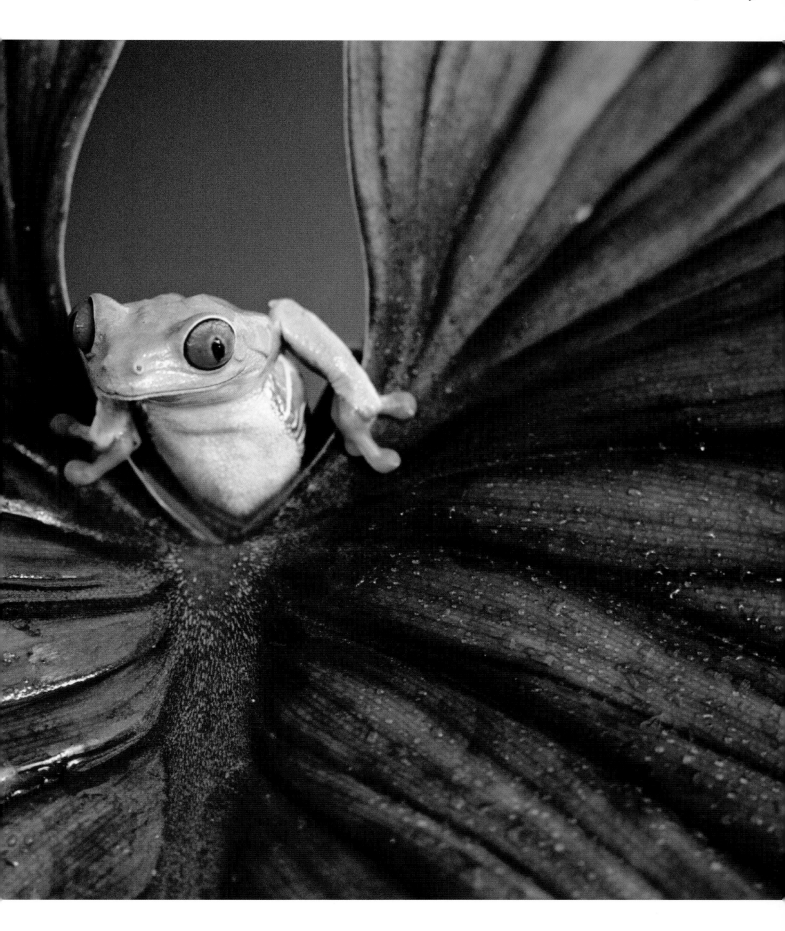

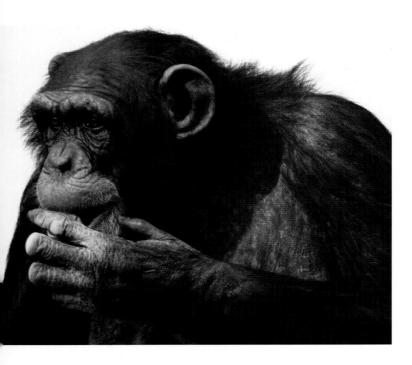

ABOVE This thoughtful looking chimpanzee was photographed in India's Delhi Zoo. I purposely isolated this chimp against the flat-looking white sky, so that the emphasis is purely on the animal. The direction of the sun has made the image slightly side lit, which creates the shadow on the chimp's right side and helps to give the image a more three-dimensional look. If the sun had been coming from over my shoulder, there would not have been the shadow and so a flatter looking image would have resulted.

300mm lens, ISO 160, 1/125 second at f/11

The opportunities afforded with photographing captive birds of prey mean that you can experiment with unusual angles and with light. Do not only concentrate on taking well-lit portraits; try shooting into the light. You can shoot silhouettes against a setting sun or experiment with moody side lighting; the options are endless and can allow for some really creative photography.

GAME FARMS

Game farms are a phenomenon born in the United States. They initially existed for the film industry and comprised of tame, and often well-trained, wild animals. These include tigers, lions, cheetahs, wolves, bears and a host of other animals. These days, they are immensely popular with wildlife photographers and, for a fee, a number of animals can be photographed in natural settings. This can provide memorable occasions for action images, such as mountain lions jumping a stream, or perhaps a tiger running through water.

These facilities hold no attraction for me, but if you are after dynamic shots of often hard to photograph animals in wild settings, they may hold an appeal, and they are worth exploring as a potential source of imagery. It is worth checking how the animals are kept before visiting one of these establishments; most have excellent reputations for treating their animals well.

ZOOS

For many of us, zoos provide the only chance to photograph some of the world's endangered or hard to see wild animals. Some zoos can offer excellent opportunities, displaying animals in natural looking enclosures that allow more natural looking shots. This is particularly true of zoos that house their country's native wildlife. A good example of this is the jaguar enclosure in Belize Zoo; many of the published natural looking jaguar pictures have been taken here.

The drawback of photographing African or South American animals in zoos in North America is that the vegetation is almost certainly going to look North American and it will not provide a natural setting for the shot. Nevertheless, even in such situations, you can try head shots and various other close-ups. By being careful with your composition and background, such limitations can often be overcome. If shooting through bars or fencing, you can use a reasonably long lens by pushing your lens tight up against the barrier, and the fencing will not show. If bars or fencing are in your background, use a shallow depth of field to throw it out of focus. If shooting through glass, try to be right up against it to eliminate any potential reflections.

There are some zoos and wildlife parks that will allow photographers special access to some animals. I have spent time in enclosures with wolves, wolverines and a very playful lynx that pounced on me! It is always worth asking; an extra fee may be required, but the opportunity is more than worth the expense.

In the United States and Canada there are a number of protected wetland areas that are a treasure trove of wildfowl. They all vary in how good they are for photography, but most give some good chances to photograph a variety of swans, geese, and ducks, some of

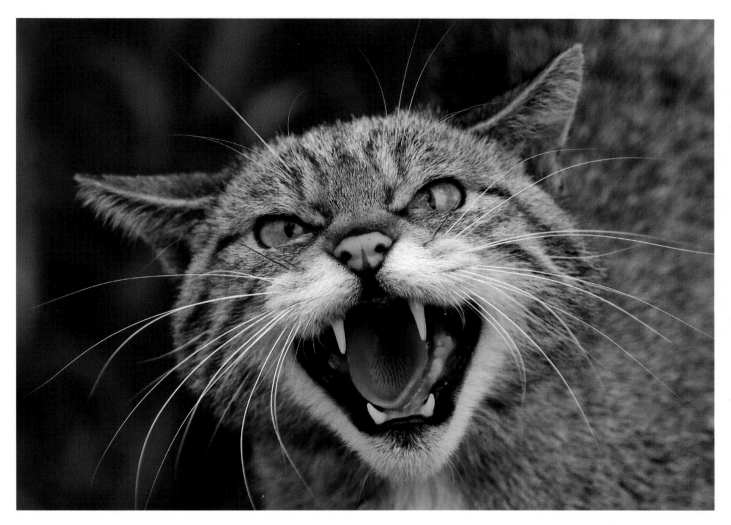

ABOVE To get this captive Scottish wildcat to snarl at the camera, I asked the keeper who normally feeds the animal to stand behind me and dangle the cat's meal of a dead rat over my head! Chatting to the people who look after the captive animals you wish to photograph will often open up all sorts of possibilities, as with this cat. When working inside enclosures with animals, take care with your backgrounds; you want to avoid wire or netting and, if you are able to, try improving backgrounds with props such as native foliage. You can lure your subject into the desired position by placing food in the desired spot, although try and camouflage this or at least don't make it too obvious.

70–200mm zoom lens, ISO 160, 1/500 second at f/5.6

which will be captive animals, as well as herons and other waterfowl. These are great places to practice your technique and, in winter, any captive birds will attract their wild cousins. Many of these sites are on natural migratory routes, giving good potential for flight shots. One thing to remember when photographing any captive wildfowl is to ensure that you do not show the clipped wing of the bird – always concentrate on photographing the bird on its good side.

Spontaneity

Wildlife subjects often present themselves away from the setups or situations where you are waiting for a specific event to happen. For this reason, whenever I am out with my camera, it is always switched on and is already set to the correct exposure for the current light conditions. Being ready to swing into action and fire the shutter within a few seconds of spotting a subject can make the difference between a great shot and great frustration as you miss the opportunity.

Often I will go out in my car close to where I live and drive around the quiet lanes looking for rabbits in the fields or roadside birds to photograph. I use this approach at my local nature reserves too; carrying only a camera and long lens mounted on a tripod, I walk paths and visit blinds. I never know quite what I will find and end up photographing that day.

CHAPTER 4

Creative techniques

Wildlife photography has come a long way since the mid-1990s. There was a time when simply obtaining a well-lit, pleasing portrait was satisfying and considered an achievement. The digital age has brought with it new possibilities for capturing action. With so many great wildlife images being produced, more and more photographers are striving to push their creative boundaries to try and create images that stand out from the crowd.

Our eyes interpret a scene one way, whereas a camera can be used creatively to produce images of the same scene in many different ways. For instance, take a running bear: we can blur the animal and give a feeling of movement; we can freeze the bear's actions; we can use a shallow depth of field or a large depth of field; or we can focus on just one part of the bear. The only limits lie in our imagination.

When you look through the viewfinder of a camera, your attention is on the animal or bird that you wish to capture. However, the camera is completely objective; everything it sees will be recorded in that picture. If there are too many distracting elements fighting for attention, the picture will fail. I have always followed the maxim that less is more. In other words, the less clutter you have in your image, the more impact it will have.

Composition

How a picture is composed will depend on a number of variables under your control. These include your position from the subject, the length of lens you use, how you use the light and how you control the background. When I am out in the field, I am subconsciously making these assessments all the time. Every scene I look at is being assessed as a picture. This is something that comes naturally to me and I know I am lucky to have this ability. Even if this process does not come naturally to you, learning to sum up a situation fast will become a great asset for making the right choices, and I provide tips on how to do this here. If I have a settled subject in front of me, I will experiment with different angles, lenses and, if I have the chance, with the direction of light.

RIGHT Freezing really fast action, such as flying hummingbirds, is relatively simple without the need of an elaborate flash setup, which would be necessary with a film camera. Digital cameras allow wildlife photographers the ability to produce more and more striking images. For this shot of a long-tailed hermit, photographed in Panama, I stood close to a flower the bird was regularly visiting and prefocused, taking lots of pictures when I judged the bird was coming into focus. I used this focusing technique rather than my camera's autofocus, as the autofocus would hunt a lot and often lock on to vegetation behind the bird.

70–200mm zoom lens set at 200mm, ISO 320, 1/1,500 second at f/4

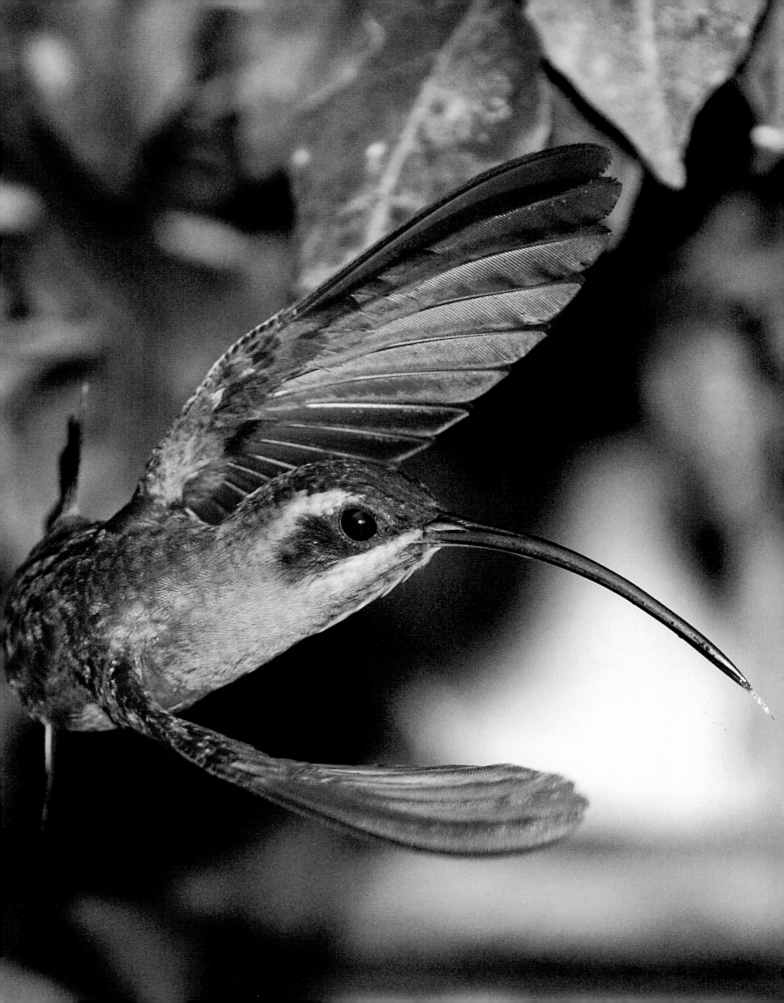

Unless your aim is to show your animal in the landscape, the more you can isolate your subject from a messy looking landscape, the stronger the image is likely to be. Furthermore, think about why you are attempting to take an image in a certain way, and the effect you are wishing to create. If you understand your own thought processes, you will be better able to hone the image so that its appeal will reach those who will ultimately view your work.

Composition and lighting are the two key elements in creating a picture with punch, and over the next few pages I describe a variety of techniques that I use to produce images that grab attention. Above all, I want to convey the idea that the more you think about why and how you compose a picture, the better and more rewarding your photography will become.

BACKGROUNDS

The background of a picture can make it or break it. Distracting elements in the background of an image, such as a light-colored twig, can draw the viewer's eye away from the main subject and impair its success. When your attention is devoted to the subject in your viewfinder, it is easy to miss distracting elements that will weaken a picture. It is important to learn to make a sweep of the frame with your eye, looking for anything that will detract. It is normally the case that light elements in a picture's background will compete with the subject, while dark elements will recede from the viewer's attention.

When taking images, I subconsciously scan my backgrounds; this has become second nature to me because I am taking pictures for a large part of the time. Nonetheless, if your photography is restricted by time, make a mental note to do this.

LEFT Quite often, the simpler the image, the more powerful it can be. This cheetah is looking out over the grassy plains of the Masai Mara, no doubt wondering where her next meal is coming from. I wanted to convey in this image both what the animal was doing and a feeling of place — where the animal lives — and produce a simple but slightly abstract portrait. To create the blurring effect on both the cheetah's left side and in the background, I have used a lensbaby, a small, fixed focal lens that allows you to create images such as this, in the camera, without having to resort to the computer. Whether you like this image or not is of course down to personal taste, but it illustrates both the concept of keeping it simple and trying to produce pictures that look a little different when compared to the usual shots of cheetahs.

Lensbaby 2.0, ISO 160, 1/2,500 second at f/1.0

There are a number of ways to overcome a bad background:

1 If possible, you can move your position; sometimes this need only be by an inch or two to the side, down or up. When I am moving into position for a subject, in a vehicle or on foot, I am checking for the background as well as looking at the subject, deciding on the best spot from which to shoot. This may mean avoiding light elements such as out-of-focus dead grass or light twigs, or perhaps a light, washed-out sky.

 When sitting in a blind, there is nothing more annoying than having a subject perform in front of you against an awful background that could have been avoided.

2 You can use your depth of field to throw out any distracting elements by using your lens wide open. A shallow depth of field is a great way to make your subject stand out from a background. Learning how to use your depth of field effectively is an important step in mastering your compositional skills.

3 If you are stuck in one place with one view that has a poor background, try using a long lens to isolate part of the subject, such as a close-up of a head, or experiment with shorter lenses. If you have a moving subject, blurring the background with movement might be the way to go.

4 Tidying up the background once the image is in your computer is perhaps the obvious thing to do. This can work well for many situations; however, it is far better to try and avoid this in the first place, not least because if your subject has a branch growing out of its head or some other intrusion directly behind it, removing this digitally can be a time-consuming job.

ABOVE AND RIGHT Two shots of the same scene: a gray heron on the edge of a pond. The first image has a large depth of field, taken at an aperture of f/11. This means that much of the foreground and background is only just out of focus, and so competing for attention with the bird. The second image has been taken with an aperture of f/4, providing a shallower depth of field, making the foreground and background less intrusive.

500mm lens, ISO 100, exposure as per caption

LIGHTING

The direction and the quality of light on your subject will give the image its mood, and it will play a big part in the impact the picture has. Take, for example, a penguin colony. Photograph this scene at midday, when the sun is high, and then photograph the same scene again in warm, evening light. The two resulting pictures will evoke two very different moods. Photographing an animal in harsh light is rarely conducive to creating a beautiful picture. When overhead, the sun saps color from your scene or animal, giving washed-out colors and a flat feel to the image.

The best light of the day will always be in the early morning or in the evening; this is when light moves toward the warm end of the color spectrum. Colors are then intensified and a more three-dimensional form is created, which breathes life into the picture of an animal. As well as this, most animals, particularly in the tropics, are likely to be far more active at either end of the day, so providing more scope for more interesting pictures.

ABOVE **Photographing furry animals against the light can prove very effective, as illustrated with this mountain hare photographed in the Scottish Highlands. This effect is commonly referred to as "rim lighting" and, in my opinion, this technique really sets the picture off. Rim lighting is at its most effective when, as in this example, there is a dark background.**

500mm lens, ISO 125, 1/1,000 second at f/4

Of course, beautiful light can be frustrating if the sun is in the wrong position for what you are attempting to achieve, and if you are unable to move your position. This happened to me in Alaska one autumn when photographing brown bears. The bears were fishing for salmon upstream from a coastal creek. I was confined to a small patch of gravel waiting for a bear to appear from one direction when one came charging through the water from the opposite direction. This was the shot I had been waiting to capture, but the light was against me, creating harsh shadows across the face of the bear. In the end, I did feel that the shot worked, and I was able to lift some of the shadow in postprocessing later. Yet if the day had been overcast, I would have benefited from little or no shadow problems.

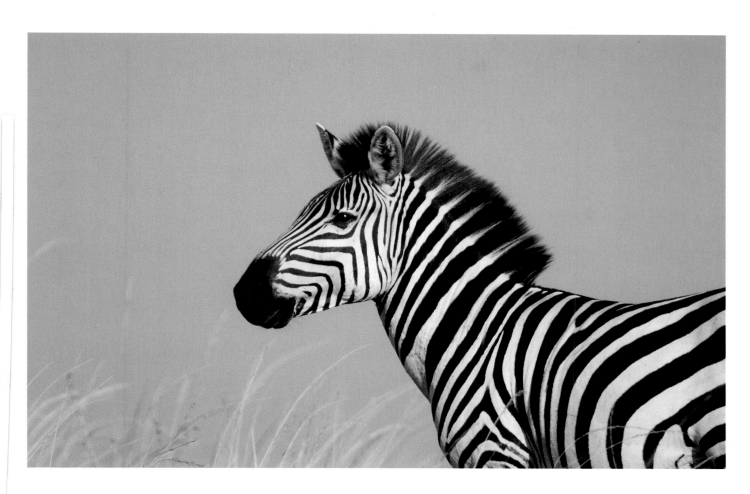

This brings me on to shooting on overcast days. Digital images handle dull light far better than film due to the digital sensor being more light-sensitive than film. Consequently, a dull day is not a bad day when shooting with a DSLR. Indeed, if I am shooting a subject that will appear in the frame without any sky, then bright overcast days are just fine. In such conditions, you can shoot at any angle and not worry about direction of light; there are no bright highlights or dark shadows (overcast days are good for white subjects), and the subtleties of colors can really shine.

When the sun is shining, if you have the ability to change the angle to your subject, you can use lighting to your advantage to produce some really eye-catching, moody images. The direction of light is one of the photographer's greatest creative tools, and when I am about to approach an animal I always look first at the light and decide how I want the subject lit. This then dictates the direction of my approach. Get close at the wrong angle, and you may lose the opportunity to move. My suggestions about how to

ABOVE A front-lit Burchell's zebra stallion, photographed in the Masai Mara. This image was taken in the middle of the day. The sun was high and so it made sense to shoot this animal in the conventional way. I took a low angle to isolate the zebra against the blue sky; the alternative background was a messy looking rocky landscape.

500mm lens, ISO 160, 1/1,000 second at f/6.3

utilize the angle of light, and a few examples showing the effects you can achieve, are given below.

FRONT (CONVENTIONAL) LIGHTING

Front lighting is achieved by shooting the animal with the sun coming from over your shoulder. This is the conventional approach that many photographers strive for on each and every shot. Front-lit subjects will show great detail in feathers or fur, and will lack shadows; colors will be shown at their best too. Certainly, a front-lit picture is often a desirable one to get. The disadvantages, however, are that without shadow the image takes on a one-dimensional look; this is because there is less contrast.

Many photographers try to avoid frontal lighting when they can, preferring the more moody feel that side or back-lighting might bring. It really depends on what you are trying to achieve. It is true that the majority of images published in glossy magazines and books are of subjects that are taken front lit; many editors and designers in charge of picture selection stick with the tried and tested formula of illustrating their subject in the conventional way. This can be a shame as many of the most creative images produced every year are never shown to a wider audience because of this conservatism.

BACKLIGHTING

While front lighting may be the safe option for producing a pleasing image, or one where you can easily identify the animal in the picture, if you go around to the other side and shoot that same subject backlit, your image takes on a wholly different mood. For me, an image can then be elevated from purely a record or pleasant portrait to a piece of art. The very fact that a subject is silhouetted or its outline illuminated (rim lit) means that the viewer is left to imagine more about the subject pictured and that a sense of mystery is created. If the lighting hits it right, it may turn from a two-dimensional to three-dimensional looking image, thus giving the picture more depth and providing more of a life-like feel to the animal. Drama is created from a backlit scene.

Rim lighting occurs when the subject is backlit against a dark background; the edge of the animal or bird is lit up producing a beautiful effect – "a glowing halo," as once described by a photographer friend of mine.

Things to watch for when shooting backlit scenes include lens flare, which is created when light entering the lens reflects off the lens elements. Using a deep lens hood or holding your hand over the top of the lens as an extra shade helps eliminate this. Also watch out for dirt on the lens surface or chips in the glass causing flare problems.

RIGHT Silhouettes work best when the sun is very low or just below the horizon; if you have some mist, as with this image, all the better. This red deer stag is making his presence known at dawn, during the rut. I planned for this image, and it took several early morning visits to get my shot.

300mm lens, ISO 100, 1/250 second at f/8

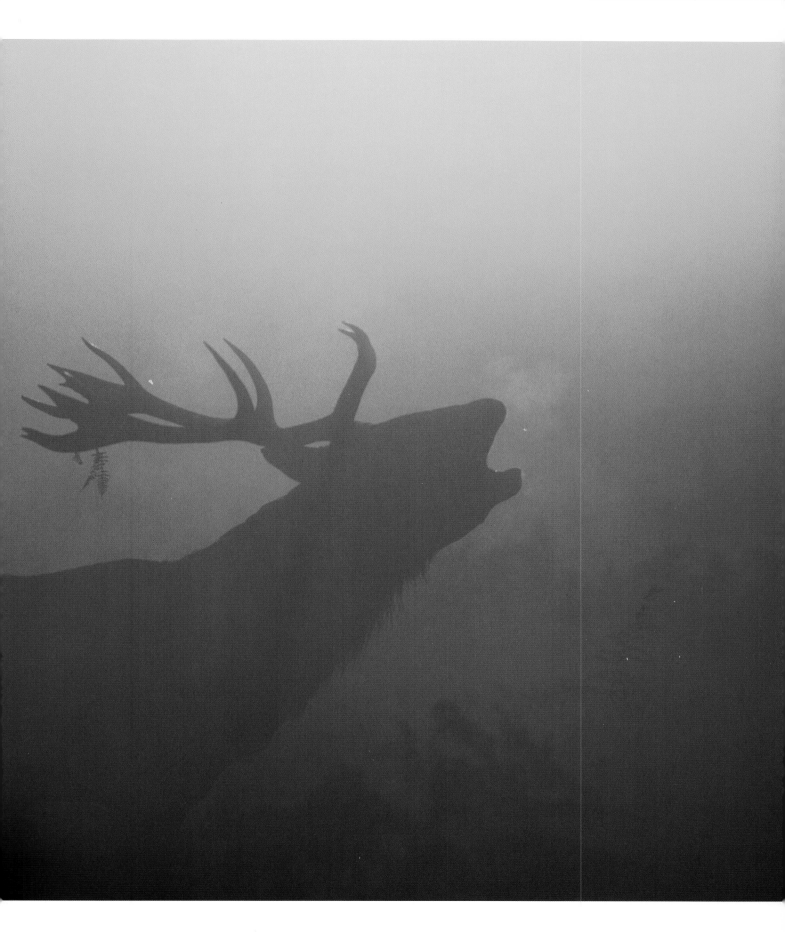

If you want to silhouette your subject against the setting sun, this is very different from shooting a rim-lit image a couple of hours before sunset. Experimentation is the name of the game – check how the images look on your camera's LCD, and take plenty of shots at various exposures to cover your options. When experienced, you can refine your technique to produce the look that appeals to you.

As an example, one winter I spent a number of evenings visiting a large starling roost on the English south coast. I took many exposures each night of the starling flocks wheeling around against the setting sun. Often, any one of four or five different exposures was acceptable. There were varying degrees of color in the sky and those I favored were not necessarily the same images another photographer might have chosen; it was down to personal choice.

SIDE LIGHTING

There are few better ways to add impact to an image than to use side lighting. The harsh shadows that result provide a three-dimensional feel to the subject, and create a mood completely different to that given by front lighting. When using side lighting, it works best when the sun is low in the sky, and when you can shoot as low as possible. Side lighting in the middle of the day can mean too much heavy shadow and not enough soft illumination for it to be effective. It is better to shoot side-lit subjects at the start or end of the day. I have found, too, that side-lit subjects are often photographed best when low to the ground – the low angle accentuates the drama in the image.

BELOW **Side lighting can create drama in a picture. I captured this fallow deer in a forest clearing in the New Forest, England soon after dawn. The animal lingered in a pool of light just long enough for me to take this image.**

500mm lens, ISO 100, 1/250 second at f/5.6

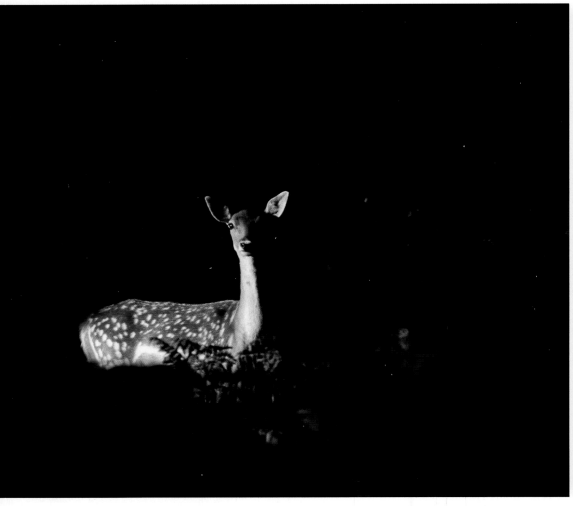

REFLECTED LIGHT

Reflected light is my favorite form of lighting, and I am envious of those photographers who live where snow is commonplace in winter. There is a special quality to light reflected onto a subject from snow or white desert sand, which is impossible to reproduce in any other situation. Reflected light works particularly well for illuminating the undersides of flying birds.

One of reflected light's great qualities is to bring out detail that would otherwise be subdued by shadow. Even on cloudy days, the light that is reflected takes on a wonderful soft quality, allowing detail to be brought out in your subject's fur or feathers. On bright days, when the light might ordinarily be too harsh, reflected light has a softening effect, allowing pictures to be taken at noon without showing the contrast that would normally occur.

There are various ways of taking advantage of reflected light other than in snow or desert environments. Often the wake of boats churns the water white, and any birds such as seagulls following a boat can have their underwings illuminated beautifully in this way. On occasions, I lay a white sheet or, more commonly, a board covered in silver foil, or a large reflector below bird feeders when photographing in my garden. The birds soon get used to the intrusion, and I am able to illuminate their undersides in a more natural looking way than if I had used a flash. When you have a lot of reflected light, such as a covering of snow, backlit images can take on a new dimension too, creating a rim-lighting effect while still retaining lots of detail in your subject.

BELOW **A great gray owl floats on silent wings from a Finnish forest. Snow lying on the ground has acted like a giant reflector, illuminating the bird's underwing beautifully.**

500mm lens, ISO 200, 1/500 second at f/4

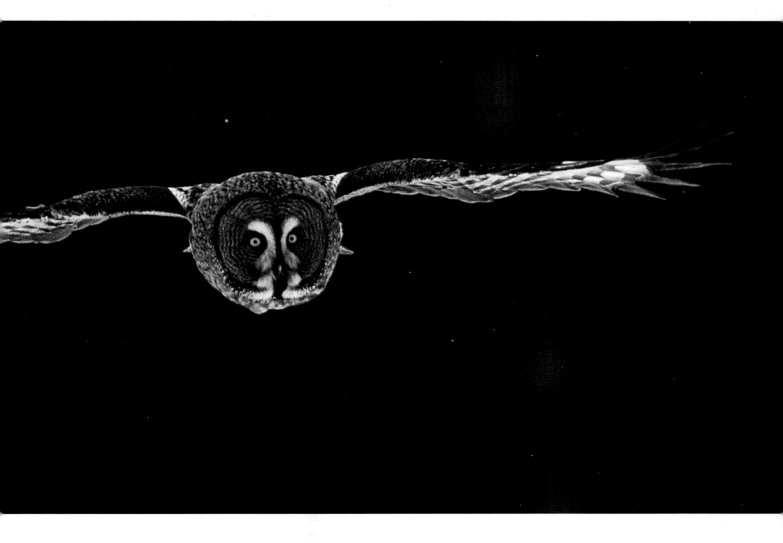

COMPOSING

How balanced a picture looks to the eye is the result of where you place your subject in the frame. An animal looking out of the frame causes the viewer's gaze to follow the direction in which the animal's eyes are looking. Place an animal so that it is looking into space within the frame, and the viewer's attention is held by the rest of the picture.

Many photographers, who rely solely on autofocus, can enter a habit of placing the subject in the middle of the frame, time after time. If the subject in the center is the main part of the picture and the rest uninteresting, there is nothing wrong with this approach. If, however, the surroundings are an important part of the picture too, then this placement can lead to the picture losing its potential. By using asymmetry and moving the main subject away from the center, a calm balance or, if desired, a tension in the picture can be created between various picture elements and their relationship.

Naturally, rules are there to be broken, not least in photography compared to other forms of art. Nevertheless, there is one rule that works well and which, if you have trouble with composing, will help you to place your subject. It is the "rule of thirds." As can be seen on the example on this page, the frame is divided into thirds, and the subject is placed at any one of the intersections (depending on which way it is looking) to give a pleasing result.

A similar idea is the "golden mean." This is the same principle as the rule of thirds with the slight difference being that the grid, when worked out mathematically, brings the intersections slightly closer together.

One of the best ways of exploring composition is to look at as much art and photography as you can. Look at how the pictures have been composed and ask yourself why they seem balanced or, perhaps, do not seem balanced to your eye. By studying other people's work, your ideas and knowledge of composition will expand.

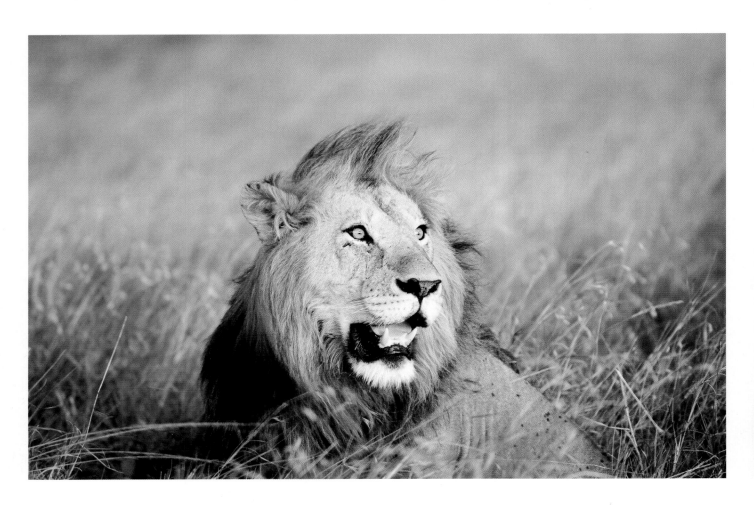

(A) BOTTOM LEFT (B) TOP RIGHT
(C) BOTTOM RIGHT

Where you choose to place your subject in the frame is of course down to personal taste. These three shots of a lion were taken at the same time from the same viewpoint, but they all look quite different. This is due entirely to where I have placed the lion in the frame, and to the focal length I have used on my zoom lens to control perspective. Picture A has the lion more or less centered in the frame, but because it is big in the frame, and partly facing, this does not matter. Pictures B and C show the lion looking into space. With picture C, I have isolated the lion's head from the background by using a shallow depth of field that helps to focus attention on the subject; I positioned the lion right in the bottom corner purely because I liked this composition. When you have prolonged opportunities with static subjects, don't be afraid to experiment with placing the animal in different places within the frame.

70–200mm zoom at various settings, ISO 200

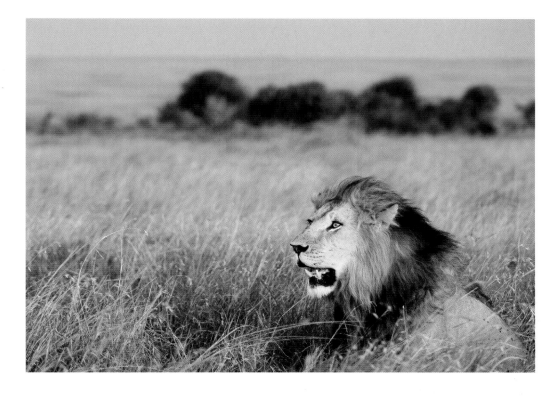

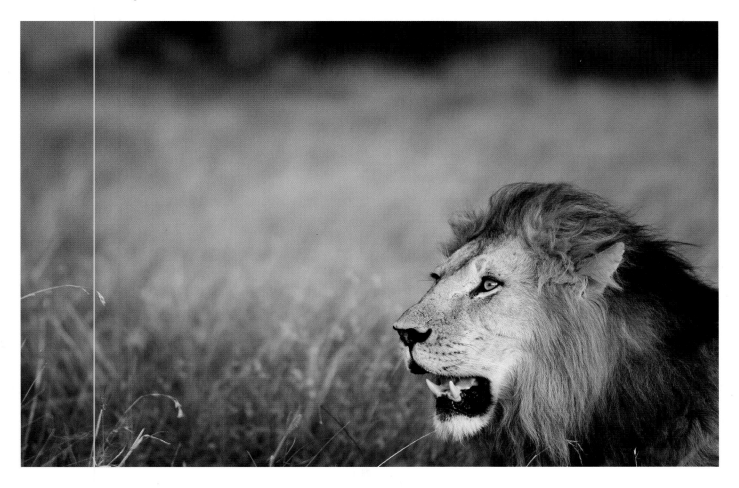

HORIZONTAL OR VERTICAL

If you sell your work, you will be aware that it is beneficial to shoot both in the horizontal and vertical formats, and to often leave plenty of space around your image for designers to be able to crop, or in which to place type.

If this does not concern you, it is still important in exploring the best composition of an image to judge whether it will look best as a vertical or horizontal shot. Simply, by switching from one to another while trained on your subject, you can create a very different feel. If the image is small in the frame and you are shooting vertically, still remember the rule of thirds; although placing the subject to one side in a vertical frame is not so important it may still make a big difference.

Unless you are shooting vertically to capture a reflection, try to avoid placing the subject halfway up the frame; better that it is toward the bottom or toward the top if the surroundings are a large part of the pictorial content.

CHOOSING PERSPECTIVE

When I first started shooting wildlife, I would often concentrate on getting as close as I could with my longest lens, and this is still often the temptation today, 25 years later. Yet there are times when standing back from the scene and taking a wider view brings a whole new perspective to the image.

The isolation that a long telephoto lens brings to the subject when used close up can add intimacy to a portrait, as I have previously stated; less is often more where visual impact is concerned. Creating the same image size by moving close with a wide-angle lens creates a whole new perspective on the same subject. The two resulting pictures are very different. Near objects when viewed through a wide-angle lens appear abnormally large, while objects in the background are rendered abnormally small. This distortion can create a focus on your subject and provide plenty of pictorial impact.

How your subject, foreground and background relate to one another helps to define the success or otherwise of a picture. We can control these factors by choice of lens, angle of view and the depth of field that we choose. In an ideal world, our animal would sit still while we experimented; however, wildlife often dictates these factors rather than us. When taking images, though, making judgments relating to perspective and its control, and so thinking about how you want your image to look, will take your photography to a new level.

THE WIDER VIEW

There are occasions, especially in locations such as the polar regions, where the landscape can be an integral part of the image and including it helps to set the scene.

My number one destination for wildlife photography is South Georgia, a sub-Antarctic island of stupendous beauty. The landscape of jagged, snow-capped mountains, hanging ice fields and glaciers plunging toward the sea is made all the more impressive by some of the world's great wildlife spectacles, for instance, huge penguin rookeries, some of which stretch for a mile or more. It is here and in similar places that shorter lenses to combine wildlife with landscape come into their own. There are many different perspectives you can take when working in places like this.

With very tame wildlife, getting up close with a wide-angle lens or even fisheye lens and accentuating the size and shape of the animal against a landscape can create eye-catching images. Parallel lines diverge or converge, depending on the angle of the lens, making for some interesting, distorting effects. This is a popular approach when a subject is very tame.

I really enjoy playing around with compositions with my fisheye lens whenever I can. When using a wide-angle lens, whether it be for showing an animal in its environment, a set of tracks or even a dead animal, it is usually advantageous to place the focal point of the image to the side or toward the bottom of the frame so that the eye can travel from the subject out into the landscape, which is likely to be a major part of the composition.

Alternatively, by standing back with a medium-length telephoto lens (200–400mm range), the landscape can be used as a slightly out-of-focus backdrop to the subject. Experimentation is vital in such situations in order to get the best out of an opportunity.

RIGHT Tame animals can provide great opportunities for taking attention-grabbing shots. The red squirrel is not always easy to photograph. This individual had been tamed over a number of months by a photographer friend living in the Scottish Highlands. The squirrel was used to nuts being put out for it at a regular feeding spot, and so I waited at this spot and stuck a nut with double-sided tape on to the top of my wide-angle lens. The squirrel spotted the nut on my lens and walked along the branch to try and retrieve it!

*24mm lens, ISO 100,
1/60 second at f/11 plus hazelnut*

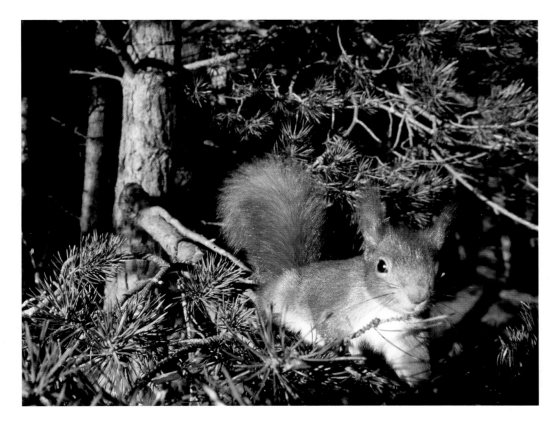

RIGHT This pair of Arctic terns photographed on the Farne Islands was taken with a fisheye lens. The terns continually mob visitors walking along the islands' paths, and so come extremely close. You should never stray into a tern colony; this type of image is only possible from somewhere like the Farne Islands, where controlled public access leads to birds nesting along paths. I like the abstract nature of this image – if the bird had been missing from the background, I do not think it would have worked as a picture, for me at least. Photography, like any art form, is very subjective.

*10.5mm fisheye lens, ISO 200,
1/800 second at f/11*

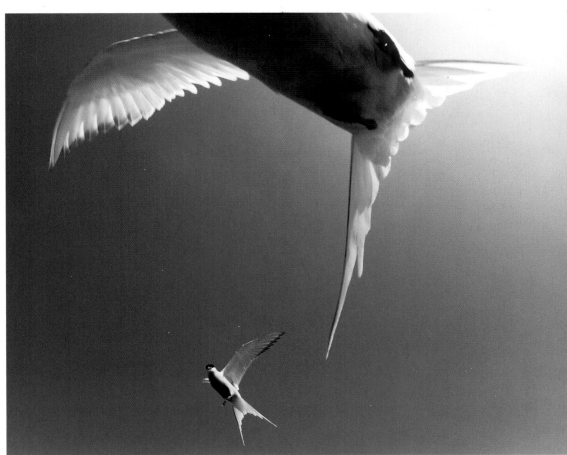

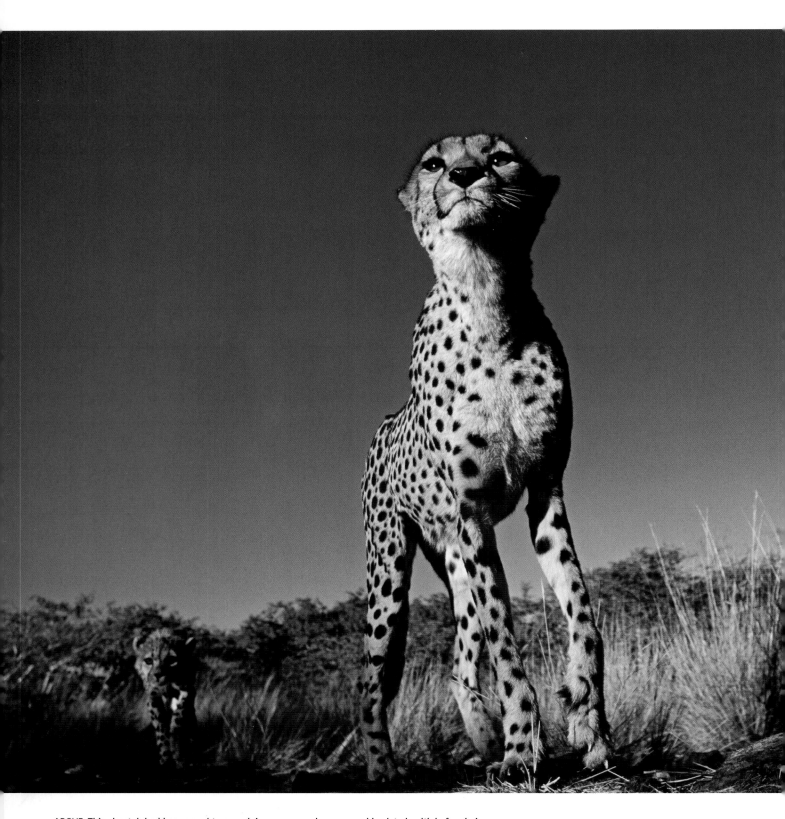

ABOVE This cheetah had been caught as a cub in a snare, and was nursed back to health before being released in a reserve. I visited the reserve with the person who had looked after her, and he was able to call her over while I lay close to the vehicle with a wide-angle lens to get this unusual shot. An added bonus was the appearance of one of her cubs in the background.

17mm lens, ISO 100, 1/125 second at f/11

I regularly visit the polar regions in my quest for pictures, and each time I go, I seek out scenes that will make panoramic images. Adobe Photoshop and other software programs give you the opportunity of stitching 35mm frames together to create panoramic pictures. The letterbox format is a great way of showing your subject within the vast and dramatic landscapes that these regions offer. When you view a panoramic image it is like looking through a car windshield; your eye cannot take in the whole scene in one go, but roams across the image. Therefore, subject placement in a panoramic picture can be very important to ensure that the image feels balanced. I tend to try and place my subjects to one side so that they are looking into space. Equally, it can work well if the image is placed in the center and the landscape has features that balance the composition on either side.

CREATIVE CHOICES WITH F-STOPS AND SHUTTER SPEEDS

I once spent three weeks photographing fishing ospreys that were regularly visiting a fish farm. The many chances I had allowed me to photograph the birds with slow shutter speeds to illustrate power and movement, and with fast shutter speeds to freeze the action. This made for very different but striking images.

Using shutter speeds to control the feel of movement is an effective tool. As a professional, I need to get my images noticed. Consequently, I will often look at an active subject, of which I may have seen hundreds of similar images, and think of ways to illustrate the animal in a fresh, new way. One of these can be to blur movement.

Motion blur is easier with image-stabilized lenses than without because it is often necessary to have a little sharpness in the head of the animal for it to work. My best results come from shutter speeds of around 1/15 second; however, I have had pleasing results with speeds as low as 1/8 second and as fast as 1/125 second—it all really depends on the effect you wish to create. To this end, taking as many images as possible is necessary as inevitably there is much wastage. All too often, action can be very fleeting, and it can be a big risk going for broke with this technique.

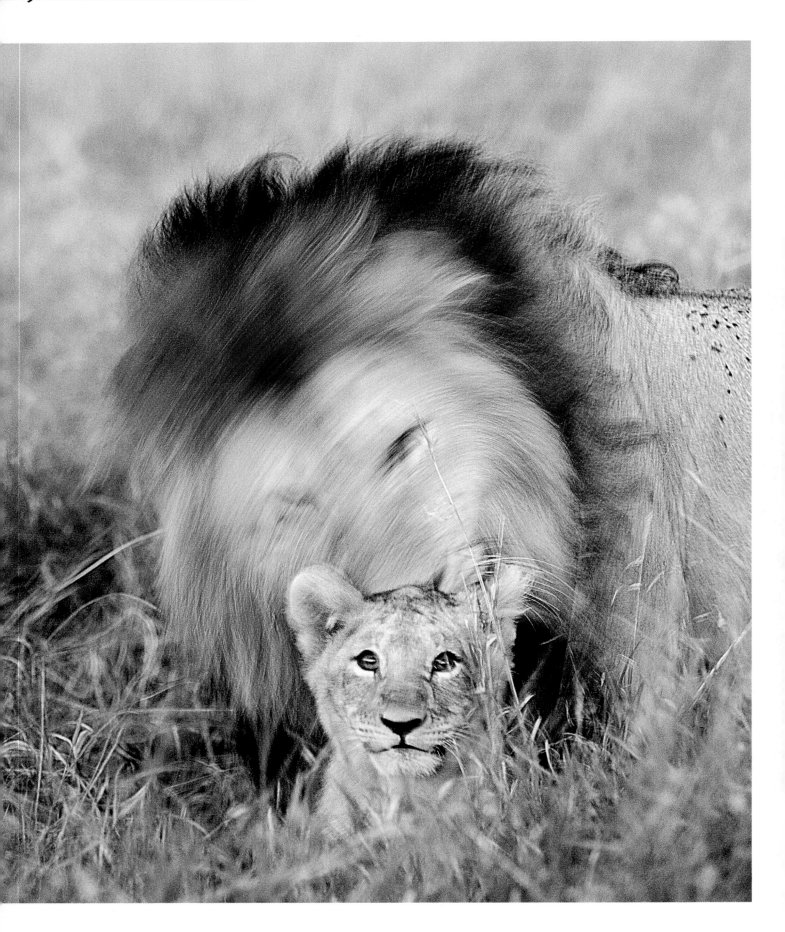

Using fast shutter speeds to freeze action is far easier to judge. Any speed over 1/1,000 second is likely to freeze most movement, and 1/500 second is likely to be fine in freezing the movement of big mammals, with the exception of, say, a fast moving cat such as a cheetah. I have used speeds as high as 1/4,000 second to freeze the wing tips of some very fast moving birds, but available light can often be a limiting factor for doing this.

Depth of field

The other tool for creating a mood, mainly with static subjects rather than with moving ones, is to control depth of field. For example, if you are up close to an animal and focusing on an eye, you could use a shallow depth of field, leaving just the eye sharp and the rest of the head in soft focus, or you could use a large depth of field to keep everything in sharp focus. The photographs below show how the mood of an image can be controlled in this way.

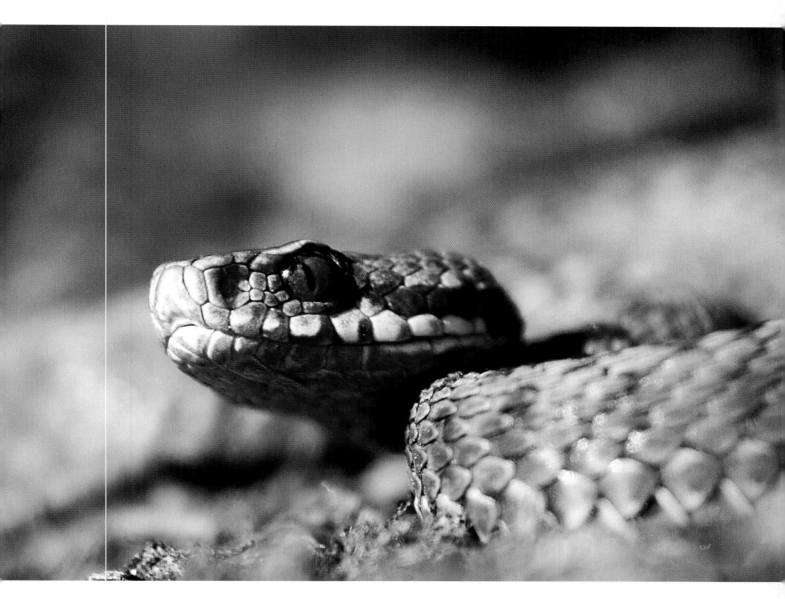

LEFT Showing motion by using a very slow shutter speed can be very effective, as illustrated here with this lion and cub. The sun had already dipped below the horizon when I took this image, and there was no other option than to use a slow shutter speed. However bad the light gets, it is always worth continuing to shoot; you never know what will happen next.

ABOVE If I had tried to keep sufficient depth of field for the entire body of this adder to be in focus, the picture would have been a little messy. Instead, by using a shallow depth of field and concentrating focus just on the head and eye, and by lying on the ground for a low perspective, a far stronger image resulted, helping to add to the sinister look of the snake.

70–200mm zoom lens, ISO 250, 1/8 second at f/2.8

300mm lens, ISO 100, 1/640 second at f/4 with angled viewfinder

The digital darkroom

If you are new to digital photography, and perhaps computers, the process of dealing with an image once downloaded to your computer may seem a daunting one. Yet, in fact, most of what you will do is straightforward. Armed with a little knowledge, you will soon become expert in optimizing your images.

The whole process of dealing with a digital image once it is on the hard drive of your computer is known as the "workflow." No two photographers will have the exact same workflow; we all edit and deal with our images differently. However, the aim is always the same – to minimize the time spent peering into a computer screen and to maximize the quality of the resulting image. For me, sitting behind the computer is a necessary evil; I want to be out taking pictures as much as possible, so the more time I can save in the workflow, the better.

My workflow is personal to me, and it is detailed over the next few pages because it is the best example I can give. When you become comfortable processing your pictures, you will find that your workflow will evolve. If this is all new to you, then I am not too modest to say that you can follow what I do until you become comfortable with adjusting it all to your own taste.

To process the images in your computer you need dedicated image editing software. There are a number of applications available, and some cameras even come with their own proprietary software. Realistically, however, Adobe Photoshop is the only choice for both flexibility and usability: it is the industry standard, most photographers use it and it is constantly being improved version by version.

If you shoot in RAW you might want to consider using Aperture. If you are a Mac user or use both platforms Adobe Lightroom is preferable. Both programs are designed specifically for photographers to organize and process images.

RIGHT A great amount of time and effort can go into capturing special images of wildlife. That effort should be backed up by a good understanding of how to process your image for the best possible result. This is a displaying group of lesser flamingos taken on the shores of Lake Nakuru in Kenya's Rift Valley. I lay under a vehicle to achieve this low viewpoint.

500mm lens, ISO 100,
1/250 second at f/10

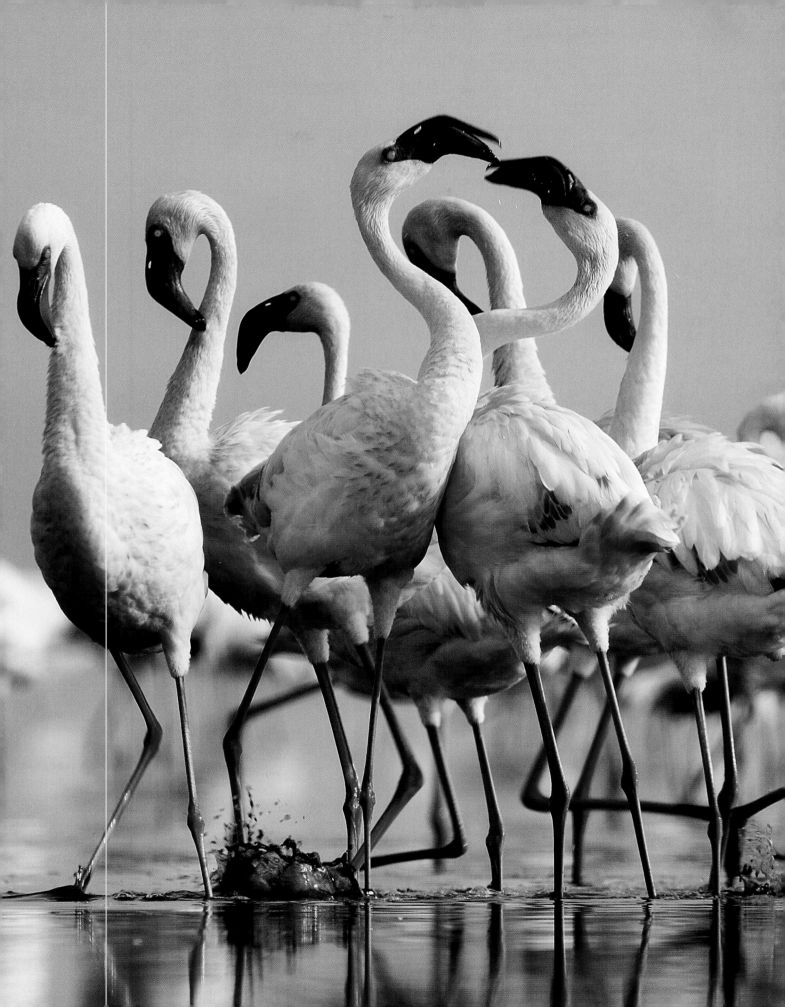

There are two versions of Adobe Photoshop. Adobe Photoshop Elements and a full version which, at the time of writing, was called Adobe Photoshop CS2. There is a big price difference between the two, however once you have the full version, you can upgrade to new versions for a considerably reduced cost. If you shoot JPEGs, then Photoshop Elements is likely to serve you well and will save you a substantial sum. The main difference between Elements and the full version of Photoshop is largely the range of tools on offer.

Regardless of the software, the basic tools for adjusting images are almost identical. I have chosen to illustrate the various processes described in the following pages using Photoshop CS2. If you use other software, you should still have no trouble following these processes, as the tools used are common to all image editing software packages.

Color management

All devices, whether printers or monitors, need adjusting so that they are talking the same color language. Without this tweaking, they will be inconsistent in the colors that they show or print. Adjusting your monitor and printer so that colors conform is called "color management."

I have heard wildlife photographers state that color management is not so important as in some other forms of photography. This is simply because we photograph our subjects in all sorts of lighting conditions. There is something to be said for not bothering if the color looks good to you, and you do not feel the need for color management. It may be that the colors on your screen are acceptable and the prints you produce are a match with which you are happy. If you do no more than produce prints for yourself, then this is fine.

However, many of us wish to share our pictures, whether through publishing, or perhaps selling, our prints. For good, consistent results, color management does matter. If your monitor is inaccurate or your printer has a poor profile, the feel of the image in color terms will be lost as the color information may not represent what you intended. Managing color to a universal standard then becomes a matter of importance.

Before making any adjustments, you need to be working in a room and viewing environment that is stable in regard to lighting. If sunlight floods in for part of the day, and for the rest of the day the room is lit by a skylight, your assessment will be compromised. The ideal situation is a room where daylight plays little part, and is not overly lit. Only then can you trust the calibration you make.

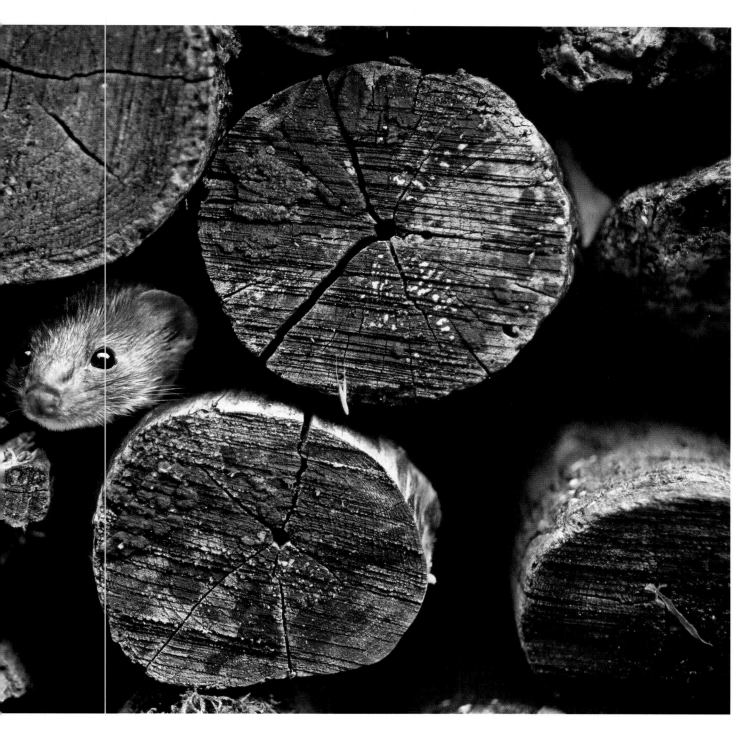

If using a Mac, the first step is to calibrate your monitor with the computer's display calibrator assistant. If you are a Microsoft Windows user, you will use Adobe gamma. This adjusts the brightness, black, white and midpoints, color temperature and sets the gamma. You will be led through a number of screens and asked to make various adjustments. If you are using your monitor in a room with normal daylight, color temperature should be set to

ABOVE When I start to look at pictures right after a shoot, I generally find it difficult to be objective about many of them. It is often best to do an initial edit to remove the junk, and then revisit the pictures a few days later when your judgment on what should be kept or deleted is not colored so much by the recent experience and expectations of the shoot. The image of a weasel shown here was one of many that I took of this animal in a studio setup. Of over 300 images taken during the shoot, I eventually edited them down to around 20 that I kept, this being one of my favorites.

70–200mm zoom, ISO 100, 1/125 second at f/8

LEFT This is the display calibrator assistant found on a Mac. If you are a Windows user, Adobe gamma is very similar.

BELOW The "Color settings" panel is found under "Edit" in Adobe Photoshop.

6,500K. Once you have done this, you may find that the first few pictures look quite different compared to the previous setting, but you will soon adjust. You are now partway there, and if you do nothing else then at least this part of the calibration process will have made a difference.

To ensure proper color accuracy, you need to use a colorimeter or, better still, a spectrophotometer. These devices attach to the screen and read colored targets stored in its software. In short they do what you are incapable of doing – measuring the color accuracy of your monitor mechanically and generating a custom ICC profile. ICC stands for International Color Consortium, and this is a group that has set color standards for all manufacturers. By having ICC standards, we can ensure that all our devices are capable of talking the same color language, and so this brings uniformity.

If the lighting in your room varies according to the time of day, it may be necessary to create more than one monitor profile for greatest accuracy. If you create multiple profiles, make sure you include the time of day when naming them. You can place the date in the profile to record how old the profile is. For example, "bright morning 23–07–06," "dull midday 23–07–06."

Many of my publishing clients do not have color managed monitors, nor do many of them know anything about color management. This often means that the pictures I send them will not look the same on their monitor as they did on mine. As mentioned previously, perhaps this is not a big problem with images of wildlife. Nonetheless, at least

RIGHT I use Bridge in Adobe Photoshop CS2 as my on-screen lightbox, and I do all my editing here – both weeding out images from the thumbnail selection shown and more careful editing using the "Slide show" function.

I know that what I produce on my screen is as accurate as possible, and for many more of my clients who do work in color managed environments they know they can trust the accuracy of the files I send them. Problems arise when a client adjusts images on a monitor that is not color calibrated.

One final point on color concerns setting up Adobe Photoshop for your color management. This means going to the color settings panel and ensuring that they are adjusted correctly. Once in Photoshop, click on "Edit" then "Color settings" to access the box. As you will probably be shooting in the Adobe RGB (1998) color space then your working space should be the same. The reason for using Adobe RGB (1998) is that it is a good general working space with a wide gamut. There is a movement toward using Prophoto RGB, which has a slightly wider gamut space.

Downloading and editing

In Chapter 1, I described the various methods for transferring your pictures from digital film to computer. When I download images, I put them in a folder labeled with the subject, which I then copy to a peripheral hard drive. In this way, I have a backup in the event of one set being lost. I also leave the images on the cards until I come around to using them again; this is another way of keeping a set for a limited time. When I come to shoot with that card again, I format it in the camera, which wipes it clean.

Now it is time to open up the folder and start editing images. I do this by entering Bridge, which is Adobe Photoshop CS2's file browser. If you are not using CS2, your application will have its own file browser in which all your images are displayed and can be edited. In effect this is your digital lightbox. Bridge displays all the images in the folder as thumbnails, and can provide previews too. If you wish, you can carry out an initial rough edit by scanning down through these thumbnails and deleting any obvious throwaways. However, I use the "Slide show" function; this is a great editing tool because the pictures are displayed full screen and, by marking those I wish to delete using the star system, I can edit quickly. Because the images are shown full screen, any that are obviously not in focus can be spotted and removed. Yet its main use for me is to cull any images where the composition does not work. Critical focus can be checked later. Once edited, the images can then be worked on. If shooting JPEGs you will then go straight into Photoshop, and so you can skip the next section. If shooting RAW, read on.

RIGHT The combination of a dramatic landscape and a tame subject can offer some great opportunities for creating pictures that give a sense of place. I have used the panoramic format to help convey this pair of wandering albatross within the landscape of Albatross Island in the Bay of Isles, South Georgia. If you have a camera with a sensor that gives you plenty of pixels to play with then it is always worth thinking about shooting pictures with shorter lenses, with a plan to crop them into panoramics later.

90mm lens, ISO 100, 1/250 second at f/5.6

RIGHT This shot shows just a small section of the magnificent black-browed albatross colony on Steeple Jason Island in the Falkland Islands. I used the albatross and chick at the front as a strong foreground to lead the viewer's eye into the picture. Without this strong foreground, the picture would lack impact. I deliberately used a shallower depth of field than was necessary to place emphasis on the foreground bird and chick, putting the birds behind into soft focus.

45mm lens, ISO 100, 1/60 second at f/11

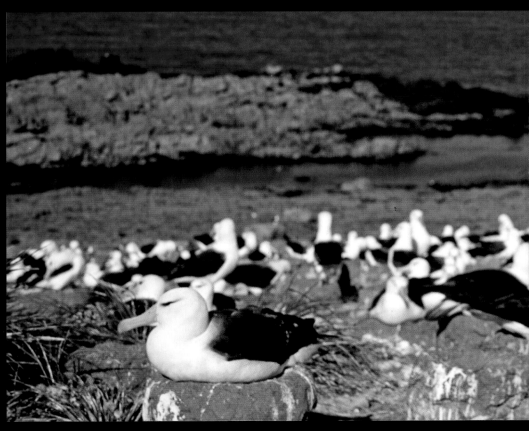

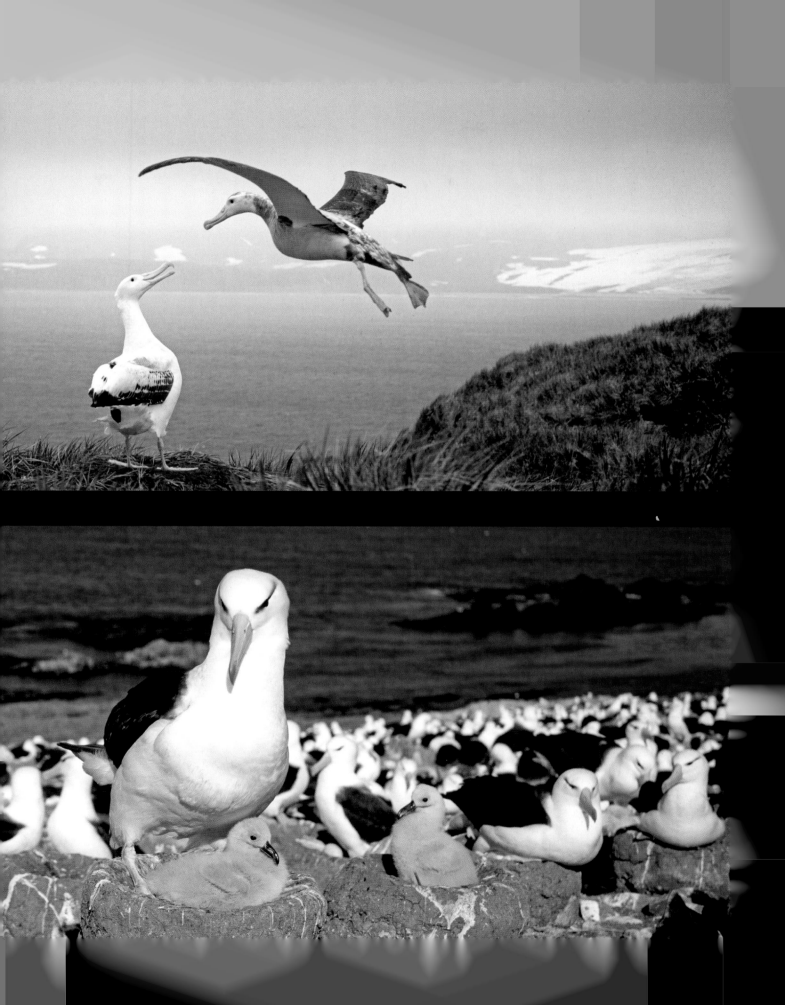

CHAPTER 6

Working in RAW

By their very nature, RAW images require processing. The processing is carried out in what is known as a "RAW converter." Critical adjustments can be made in the converter, including adjusting the white balance, exposure, contrast, saturation and so on. When you take a photo, it is stored along with the various parameters set in the camera, but these are not applied. Now you can either use these parameters or change any of their values to improve your image. Once these adjustments have been made, the image can be opened in Adobe Photoshop for further adjustment or optimization.

RAW converter

Once an image has been selected in the file browser, in this case Bridge, it is opened in the RAW converter. I use Adobe's own converter for Photoshop, called Adobe Camera Raw (ACR), which comes preinstalled in Adobe Photoshop CS2 and in Elements.

You will find plenty of photographers who swear by third-party converters – these include Bibble, Capture One, BreezeBrowser and RawShooter, to name the most popular. Many point to improved picture quality gained through using some of these converters, and a greater ease of editing. Nevertheless, I find that Bridge and ACR working together are perfect for my workflow, and they are a powerful combination for both quality and speed of editing. Like much in digital photography, what you choose may come down to personal preference or what you are used to, rather than any tangible advantage.

When your image is opened in the converter, you will see a screen with the controls, as illustrated on page 102. All of these tools will be useful to you at some stage or another over time. While many of the tools for adjustments exist in Photoshop, and much can be done within that program, I prefer to optimize the image as far as I can while in ACR. I also crop and, if necessary, resize the image at the same time. This is a personal choice, but it does mean that the more you do with the image in its RAW form, the less you have to do in Photoshop, and this helps to keep image quality high.

RIGHT A male howler monkey delivers his sinister sounding call from a treetop vantage point within a Central American rainforest. The picture was taken from a tower that gave wonderful access to the forest canopy. The image was slightly backlit and was difficult to expose for, but by shooting in RAW I was able to fine-tune the picture to achieve exactly the results I wanted.

500mm lens, ISO 100,
1/500 second at f/8

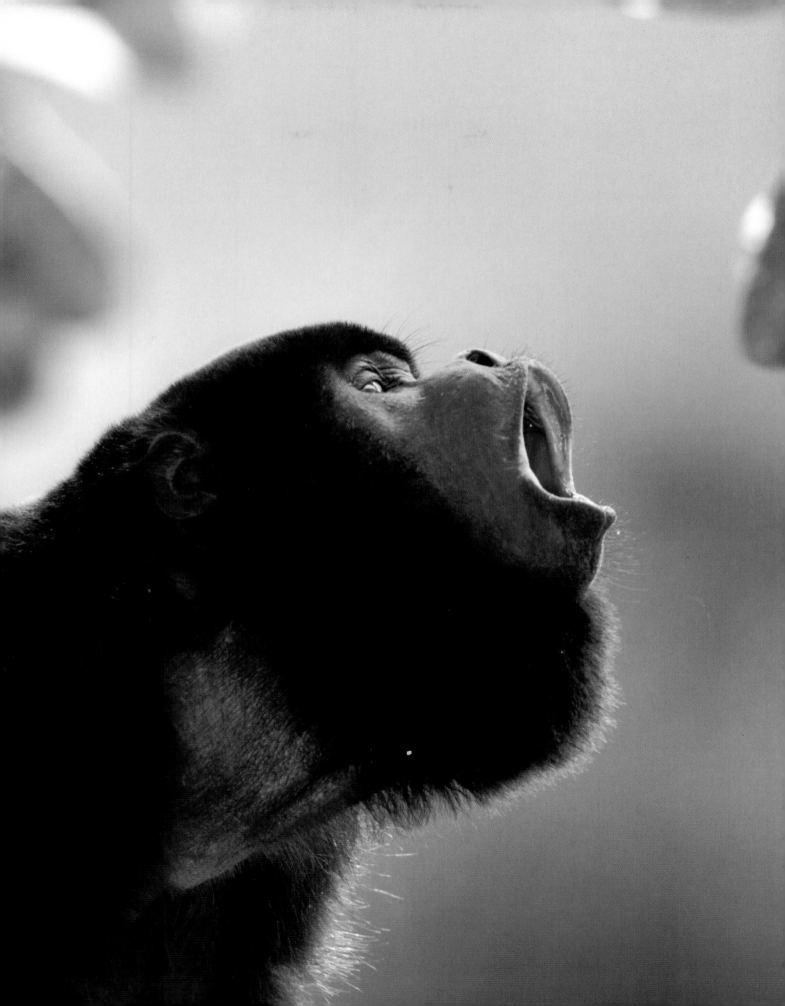

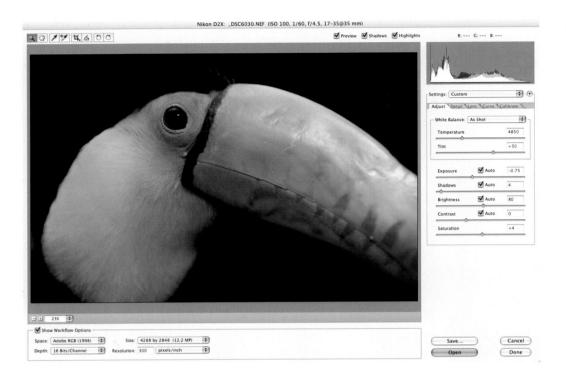

LEFT **The Adobe Camera Raw converter.**

The following sections detail the controls in ACR. If you use a different RAW converter, such as Capture One, you will find the same or similar controls working in exactly the ways I describe.

COLOR SPACE

Once the image is opened in ACR, you will see that there are various options available when the "Show workflow" options box is ticked. At the bottom left, these include setting your color space which, as already discussed, is likely to be Adobe RGB (1998).

IMAGE SIZE

Size of image allows you to interpolate (enlarge by adding more pixels) the picture at camera RAW stage – a good idea if you know your required file size in advance, perhaps for making a big print or interpolating to a minimum requirement for a stock agency. You can reduce the file size too. The captured size of your file will appear highlighted with a tick, and the alternative options shown with a minus for reducing and a plus for interpolating.

RESOLUTION

The "Resolution," which I set to 300 pixels per inch (ppi), does not alter the number of pixels in your picture. I set this to 300 as it is the most commonly used output for print.

BIT DEPTH

I set the "Bit depth" at 16 bits. For an explanation of bits and bytes, look back to Chapter 2. Most DSLRs capture images in 12 or 14 bits. By converting to 16 bits to carry out any work on the image, you are keeping as much color information as possible, and ensuring that smooth and accurate tonal gradations are maintained.

ZOOM

At the top left of your screen there is a line of tools. Double-clicking on the first icon, the "Zoom" tool, magnifies the image to 100 percent; at this enlargement you can check whether the image is sharp. Double-click on the "Hand" next door, and this restores the whole image to the screen or, if zoomed in, you can use this to move the image around the screen by dragging the hand with your mouse.

PREVIEW, SHADOWS AND HIGHLIGHTS

At the top right of your screen there are three boxes: "Preview," "Shadows" and "Highlights." I have all three of these ticked. The preview ensures that, as you make changes to the image, those changes are immediately updated. The shadows ensure that any clipped shadows (blacks become pure black retaining no detail) appear as blue. Using the highlights means that any highlights that have been clipped (blown out) are highlighted in red on

the image. This is most useful to alert you to such areas if they already exist, but also to make sure that when making adjustments you don't end up accidentally clipping. Another way to assess where the ultimate shadows and highlights occur is to hold down the "Alt" key for Macs or "Option" key for Windows when moving the sliders – you will see a posterized view, starting from white when moving the "Shadows" slider, and black when using the "Exposure" slider. The same technique can be found within the "Levels" control in Adobe Photoshop proper.

SLIDERS

On the right of your screen there are various controls for adjustments in the form of sliders. You will make most of your basic adjustments to the image with these. "Auto adjustments" is one of the default settings. This will give you ACR's version of what the optimum settings should be. I find this feature very useful as a starting point. When you have this option turned on, you are also viewing the images in Bridge as optimized; if you turn it off, the images in Bridge, and when opened in ACR, will be viewed exactly as they were shot.

COLOR AND TONE

Color and tone are modified by the sliders under the "Adjust" tab. You are likely to do most of your adjusting here and, indeed, the majority of image adjustments will be confined to these tools. The first set of tools controls the white balance, and this is one of the big advantages of shooting in RAW – you can change both color temperature and tint, allowing for a complete change in the mood of the image if you wish. Warm glows can be neutralized or increased simply by moving the "Temperature" slider. There have been times when I have photographed animals in water that appeared blue at the time, but because the automatic white balance recorded the scene a little warmer, the water lost its color and ended up looking muddied. By reducing the temperature a little, blue water can be restored. This is "cooling the image." In summary, by moving the slider left, you introduce a blue cast to your image; by moving it right, you are adding a redder cast.

"Tint" controls both magenta and green color casts – by moving to the right you increase the magenta, to the left

the green. Temperature and tint are also very useful for pepping up your sunset and silhouette images when warm color is wanted. As you can see, the white balance is a very powerful tool.

EXPOSURE

My first adjustment before looking at the white balance is "Exposure." The exposure can be adjusted by four stops either way. However, be warned that these adjustments can damage your final image, and this is why it is important to get exposure right when taking the image. The main problem with an underexposed image, as already discussed in Chapter 2, is the introduction of noise in shadow areas once corrected. If the noise is bad, this can be very distracting in an image (see page 106). If the picture is overexposed to the point where highlights have been clipped, this lost detail cannot be rescued.

By watching the histogram when making adjustments, you will gain a better impression of what is happening to the image. Tall spikes at either end indicate clipping is occurring, which you need to try to avoid.

SHADOWS, BRIGHTNESS AND CONTRAST

"Shadows" is used to set the black point in the image. In other words, it sets how dark you want your darkest pixels to be. I set the "Shadows" slider immediately after adjusting exposure. The "Brightness" slider is used to make the overall image either lighter or darker. It is often useful in lightening an image a little, but I rarely make huge changes with this tool as further adjustments can be made in Adobe Photoshop. I tend to leave "Contrast" alone, making any necessary adjustments in Photoshop using "Curves," but more of that later (see page 116).

SATURATION

Finally we come to "Saturation." I leave this until last, before converting into Photoshop. On some of my images, I tend to increase saturation, but very rarely above 25. If increasing the saturation by much, once you are in Photoshop it is worth doing an out of gamut colors check. Use "Command-Shift-Y" to toggle to see whether you have pushed any colors too far. How much saturation you apply is a very personal choice.

RIGHT I love the wide open spaces and often dramatic landscapes Antarctica has to offer. Add to those spectacular and often very tame wildlife and you have a recipe for taking creative images. Here I tried to convey the awe-inspiring landscape in which emperor penguins live. By using a telephoto lens I have compressed the image so that the penguins, although small in the frame, are not lost against the towering ice cliff behind.

300mm lens, ISO 100, 1/250 second at f/5.6

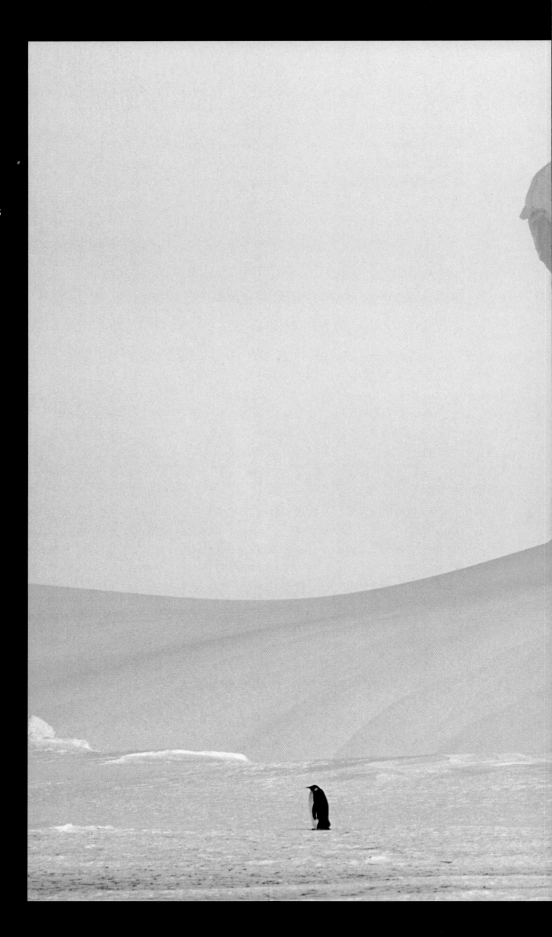

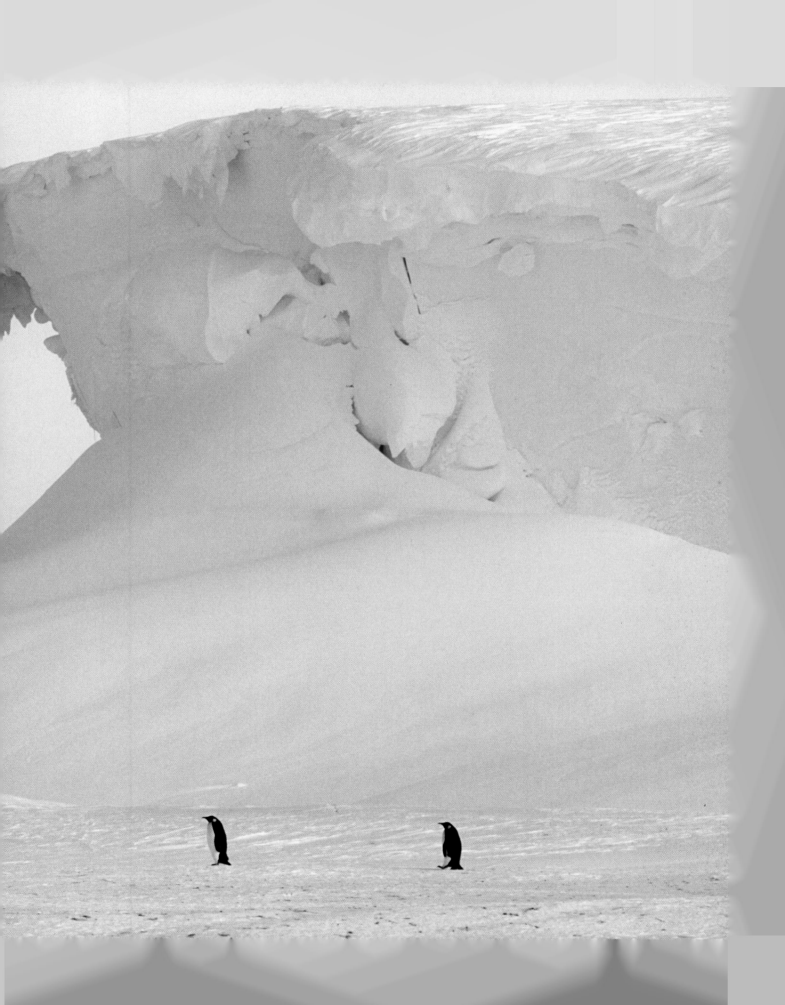

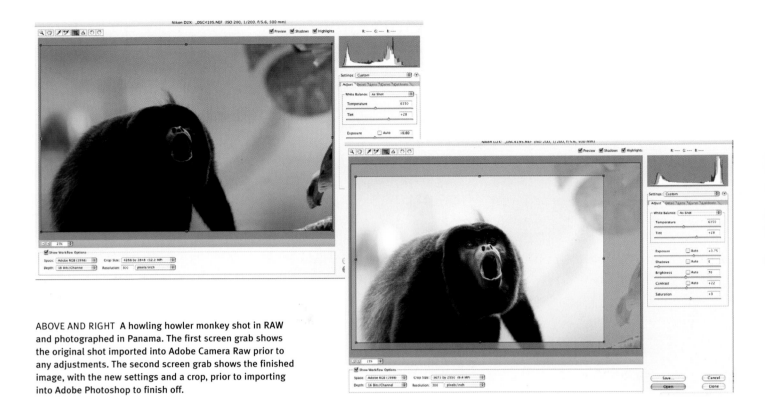

ABOVE AND RIGHT A howling howler monkey shot in RAW and photographed in Panama. The first screen grab shows the original shot imported into Adobe Camera Raw prior to any adjustments. The second screen grab shows the finished image, with the new settings and a crop, prior to importing into Adobe Photoshop to finish off.

The next tab along is "Detail." You can use the "Sharpness" slider to lessen the softening effect some camera chips create. I tend to leave mine on the default setting of 25.

NOISE

Some cameras deal with noise better than others. There are various methods to help reduce noise, including third-party plug-ins (software). ACR offers two sliders under "Detail." The first is "Luminance smoothing." Luminance noise shows as variations in brightness within tones, and by using this slider you can smooth out the effects. Subtle use is required as overall sharpness of the image can be harmed. I always enlarge the image on screen to at least 100 percent when using this tool so I can closely monitor the effect I am having. The second slider is "Color noise reduction" and this does what the label says. Color noise often occurs in darker tones where random colored pixels appear. As with luminance smoothing, it is best to enlarge the image and go easy with any adjustments.

LENS

Next to "Detail" is the "Lens" tab. You may never need to use these controls, depending on your equipment. Chromatic aberration is color fringing that can occur along edges of contrast. This is normally a result of using lenses that are not designed for digital cameras, generally those that are a few years old. Chromatic aberration also occurs with some wide-angle lenses where the problem may be more noticeable toward the edges of the image. The cause is the failure of the lens to focus different wavelengths of light to the same point. The solution is to use these sliders. By holding down the "Alt" key for Macs or the "Option" key for Windows, the color channels are limited, helping you to make the necessary adjustment. As with many other fine adjustments, it is best to magnify the area you are working on to 100 or 200 percent. This is a graduated effect, and so it is also best checked at the edges of the image.

VIGNETTING

Vignetting is the darkening of the corners of an image. This can be caused by filters on wide-angle lenses, using a lens that is not designed for a specific digital camera, or perhaps using the wrong lens hood on a wide-angle lens. Whatever the cause, if you cannot cure the problem by cropping, the two sliders will assist. The "Amount" controls the amount of lightening or darkening to the corners, and the "Midpoint"

is used to set the size of the area being adjusted – the higher the value, the wider the area. You can use vignetting creatively by darkening the corners of an image so that the eye concentrates more on the central point of the image.

CURVE

On to the "Curve" tab. I find this to be one of the more useful tools in ACR, particularly if after making my adjustments under the "Adjust" tab I feel that the image needs less or more contrast. The "Curve" tool gives you three contrast settings on the drop-down menu, or the ability to set your own custom curve. You will find that setting the curve yourself is best, but you may need to experiment on a few images before you feel comfortable. It is important to bear in mind that drastic adjustments can lead to clipping, so keep an eye on this.

CALIBRATE

Finally we come to "Calibrate." This can be left alone unless you find you are consistently getting a color cast on images from your camera. If so, you can set and save this so that it is corrected, without having to correct each image that you work on in ACR. Alternatively, there may be the occasional image where you want to, say, increase the saturation of a color. You can do this under "Calibrate."

SAVE, OPEN AND DONE

At the bottom of your screen, you have the "Save," "Open" and "Done" buttons. The "Save" button saves your adjustments, and converts the image for opening in Adobe Photoshop. A dialogue box appears asking you to choose and name a location for that image. If you do not wish to see this box, simply hold down the "Alt" key when you click "Save." The "Save" choice is fundamentally the opportunity to do batch renaming of files.

The "Open" button applies any adjustments you have made and opens the file in Adobe Photoshop. Once you have made further adjustments, you then have the option of saving the file as a JPEG, TIFF or another format of your choice. The changes you have made to your RAW file are saved, and you can revisit this file at a later date if you wish. The "Done" button applies the changes to the metadata (data about data), but does not open the image.

Adobe Lightroom and Aperture

There are many RAW converters available and different photographers have their favorites. Two worthy of closer inspection are Adobe's Lightroom and Apple's Aperture. While not strict replacements for Adobe Photoshop, both of these applications offer a new way ahead for RAW shooters, and will no doubt evolve to become extremely effective tools for photographers. Each of them is far more than just a RAW file image processing application: they also aim to provide photographers with all the tools needed for cataloging, presenting and printing files.

Aperture is a Mac-only program and it requires a lot of computer processing power. Its strengths lie in its ability to allow you to group and catalog images automatically and to edit images very quickly. In effect it works like a virtual lightbox.

Adobe Lightroom is a cross-platform program and has one advantage over Aperture in that it requires far less processing power. It shares many similar applications, including cataloging and powerful editing applications.

Either one of these programs will provide many photographers with all the tools they need, but other photographers may still want the additional tools that can be found in Photoshop. However, if you currently do no more than edit, optimize and catalog your images, you may wish to take a look at one of these programs.

BATCH PROCESSING

One final point when working with RAW images regards batch processing. This is the ability to identify a number of images that have the same or similar qualities, and to process them altogether at one time, using the same parameters. This is extremely useful if you have a series of images taken at the same time in the same conditions. It will save you a great deal of time and bring consistency to a set of images. Nonetheless, I only ever use this tool when I have a set of images taken together, for instance, of a mammal set up in the studio, or if a number of images need tweaking in a certain way. Although more time-consuming, most of your images are likely to need tweaking individually at some point for the best results.

CHAPTER 7

Basic image adjustments inside Adobe Photoshop

Once your adjustments are made in Adobe Camera Raw (ACR), you can click on "Open," and your image is transferred into Adobe Photoshop. You should have been working in 16 bits if coming from ACR. If so, remain in 16 bits for all your adjustments in Photoshop because of the benefits explained in Chapter 2.

The first thing to state about Photoshop is that it is an extremely powerful program. You will also find as you speak to other Photoshop users that there is always more than one way to do the same job. Books twice the size of this have been written on working in Photoshop but, unless you want to start making composites and complex adjustments, there is much you will never need.

This chapter covers basic Photoshop work that will enhance your images. For tips on using image processing software that comes with cameras, scanners or computers to enhance your photos, see page 125. If you skipped Chapter 6 because you are a JPEG photographer, welcome back. The adjustments I describe in this chapter are equally applicable to either JPEG or RAW files.

RIGHT This lioness, photographed in Kenya's Masai Mara, was beautifully backlit soon after sunrise. I underexposed the image slightly in order not to lose detail in the highlighted areas, then in Photoshop I was able to fine-tune the picture to my liking.

500mm lens, ISO 100,
1/125 second at f/8

Cropping

Your first job is to decide on your composition. If your image needs cropping, and you have not done this in ACR, now is a good time to do so. Use the "Crop" tool for this. If you wish to keep specific dimensions, such as 8 x 10 inches, you can enter your chosen values in the "Options" bar at the top of the screen. Otherwise, just crop to the dimensions you wish visually by dragging the "Crop" tool across the screen. This same tool can be used to straighten the picture if needed. Perhaps your tiger or lion is looking like it is running downhill – by cropping the image and then using the arrowed cursor, you can tilt the image back to the horizontal.

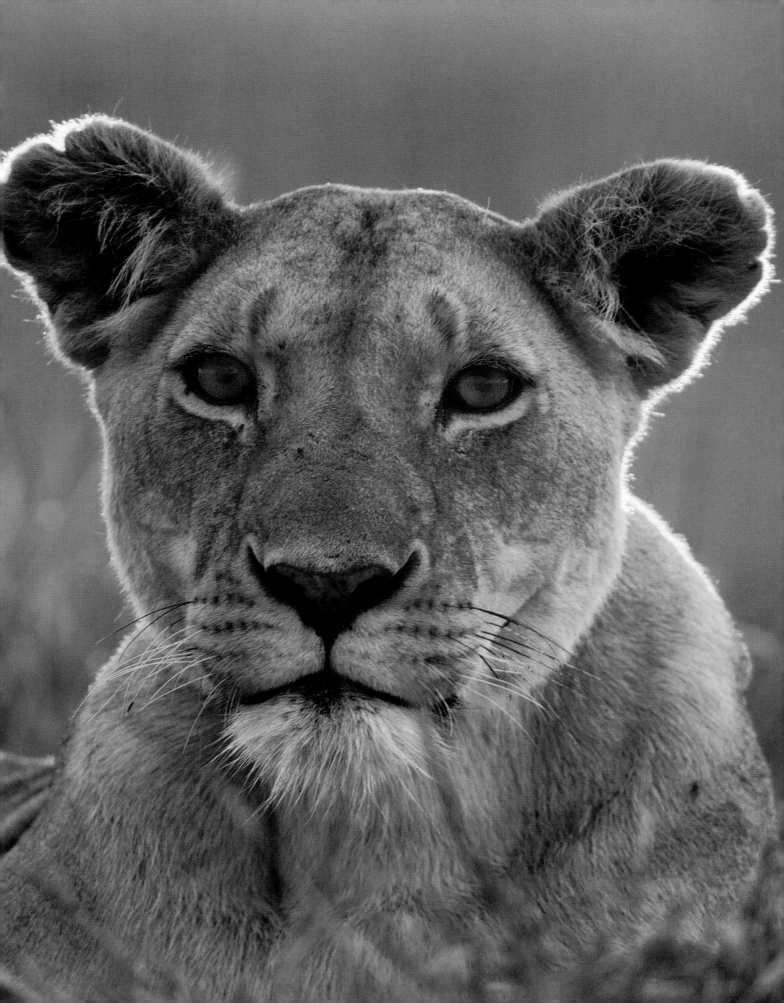

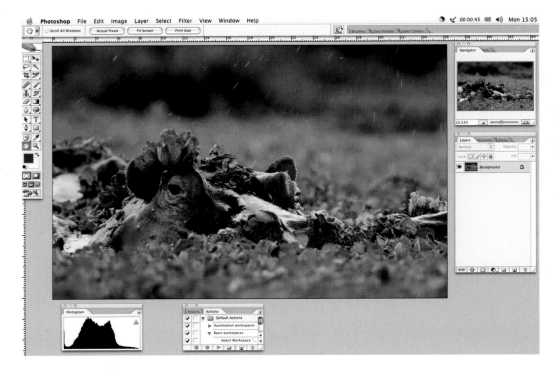

Cleaning

Whether dealing with a digital image taken in camera or one scanned from a transparency or print, the chances are that it will need cleaning. Dust is a big enemy of the digital photographer, and it can be a particular problem when shooting in dusty environments. Sensors with their static charge attract dust particles easily. Although constant cleaning will keep the problem in check, you are bound to have images spotted with particles that need to be removed.

ABOVE **In Adobe Photoshop, the palettes to the right and below the image can be positioned according to your own taste. Just about everything in Photoshop can be customized. As you work in and familiarize yourself with the program, you will gradually pick up new tricks and discover different and better ways of working.**

Hippo, 500mm lens, 1/250 second at f/11

This simple retouching can be done by one of three different tools: "Clone stamp," "Healing brush" and, in CS2, "Spot healing brush" and "Patch." In the drop-down menu under "Brush" in the "Options" bar, you will see a measurement for hardness for all these tools. Generally, the more detailed the area to be cloned, the harder the brush should be. For areas with little textural detail, such as sky, a low level of hardness is required. However, avoid making the healing brush tools soft as this prevents the healing function. Setting parameters such as these comes with experience, and you will soon master what is an easy operation. To use these tools and to be able to effectively check for dust, you need to systematically work your way across the image while zoomed in and working at 100 percent magnification (to do this, double-click on the

"Zoom" tool). To return to the standard screen, simply double-click on the "Hand" tool. The brushes for all of these tools can be resized quickly by using the square bracket tools on your keyboard.

CLONE STAMP

The "Clone stamp" works by copying the pixels you specify in one place and stamping them over the spot you want eliminated. This is not only good for eliminating dust spots, but also for tidying up background, for example, an annoying out-of-focus bird in the background or a distracting twig. Such things are relatively easy to remove, and once gone can make a big difference to the image. You may need to practice a little with this tool as you need to clone areas sympathetically to the surroundings to avoid any telltale round blobs of

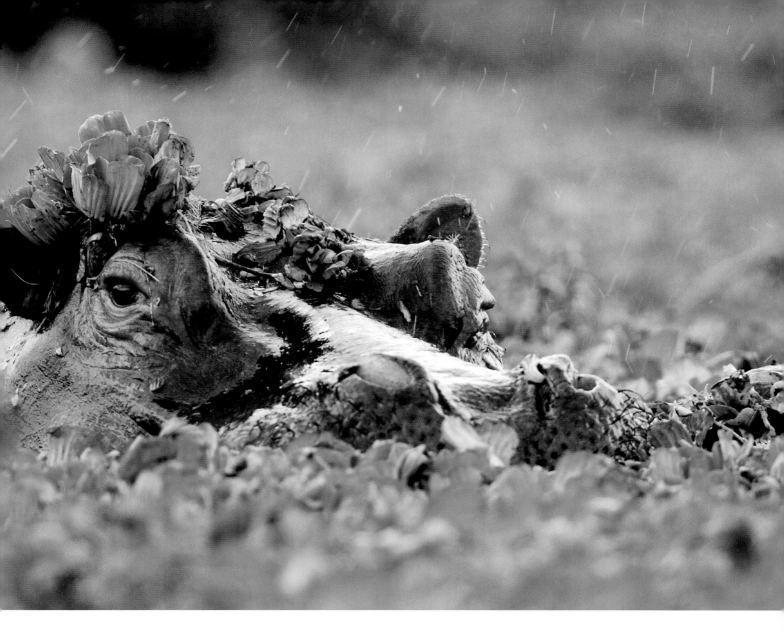

obviously different pixels. Keep moving the sampling point to avoid nasty repetitions or "herringbone" effects.

The clone brush area is defined by the brush shape, and defaults to a circle. It is controlled on the "Options" bar by clicking on brush and choosing the circumference (number of pixels) you wish to clone in each stroke. To use the "Clone stamp," you simply place the cursor over the area you wish to clone and then hold down the "Alt" key for Macs or "Option" key for Windows. This samples the area, and you then move the cursor to the area to be replaced and click.

HEALING BRUSH AND SPOT HEALING BRUSH
The "Healing brush" is operated in exactly the same way as the clone stamp. The difference is that the healing brush copies the texture of the source, and could be considered as the smart version of the clone stamp. The latter is often still the better option in areas where there are sharply contrasting edges. The "Spot healing brush" in CS2 is even easier to use – no sampling is needed. Place the cursor over the area to be replaced and click; this is a great tool for quickly cleaning spots from areas of sky and water.

PATCH
The final tool in this series is "Patch," found under the "Healing brush." This is great for healing larger areas, and can be very useful for repairing butterfly wings, for example. If the insect has one good wing and one damaged wing, by selecting "Source" in the "Options" bar, a simple selection of the bad one dropped over the good one will fix the problem.

Exposure adjustments

ADJUSTMENT LAYERS

We now come to making exposure adjustments. When making these you should work in "Adjustment layers." Adjustment layers are, in effect, filters placed over your image, each with instructions you have given to change the appearance of the picture's pixels. However, the pixels are not physically altered until you come to flatten the file (remove the layers) at the end of your adjusting. To flatten an image after using layers go to the "Layer" drop-down menu, where you will have found the layer commands, scroll down to the bottom and simply click on "Flatten Image." If you work without "Adjustment layers," each time you make an adjustment you physically alter the pixels and so damage them, losing some quality. This becomes more and more relevant the more adjustments you make. Consequently, by using layers, rather than making many alterations to the pixels,

you make just one alteration at the end. Coupled to this is the flexibility that layers bring; layers have the added advantage that you can go back and modify a layer without having any destructive effect on your image.

To use "Adjustment layers" ensure you have the "Layers" palette visible, and click on "New adjustment layer" under "Layers." Many of these allow individual access to the color channels of your image for added control. You can return to these settings time and again without accumulating damage to the quality of your image.

LEVELS

The "Levels" tool allows tonal adjustments by enhancing contrast and adjusting brightness, which helps to bring out the detail and texture in your subject.

"Levels" is often the first port of call for image optimization when entering Adobe Photoshop, especially if you are shooting JPEGs. If you have worked on an image in RAW, the likelihood is that you may not need to do anything in "Levels." You will be confronted with a histogram when entering and, as with the histogram on the back of your camera, it shows the distribution of pixels across the tonal range from black (shadows) on the left to white (highlights) on the right. The vertical axis shows the number of pixels in each tone.

Reading the histogram is simple. For instance, if the majority of the pixels are on the right, the picture will have a lot of light areas, perhaps snow, or be overexposed; equally, if the majority of the pixels are to the left, the picture may be underexposed or simply contain a lot of dark tones. A histogram that looks like a nice, rounded hill sitting in the middle represents a well-exposed scene with many midtones, but no great highlight or shadow areas, and so it might lack sparkle. A series of small hills across the histogram is likely to represent an image with more contrast, and so sparkle. The thing to remember here is that no two histograms are alike; the histogram is simply a tool illustrating where the pixels in an image are distributed.

ABOVE The "Adjustment layers" menu. With an image, if all you intend on doing is an adjustment in "Levels" and other minor changes, it is not so necessary to work in layers. The big advantage with layers is when making more complex adjustments — being able to go back and delete that layer and start again without affecting the image. When working in layers, the adjustments are physically made to the pixels when the layers are flattened. When making individual adjustments outside of layers, the pixels are altered each time you hit the "OK" button. This is fine unless you start going back and redoing adjustments, and then the cumulative effect can begin to degrade image quality.

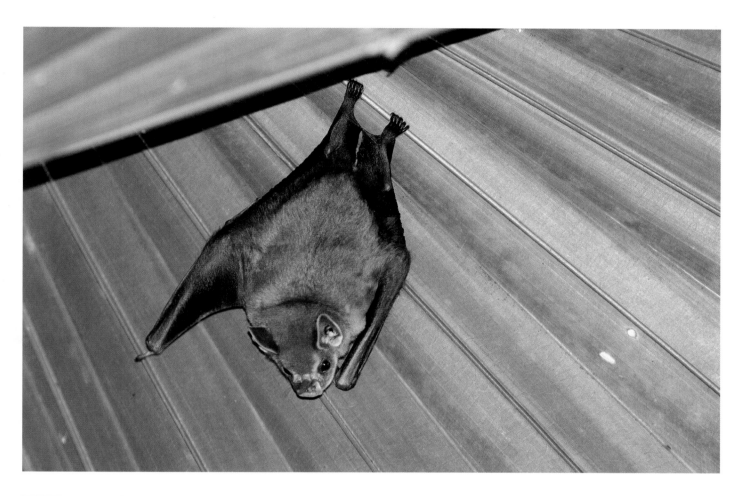

LEFT AND ABOVE The "Levels" palette. This histogram represents a mainly midtone scene (tent-making bat) with no major highlight or shadow areas. The pixels stretch right across the histogram, so there is no work to do with the outer sliders.

To make adjustments, you use the three sliders below the histogram. You will notice that some of your pictures will look flat, lacking any contrast, and this is where you can make a difference with levels. Your aim is to have the brightest pixel value set to white and the darkest pixel value set to black. This will maximize your tonal range and optimize contrast. To do this, drag the sliders at each end to the start of the histogram on either side. You can do this accurately by holding down the "Alt" key for Macs or "Option" key for Windows. The screen will go black for shadows and white for highlights. When you drag the sliders in, you will see the first indications of clipping. As soon as you start to see this, stop, because the adjustment is done for that end. The middle (gamma) slider allows you to brighten or darken the image. The image should now be optimized, with the histogram expanded to resemble a mountain range stretching across almost the full width of the chart. With the "Input" histogram, moving either end triangle will increase contrast, with the "Gamma" or central pointer of the "Input" slider acting like a fulcrum, or pivot of a seesaw, tipping the distribution either toward the highlights or shadows.

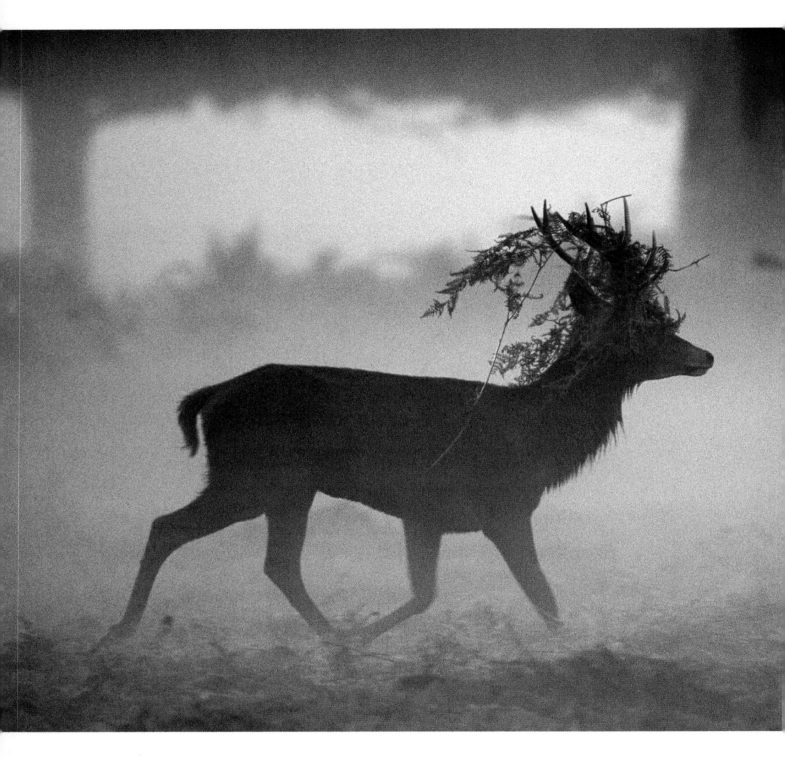

A histogram can alert you to the two key things to avoid. The first is clipping which, as discussed earlier (see Chapter 2), is when tonal information has been lost, either in the highlights or shadows, or both. This is illustrated by the histogram being cut off at either end. If this cut is abrupt, in other words, the histogram looks like it has been chopped, this may mean that some important tonal information is lost, and that your exposure was badly wrong. If, however, the clipping is shown in the form of a thin spike, this may represent a specular highlight such as water reflections, the sun or a similar bright or highly reflective object. This is not a problem as you would not expect to retain detail in such areas. Equally, you might have a picture of an owl or other animal against a deep

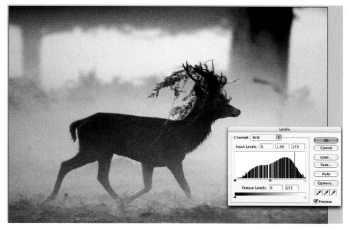

ABOVE AND LEFT This image of a red deer stag at dawn has been worked on in 8-bit and adjusted with the "Brightness/Contrast" tool. The resulting histogram shows combing, which is the loss of tonal information through the image; the gaps denote where pixels once were. This histogram indicates that there have been either heavy-handed or simply too many adjustments made to the image file. While this image may still print acceptably, any more combing than shown here would result in a significant and discernible reduction in the quality in a print.

The second key thing to avoid is combing. This is when gaps appear in the histogram, as shown in the illustration. This is far more common when working with 8-bit images as opposed to 16-bit images because it illustrates the removal of tonal information resulting from major adjustments being made in Adobe Photoshop. With 16-bit images, there are far more tonal values, some 32,768 possible levels in each channel compared to just 256 in 8-bit images. Therefore, in 16 bits there is less risk of this happening. These gaps, if plentiful and wide, will result in posterization – the stepping effect between colors – that is, a lack of smooth gradations between tones. A few small gaps may not represent a problem as these may not be visible on your final output. This is another reason why it is good to shoot in RAW – by converting an 8-bit JPEG to 16 bits there is no advantage (see Chapter 2).

Combing can also be caused by using the "Brightness/Contrast" tool under "Adjustment layers." This tool is worth avoiding because the adjustments it makes lack subtlety.

Finally, while looking at Levels, you can use the palette to adjust color balance. By selecting color channels separately from the drop-down menu and then dragging the middle slider to the left or right, you can change the overall color balance of your image.

black sky. The likelihood is that you want to keep the deep black as a feature of the picture, even though the image might look badly clipped on the histogram. It all depends upon the image as to whether there is a problem or not. Clipping can also be a result of heavy handed adjustments to contrast and other controls – when making adjustments, always keep an eye on the histogram.

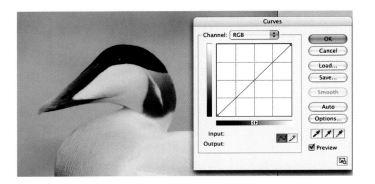

RIGHT The subtle colors of this male eider's plumage attracted my attention so I closed in to take this head and shoulders portrait. I used a shallow depth of field to retain a pleasing out-of-focus blue wash (the sea) as a background.

500mm lens, ISO 100, 1/500 second at f/4

ABOVE "Curves" is perhaps the most powerful tool in the box when it comes to image adjustments. This first screen grab shows the "Curves" palette overlaid on an image of a common eider.

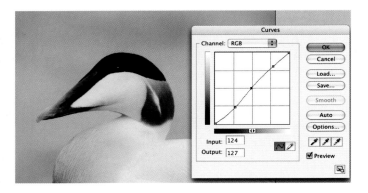

ABOVE I have increased contrast, creating a shallow "S" curve. This shape of curve is most typical when midtone contrast is increased. When exploring what you can do in "Curves," simply play around, make dramatic movements with the curve, and try plotting different anchor points and playing with different parts of the curve. This will help you to master the subtle adjustments needed for some images. "Curves" will do everything, and more, that "Levels" can; one of the advantages of "Curves" is the ability to apply anchor points — pegging some tonal values while adjusting others.

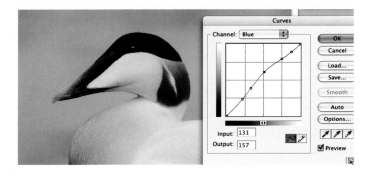

ABOVE By making "Curves" adjustments in individual color channels, you can target and adjust specific areas of your image. With this eider I wanted to restore the very pink breast and the blue sea background from the muted colors on the original. I have done this by making an adjustment in the blue channel, as shown in the screen grab.

CURVES

Staying with the tools under "Adjustment layers," we come to "Curves." Many people find "Curves" tricky to master, but it is one of the most powerful adjustment tools at your disposal and worth persevering with. As in "Levels," brightness and contrast can be adjusted in "Curves" but with far more finesse; "Curves" allows

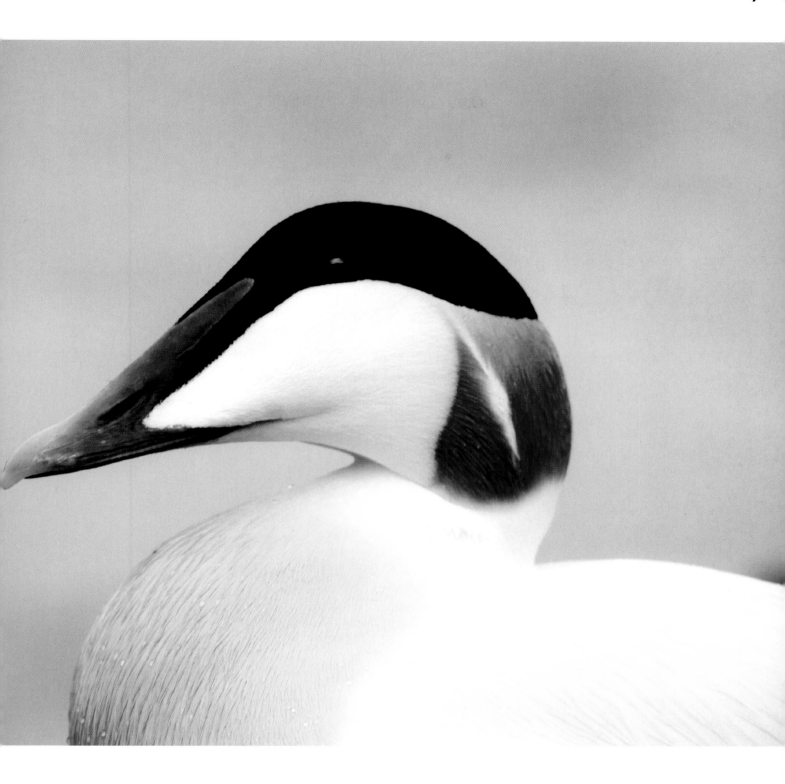

adjustments to individual tonal values. When opening "Curves," you are presented with a graph with a grid, and the curve, which is presented as a straight line at default. The highlight point of the curve sits at the top, the shadow point at the bottom. You can move the top and bottom of the curve individually to set your shadow and highlight points. Once this is done, you can place holding points down the curve to limit the effect on more local areas, and adjust accordingly. The curve represents the range of tones in the image. To adjust the brighter tone, you need to move the curve toward the top of the graph; while the dark tones are toward the bottom.

SHADOWS AND HIGHLIGHTS

Finally, we come to the "Shadows and highlights" tool. This tool does much of what can be done in "Curves," but it is easier to use. Wildlife photographers find this tool extremely useful; it helps to bring out detail in shadow and highlight areas. However, take care when using this tool – overdoing corrections can have a destructive effect, producing nasty haloes or an image that looks very flat overall.

You access "Shadows and highlights" by going to "Image," then "Adjustments." You will notice there is no adjustment layer for the tool. This is because it is looking at adjacent pixels to make its adjustments. Consequently, you should create a layer to work in. You can do this by duplicating your background layer. Go to the "Layers" palette and click on the thumbnail of the image, dragging it down to the "New layer" button at the bottom of the palette. Now you have the duplicate image layer active.

To maximize "Shadows and highlights," click on the "Show more options" box, which gives additional sliders to help control your adjustment. The top slider allows tonal adjustment of the shadows, and is really useful for bringing out detail hidden by shadow. The next slider down is tonal width, which allows a targeting of the adjustment—the lower the setting, the darker the tones affected by the adjustment above. The radius increases the distribution of the effect; in other words, it sets the radius around each pixel sampled. Experimentation is needed with this to find the optimum setting.

These sliders are repeated for the highlights. Below this are two adjustment sliders, first "Color correction." When shadows and highlights are adjusted in a picture, you can notice a change in color saturation, and the "Color correction" slider allows you to increase or decrease your color saturation once your shadow and highlight adjustments have been made. Second, "Mid tone contrast," controls just that, the contrast in the midtones of your image. Adjusting shadows and highlights can render the image a little flat, and "Mid tone contrast" can be used to restore contrast.

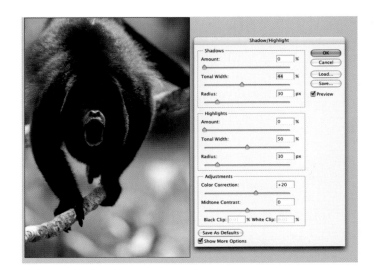

ABOVE AND BELOW The "Shadows and highlights" tool can save a lot of fiddling in "Curves" when you are looking for a quick fix for a picture that is suffering from detail being lost in shadow or highlight areas. Here we have a howler Monkey taken against the light; the original image has the monkey's face in heavy shadow, but you can see from the second screen grab how "Shadows and highlights" has helped to take this away.

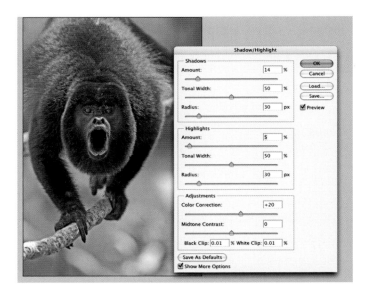

Image processor

One final automation function found both in Bridge and Adobe Photoshop CS2 is the "Image Processor," which can save you lots of time. To find it in Photoshop go to "File," "Scripts," then "Image Processor." It is found in Bridge by going to "Tools," then to Photoshop. The "Image Processor" allows you to convert a batch of files from one type to another and to resize them. For example, you can convert a batch of RAW files to TIFFs, or TIFFs to

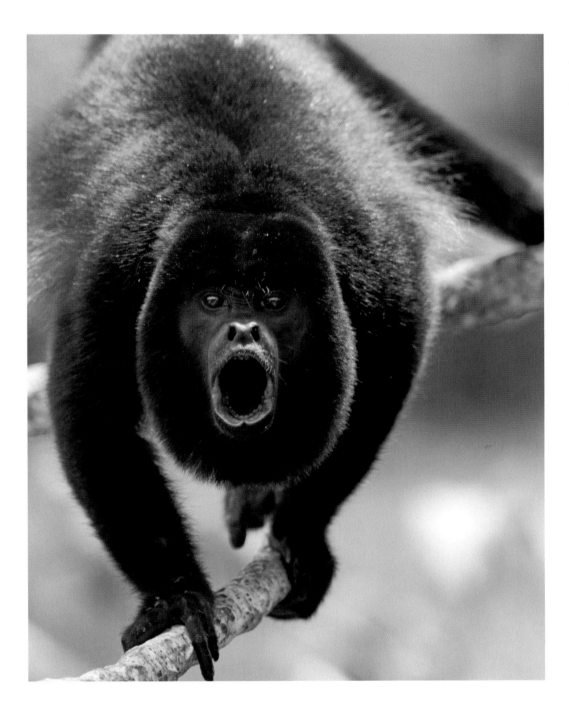

LEFT A male howler monkey projects his spine chilling howl from the top of a secropia tree from deep inside a Panamanian rainforest. While many good wildlife images are the product of much patience and planning, there are times when opportunities present themselves at unexpected moments; this was one such spontaneous moment when, returning to the Canopy Tower Lodge in Soberiana National Park for lunch one day, a troop of howlers had taken up residence outside the dining room, and the male was in full voice. I seized the moment. I learned a valuable lesson a long time ago to grab every opportunity that comes my way. It can be easy at inconvenient moments to tell yourself an opportunity will come around again, and I could have settled down to lunch and foregone obtaining this image. But I'm very glad I didn't on this occasion as the monkeys never came back within range of my lens for the rest of my stay.

500mm lens, ISO 100,
1/800 second at f/8

JPEGs, and you can choose in which folder you wish to store the files. This tool is very useful when I want to convert a batch of worked-on images saved as TIFFs to small JPEG files to send to my stock agents to view, or for putting on my website. With the latter, I can convert the profile from Adobe RGB (1998) to sRGB; this color space ensures images have a better chance of looking right when viewed outside Photoshop on the web.

The above sections have provided a review of the basic image adjustment tools you will want to use when enhancing your digital images. I rarely use any others in my workflow, but you may find you want to do more than just make basic adjustments. Such work is beyond the scope of this book, but if you would like to learn more there are many published books devoted solely to working in Adobe Photoshop.

RIGHT Two male black grouse spar at a lek (display site) on a frozen bog in Finland in early spring. This shot took a lot of hard work and planning. A blind was introduced to this traditional lek a few weeks before lekking commenced, so the birds were used to this intrusion in an otherwise barren, snow-covered bog. Many mornings in the blind in subzero temperatures were then needed to secure the shot. The males regularly spar and occasionally launch into a full assault, but the fighting is normally over within a second or two, so quick reactions are needed to catch a good photo.

300mm lens, ISO 200, 1/1250 second at f.2.8

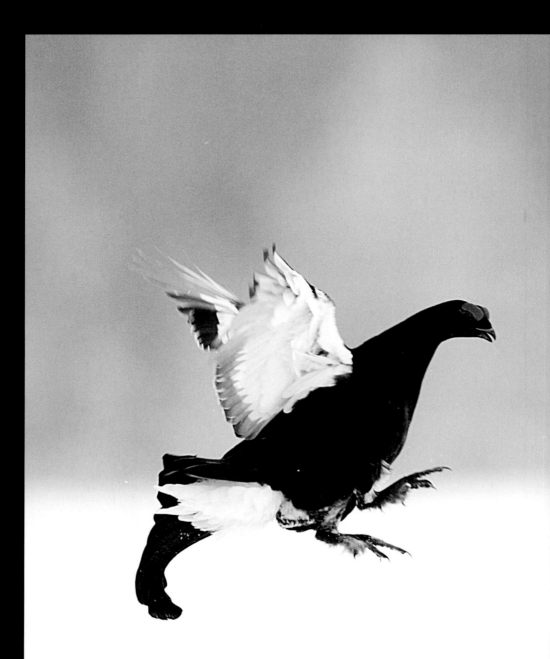

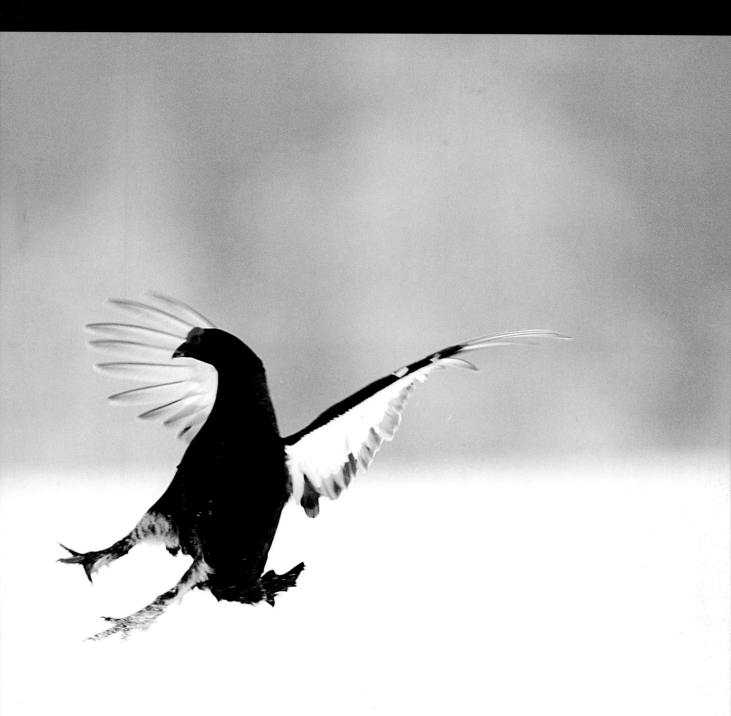

Interpolation

There will be occasions when you need to increase your file size, perhaps to make a big print enlargement. This is known as "interpolation." If you know that a larger size is needed when shooting RAW, then this upsizing is best done in ACR. If not, to change image size go to "Image size" under "Image." At the bottom there are three boxes that need to be checked. The "Constrain proportions" box ensures the aspect ratio for the image is retained. The "Resample image" allows Photoshop to resize the image by changing the number of pixels. Next to this is a drop-down menu that lists the algorithms used to either interpolate or reduce image size. "Nearest neighbor and bilinear" can be ignored. For interpolating an image up in size, "Bicubic smoother" is the one to go for; if reducing the size of an image, I use "Bicubic sharper." There are third-party applications that you can use for interpolating images, and one of the most popular is Genuine Fractals. However, I have conducted various tests between third-party applications and Adobe Photoshop, and certainly with the latest version of Photoshop (CS2 at the time of writing) I can see no advantage.

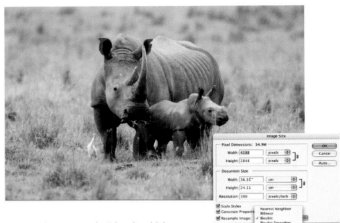

ABOVE The "Image size" box in which you can enlarge (interpolate) or reduce the size of your picture. The screen grab shows the drop-down menu of algorithm options for resizing.

Above are the pixel dimension and document size values. In either box you can apply the new values needed for your proposed output. Changing the value in one box automatically adjusts the sizes in the others.

Once all your adjustments are complete, if you have been working in 16-bit, convert back to 8-bit. This saves on the space needed to store the image, and 8-bit images are currently the size used for output to print.

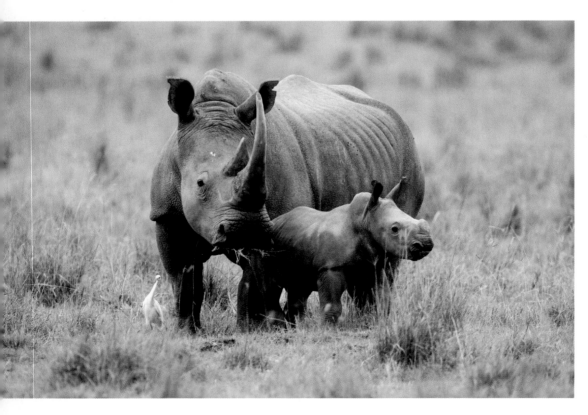

LEFT A white rhino and calf at Kenya's Lake Nakuru, with a cattle egret feeding around the feet of the rhino.

500mm lens, ISO 100,
1/250 second at f/4

Sharpening the image

Now you can sharpen the image. Sharpness is very subjective. A high-contrast image will look sharper than one with low contrast, and how much you sharpen depends upon the picture and on your judgment. Sharpening should be the very last thing you do in the workflow. I always keep my worked-on TIFFs unsharpened because different applications dictate different levels of sharpening. If you sell your images through stock agencies or you send them to clients who may want to interpolate (increase file size), you should not sharpen at all. Only when I have resized my file for the use it is intended, and converted it to 8-bit from the 16-bit file I was working in, do I sharpen.

UNSHARP MASK

Adobe Photoshop has two tools for sharpening, the most commonly used is "Unsharp mask," and it is reached by clicking on "Filter" then "Sharpen." The percentage amount determines how much contrast is enhanced along edges. I rarely, if ever, exceed 200 percent. The radius affects the area affected by the boost in contrast; I rarely go above 3.0. The more contrast the image has, generally the lower the radius should be. The threshold measures the contrast between pixels – the lower the threshold, the more areas are sharpened; go higher and less sharpening is apparent. You need to play around with these sliders to gain the ideal effect.

SMART SHARPEN

Just above "Unsharp mask" is our second option, "Smart sharpen." This gives the option of sharpening highlights and shadows separately. It is extremely useful if, for instance, you want to avoid sharpening shadow areas with lots of noise. An added benefit of "Smart sharpen" is the avoidance of nasty highlight haloes when you have twiggy tree branches against a bright blue sky. One advantage of "Smart sharpen" over "Unsharp mask" is the "Blur removal" settings. Removal of "Gaussian blur" gives similar results to "Unsharp mask," but "Lens blur" is the one I use most, giving the best effect for detail within the image. The third, "Motion blur," compensates to some degree for blur created by motion.

LEFT Sharpening using "Unsharp mask." Every subject is likely to need different levels of sharpening. This yellow-winged bat photographed in Kenya required more sharpening than most of my images in order to give the fine fur on the bat some definition. Like so much in Adobe Photoshop, experiment until you get the result that pleases you, but if you intend on sharpening for printing or for publication, what looks satisfactory on your screen may not once printed. Gaining experience where sharpening is concerned is a great asset.

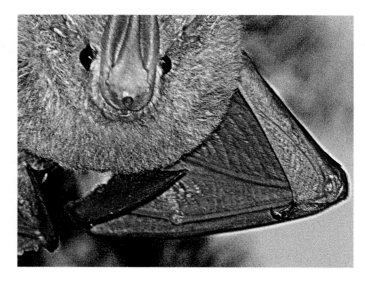

ABOVE If you oversharpen, nasty haloes can appear, as here along the edge of this bat's wing.

EYES

An animal's eyes are often the focal point of a picture. If the eyes are not sharp or clearly defined, the image can lose impact, and we as the viewer can feel detached from the subject.

Using some simple techniques, I have developed a few tricks to help define eyes in my pictures more clearly. Some animals have their eyes recessed, causing shadow areas around the sockets, or they have such small eyes that they can be a little indistinct. Placing simple catch-lights will immediately enhance this look. This can be done either by using the "Clone stamp" and sampling a light area to place a small spot of light in the eye, or an alternative, and often a more subtle, method is to use the "Dodge" tool. With "Dodge," you can pick up any lightness in the eye, and this can be subtly expanded by careful use of this tool. This can look far less obvious than using the "Clone stamp." The "Clone stamp" can eradicate red-eye

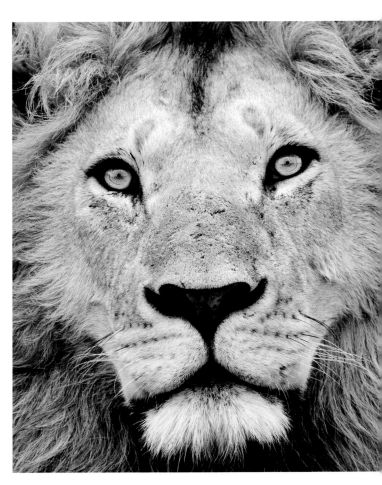

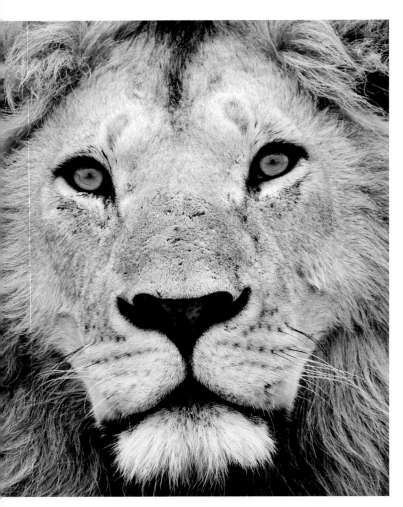

Eyes are a big part of any portrait of an animal. This lion's eyes (LEFT), although of a wild individual photographed in Africa, seemed a little lifeless compared to some I have seen. So putting my eye doctor's hat on, I enhanced them for the second image (ABOVE), which in my opinion is a big improvement. I did this by selecting each eye and applying some brightness and contrast using a "Curves" adjustment, followed by some selective sharpening.

or silver-eye, unwanted flash effects discussed in Chapter 2. If you suffer from red-eye, then a tool in Adobe Photoshop CS2 under the "Healing brush" called the "Red eye tool" provides an immediate fix.

A little selective sharpening of eyes is another way to draw attention to them. This can be done by only selecting the area you wish to sharpen by using the "Lasso" or "Magnetic lasso" tools, and by using "Unsharp mask;" you may want to experiment with the degree of sharpening applied.

Finally, try saturating the color of the retina for some animals. By selecting the area with the "Magnetic lasso" tool, a little saturation can really add impact.

Captioning

In the same way that you labelled your old transparency mounts or scribbled on the back of prints, you will want to label your digital files with subject name and location. If you are selling your work, you also need to add your name and any credit and copyright information.

You can do this by adding metadata to your image. "Metadata" is simply another word for data about data, and this can be attached to the file by way of the "File info" box found under "File" in Adobe Photoshop. Once you enter the box, you will see a straightforward template as shown above. Once saved, this information will travel with the file whenever it is copied.

Image enhancement on a budget

If you don't want to buy Adobe Photoshop and simply want to use the image processing software that came with your digital camera, scanner or computer, the pre-supplied, easy-to-use programs all have the same basic tools to help enhance an image. If you go down this route, you are likely to be shooting in the JPEG format.

The first thing to do is to use the crop tool provided and crop the picture to your taste. Many of the software programs on cameras exclude tools, such as levels and curves, and have basic slider controls, such as brightness,

ABOVE The "File info" box, in which you can add your details and title of the image, along with keywords and your copyright information. If you send out your work for publication, it is important to attach such metadata to your file so that you can be identified as the owner once it is on someone else's computer. Files that contain no data and become lost from their owner as a result are referred to as "orphan files."

contrast, color booster or saturation. These are simple to use — just make the adjustments on screen as you see fit. An image taken in poor light can be vastly improved by adding brightness and a little color saturation. Pictures taken in flat light will respond well to adding contrast. Most of the software programs have an auto adjust feature where the software assesses the picture and makes all the adjustments automatically. These can be surprisingly good, and it is worth experimenting if you have this option. However, I would always favor adjusting sliders individually for a more precise result.

Once you have optimized your image, you may want to label it and perhaps, if the program allows, add keywords. By adding keywords or titles to your picture, you can then search for images quickly and efficiently at a later date if your software offers a search option.

While such software will do the job, if you really want to get the best out of your equipment, there is no substitute for using Adobe Photoshop, or other programs with more advanced tools, because your control over the final image will be far greater.

CHAPTER 8

Storage and backup

If you are not prepared, after a very short time of shooting digitally you will start clogging your computer with hundreds of image files. Finding a particular image can then become a nightmare. How you store and catalogue your files is personal to you, and there are any number of ways of doing so. If you decide not to develop your own system, there are also good database software packages available.

I have outlined below, in simple steps, how I file images. This works well for me, but I am always on the lookout for ideas to refine my system.

1 Once I have identified the images I wish to keep and optimize in Adobe Camera Raw (ACR), I renumber them with a reference that fits my filing system. This typically includes two digits for the year, for example, an image shot in 2006 will have the first two digits as 06, followed by a sequential number: 063124.NEF. When this image is processed in ACR it will, when finished, end up with the TIFF suffix. Consequently, I will have the two identical images in my system with the same number but different suffixes. However, beware if you are a Microsoft Windows user. In Windows, suffixes are hidden by defaults, and you will see two identical file names!

2 Once my TIFF is produced, I then file both this and the RAW file in two different folders. If I am dealing with an image of an emperor penguin, say, the TIFF will go in the "Emperor Penguin" folder and the RAW will go in a folder entitled "Emperor Penguin RAW."

3 The two TIFF and RAW folders are both kept in another folder entitled "Penguins," and the "Penguins" folder is placed in my main "Birds" folder. I have master folders for "Mammals," "Flowers," "Landscapes" and a whole range of other categories. Within these, the subjects are broken down into folders for family and then species, etc. When looking for images of emperor penguins, I click on "Birds" then "Penguins" then "Emperor Penguins," and to quickly view them I browse the images in Adobe Photoshop's file browser, Bridge.

The above system is very straightforward and allows me to find my images quickly. I store the images not on my computer's hard drive, but on peripheral hard drives that connect to the computer. All my images, both RAW and TIFFs, are copied to three different hard drives, in the event of failure.

RIGHT You want to ensure that your most treasured images — your family jewels — are as safe as you can make them. Hard drives often give no warning of impending failure, rather like light bulbs, and so backing up your images to some form of storage media, such as DVDs or on another hard drive, will avoid a catastrophe. This leopard was photographed in Samburu in Kenya early one morning.

600mm lens, ISO 100,
1/250 second at f/11

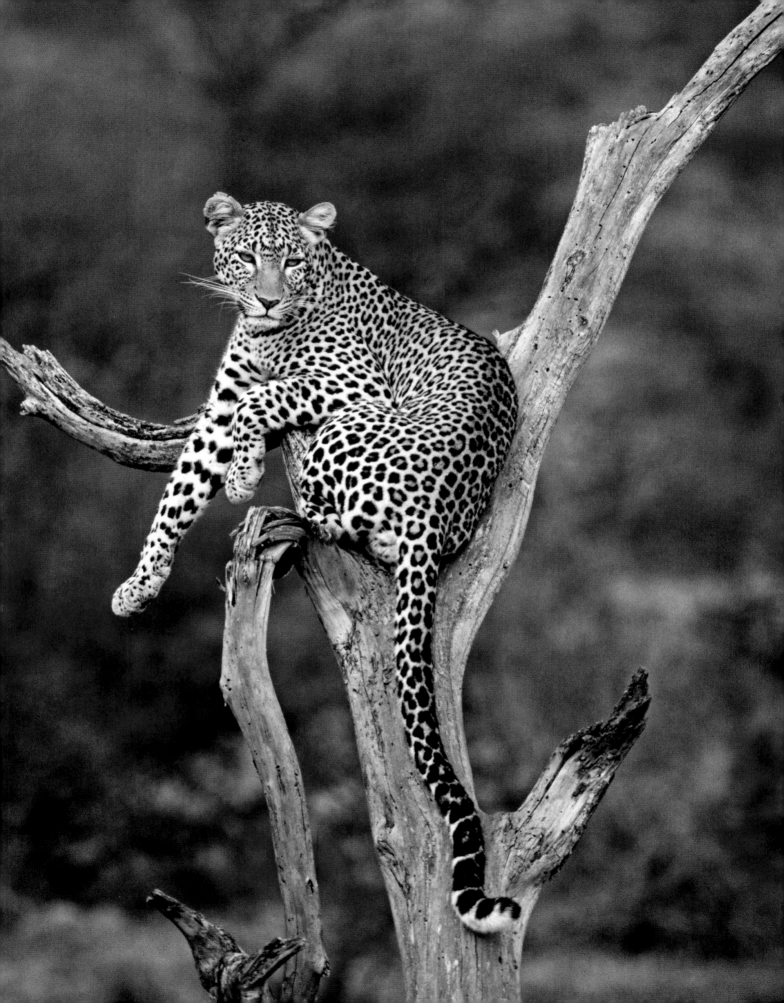

Hard drives are like light bulbs, and can fail when you least expect it. You can set up your hard drives so that they save new data automatically without overwriting previously saved images.

RAID (Redundant Array of Independent Discs) arrays are becoming increasingly popular as a backup solution. A RAID consists of at least two or more hard drives, and each time you save an image it is saved to two or more of these drives.

RAID zero is the most common and it is touted for its speed. Nevertheless, lose either one of the drives and all is lost. RAID 5 is where you get both speed and safety. Only in this configuration would I suggest its use for storage, but it is an expensive option.

Backup to DVDs or CDs is another option, but these can easily stop working, and longevity has never been proved. CDs and DVDs have a layer of dye sandwiched between polycarbonate discs, and a laser "burns" data into the layer of dye. Discs with poor reflective properties in their dyes are the ones that CD and DVD players can struggle to read after a while. Longevity is now being helped by some manufacturers using gold in their dyes. The gold does not degrade very quickly and is reflective, so helping the disc to be read. Some of these discs now have life-expectancy claims of beyond 200 years. If you go down the disc route, don't buy cheap, unknown brands – spend some money and buy those with the best reputations.

Backup is of course vital to prevent potential loss of images, and how you do it and which system you opt for is again down to personal choice. Yet, whatever you do, do something. Without back-up, if your computer hard drive does crash, you might find that your pictures are lost forever.

RIGHT You can spend much money and time accumulating wonderful images, and so spending a little extra to make sure that your work is properly backed up is money well spent. This three-toed sloth was encountered along the side of a road in Panama.

500mm lens, ISO 320, 1/125 second at f/4

LEFT External or peripheral hard drives are a good storage solution, allowing the storage of many images in one place, and providing an easy backup solution.

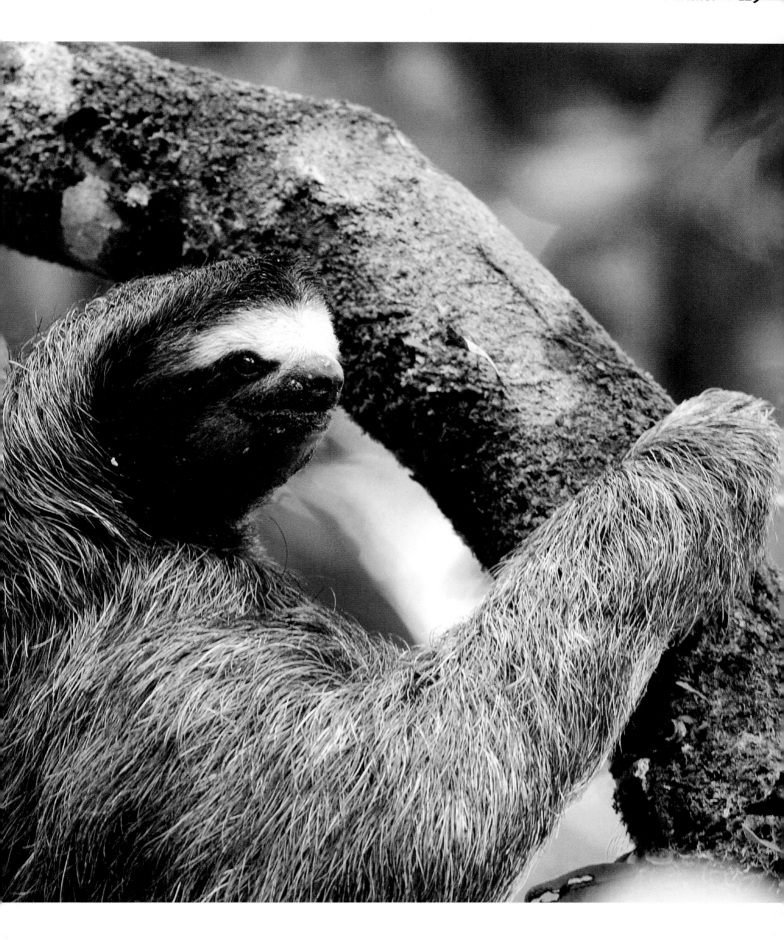

RIGHT A flock of red-breasted and a few white-fronted geese photographed on their wintering grounds in Bulgaria. Moments before this image was taken it had been a very gray day with little light, as this flock banked around in front of me the sun poked through the clouds illuminating the birds beautifully. The flock numbered around 3,000 birds. Even when photographing part of large concentrations of birds and animals, composition still needs to be considered. I took many images of this flock in flight but only a few were acceptable due to varying densities of birds.

500mm lens with 1.7x teleconverter, ISO 400, 1/1000 second at f/11

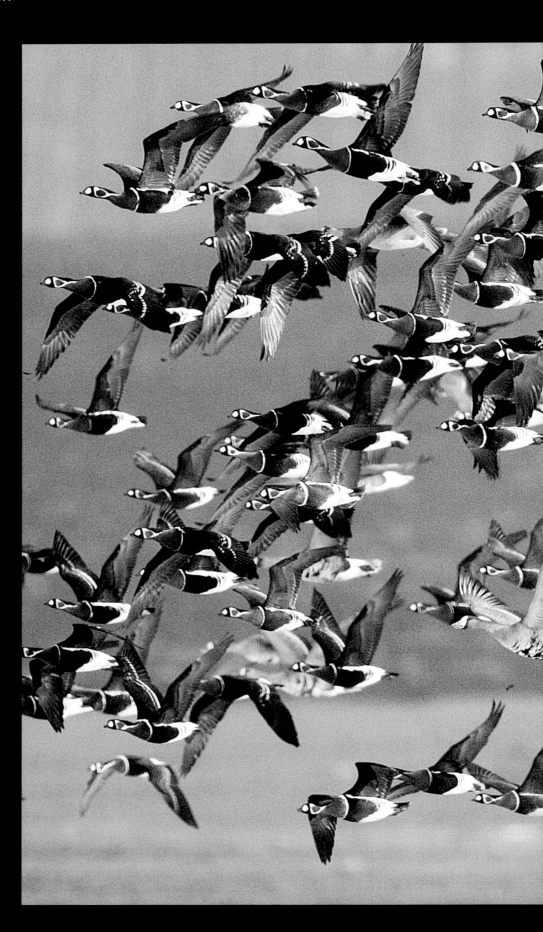

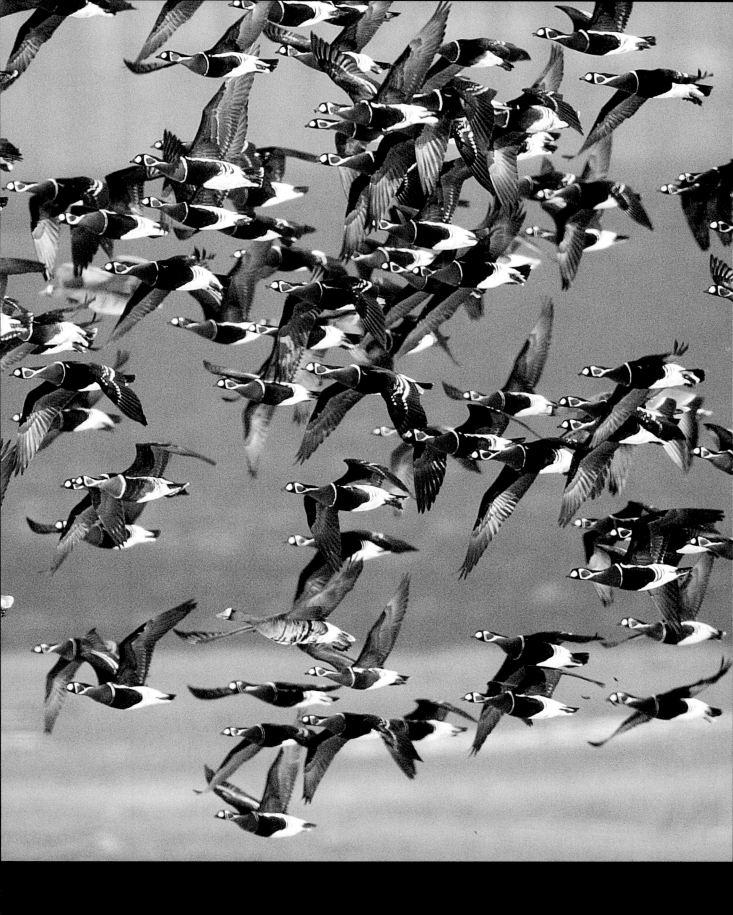

CHAPTER 9

Printing and scanning

If you are shooting digitally, it is likely that you will want to print your own pictures at home on the desktop. You may also have photos taken on film that you would now like to digitize. Inkjet printers and good desk-top scanners are relatively cheap to buy and, although you spend money keeping the machine in ink and paper, they offer superb quality. Moreover, you can take control of the whole process rather than handing your images to your local lab.

Choosing a printer

With so many printers now on the market, how do you choose the right one for you? The following points should help you with this process.

1 Narrowing down a manufacturer helps to focus the search for a printer. Epson and Canon lead the field. Any of its machines will deliver high-quality prints, and it manufactures a range of inks and papers to match.

2 Size is both a cost and space issue. The bigger the printer, the more expensive it is likely to be. Some printers come with their own stands and roll-fed paper, and take up the room of a large desk, but a decent desktop printer is adequate for most people's needs. The small models will produce prints up to 8 x 10, the medium-sized machines will produce 10 x 13 prints, and these are the most popular among photographers. The larger printers can produce large, impressive prints, but are normally the domain of those who exhibit and sell their work.

3 Some machines have just one ink cartridge to serve all the colors, while others have individual color cartridges. The latter are best if you do a lot of printing as you can replace each color as its used, which works out cheaper in the long run. If you intend on doing a lot of printing, it might pay to invest in a Continuous Inkflow System (CIS). This is a special cartridge in place of the usual cartridges, which links to separate ink reservoirs. The reservoirs feed a continuous flow of ink to the printer head.

4 The number of colors a printer can produce is important. Lower priced models have fewer colors, normally four, while more expensive machines may provide six or seven colors. The more colors, the better tonal gradations there will be in your print.

ABOVE RIGHT Color management is an important part of getting the most from your printer, but don't get too hung up on matching your prints exactly to what you see on your computer monitor — what looks good on a computer monitor may not translate into print. This image of a pair of mute swans at dawn makes a really nice print, but the orange mist always seems to print a little too dark and I have to lighten the image a little whenever I print it. I like to look at printing as more of an art than a science!

300mm lens, ISO 100, 1/500 second at f/11

BELOW RIGHT This is the same pair of swans as above, photographed on the same morning, but this time reproduced in black and white. Printing reawakened my interest in black and white photography, and I now regularly convert color images to black and whites in Adobe Photoshop, and then print them to hang on the wall. There seems to be a greater acceptance of black and white images as pieces of art suitable to be hung as prints on a wall or in a gallery.

300mm lens, ISO 100, 1/1000 second at f/8

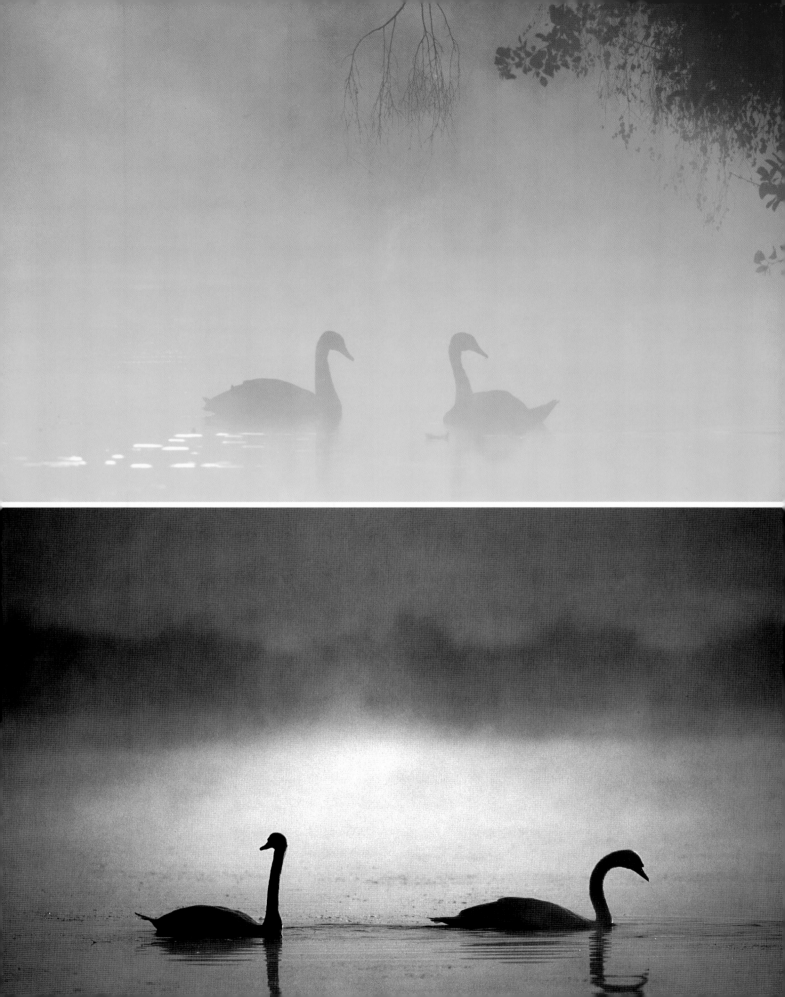

5 Photo quality is determined by many factors, but one of the more important is ink droplet size. Smaller droplets sprayed onto the paper will give smoother tones.

6 Almost all color printers have excellent resolution. To a point, the higher the resolution, the better the print will be for rendering fine detail. Nonetheless, once you pass a certain threshold, the time taken in printing and the differences that are actually visible to the eye can negate any advantage. Excellent photo quality can be achieved at 720 dpi (dots per inch).

Printer calibration

A common experience when printing for the first time is to find that your printer is producing prints with colors that do not resemble those on your screen. To make sure that you can produce prints with colors that match your monitor, you need to calibrate your printer. But, and this is a big but, don't get too hung up on producing prints that accurately match your monitor. You should be aiming for consistency in producing prints that look good to you, and that reproduce satisfactorily. Printmaking is more art than science. However, taking the guesswork out of the equation will waste less of those valuable commodities of ink, paper and time.

I discussed ICC profiles when covering color management in Chapter 5. Your printer needs to be able to correctly interpret the colors sent to it, and to do this it needs an ICC profile. Printers come with generic profiles that may be adequate for your needs – if you do a match using your eyes and the results look fine, there is no need to worry. Yet the chances are that generic profiles will not give consistent results, and they may be way off. Printer profiles you can buy from the internet that match printers with specific paper combinations are more accurate.

If you are producing high-quality prints regularly to sell or exhibit, or indeed for your own use, and you desire the most consistent results possible, it will pay to either spend the time creating a custom profile yourself for the paper and ink you use, or to get professional help. To create a custom profile yourself, you need an objective measuring device. You can buy reasonably priced packages for both monitor and printer calibration that will do the job adequately. For exacting accuracy, you need to use a device called a spectrophotometer, which is expensive. An alternative, less expensive, option is a colorimeter. Or a profiling service will do this for you if you prefer.

Once your printer is profiled with the paper and inks you use, you should get regular consistent results, with your monitor and printer talking the same color language. We call this a "closed-loop system."

Below are the three simple steps you should take when color managing your print production.

1 Make sure your computer monitor is calibrated (see Chapter 5).

2 The software you use must have the appropriate color space set to the color workspace in which you wish to work. Adobe RGB (1998) is the most convenient color space to work in from digital capture right through to making a print.

3 Use a profile from your printer manufacturer that matches the paper you intend on using, or create this profile yourself, and enter this in your image-processing software.

Inks and papers

Inkjet printers use either dye-based or pigmented inks. For a long time, dyes were the only inks used; but the drawback of dyes has always been their lack of longevity, with fading noticeable often after a short period of time. Pigment-based inks are now commonly used and give excellent archival results. How long a print lasts depends on all sorts of factors, not least the environment in which it is displayed. Yet, if all things are equal, a long print life is dependent on using pigmented inks with the right paper. With some ink and paper combinations, a life in excess of 100 years with no noticeable fading is now claimed for some products.

To produce the best results possible, you do need to use good-quality photo paper designed for inkjet printers.

Choosing a paper is personal; some prefer matte, while others like the glossy look. The weight of paper also adds to the conundrum. I favor using various fine art papers, and sometimes canvas, for the pictures I exhibit, as I feel I achieve a more painterly rather than photographic effect with the print. This is, of course, just my preference, and I urge you to experiment with different papers; this is all part of the fun of printing.

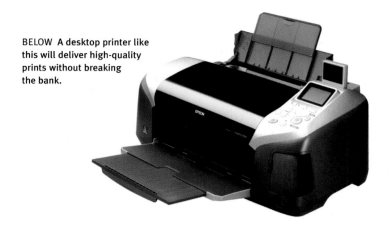

BELOW **A desktop printer like this will deliver high-quality prints without breaking the bank.**

Resolution and print sizing

When talking about printer resolution and image resolution, confusion can quickly set in. They are not the same. Printer resolution refers to how the printer puts the ink down on the paper. Generally, printing at a dpi of 720 will give excellent results.

It is important to understand image resolution and to get it right. You set this in "Image size" in Adobe Photoshop. Typically when printing, a resolution of between 200 and 300 ppi (pixels per inch) is required for optimum results. This refers to actual pixels in the photograph. By changing resolution in image size, the dimensions of the photograph will change, but not the overall file size. You should set the document size to fit with the size of print you wish to produce, and if the file size is too small for the size of print contemplated, you will need to interpolate. If, however, the file size is too big, say a 50 MB file to produce a 8 x 10 inch print which would normally need a 20 MB file, then the file should be resized.

Scanning

Many wildlife photographers come to digital photography from film. Having hundreds, perhaps thousands, of transparencies that you wish to digitize means having to scan them. Very good desktop scanners can be bought very reasonably, and most will give excellent results – ideal for both producing inkjet prints from and for publishing.

The expression "desktop scanner" can refer to dedicated film scanners that are used for scanning transparencies (film), and also to flatbed scanners that can scan film as well as prints, but which usually offer a much lower dynamic range than film scanners (i.e., they capture less

information from film than a dedicated film scanner is able to). Most flatbed scanners are much more reasonably priced than dedicated film scanners and they offer better utility. For the best results when scanning transparencies, however, a dedicated film scanner is best as they are able to scan both mounted and unmounted transparencies. Some flatbed scanners have built-in transparency units, which tend to be machine-specific, so you may not be able to buy one if your machine did not come with one originally.

When selecting a scanner, check for the resolution – this is the figure that tells you how much detail the scanner can resolve without the need for interpolation. At the lower end, good machines start at around 2,700 dpi. When discussing scanner resolution dpi is used instead of ppi as the scanner is effectively reading a print or piece of film as a series of dots. Some of the best machines offer 4,000–5,000 dpi. At 4,000 dpi an image file will print to 12 x 19 inches (30 x 50 cm) without the need for interpolation. If you will only be scanning prints then resolution is much less of an issue; since a print is much larger than a piece of film less resolution is required to scan it.

You should also check the speed per scan. The speed will depend on the resolution you scan at, but machines vary and it is worth comparing – if you have a lot of scanning to do, sitting and waiting for a scan for 10 seconds is very different to waiting 30 seconds.

I scan my images in 16-bit as this retains the maximum amount of color information in the image. Once scanned, I take the image into Adobe Photoshop and work on it, making minor adjustments to optimize the image before converting to 8-bit and filing the image within my system.

CHAPTER 10

Examples from the wild

In this chapter, I use case studies to illustrate many of the techniques and concepts discussed so far. It makes no difference whether you are attempting to photograph polar bears in the icy wastes of the Arctic, dippers in Derbyshire or foxes in your local park; many of the same techniques still apply.

Brown Bears: Katmai, Alaska

AUGUST

Ever since seeing my first wild bear in Finland many years ago, bears have held an allure for me. I have made many photographic forays to Finland photographing European bears, but in Europe, bears are largely nocturnal and, to photograph successfully, you need to work from a blind. The bears are attracted to bait, normally fish or a dead pig or cow and, as long as the bears arrive during the early evening when the light is good, this baiting can be reasonably successful. Nonetheless, opportunities do not exist on the scale of those available in North America, most notably in Alaska where bears are active during the day.

After a largely failed attempt at photographing the huge grizzly bears found in Kamchatka in the Russian Far East, I visited Katmai in Alaska. My visit was timed to coincide with salmon running up the coastal creeks and, rather than visit Brooks Falls or one of the other honeypot sites within Katmai that attracts hundreds of photographers each summer, I chose a location on the coast visited by a limited number of photographers.

RIGHT Placing yourself in the right place at the right time is a key ingredient for success when taking good pictures. This image was taken on a coastal creek in Alaska's Katmai region. I arrived with my guide at the mouth of the creek, just as the tide was starting to rise. It is then, once the water is at a reasonable depth, that salmon will start running up the creek, which attracts bears to the fish. By waiting close to the creek, we knew that a bear or two would eventually appear. I wanted an image of a bear appearing to run toward the camera, and so I placed myself on a bend in the river and, using a long telephoto lens (500mm), was able to take this image of a bear running down the river toward the sound of splashing salmon. The bear ran straight past me, preoccupied by the upcoming meal. For added impact, I crouched low to the ground for a more intimate feel. This was an exciting moment, although having a large bear charging through water toward you can feel quite intimidating. However, my guide was right by me, watching my back, and allowing me to concentrate on taking the picture.

500mm lens, ISO 200, 1/800 second at f/5.6

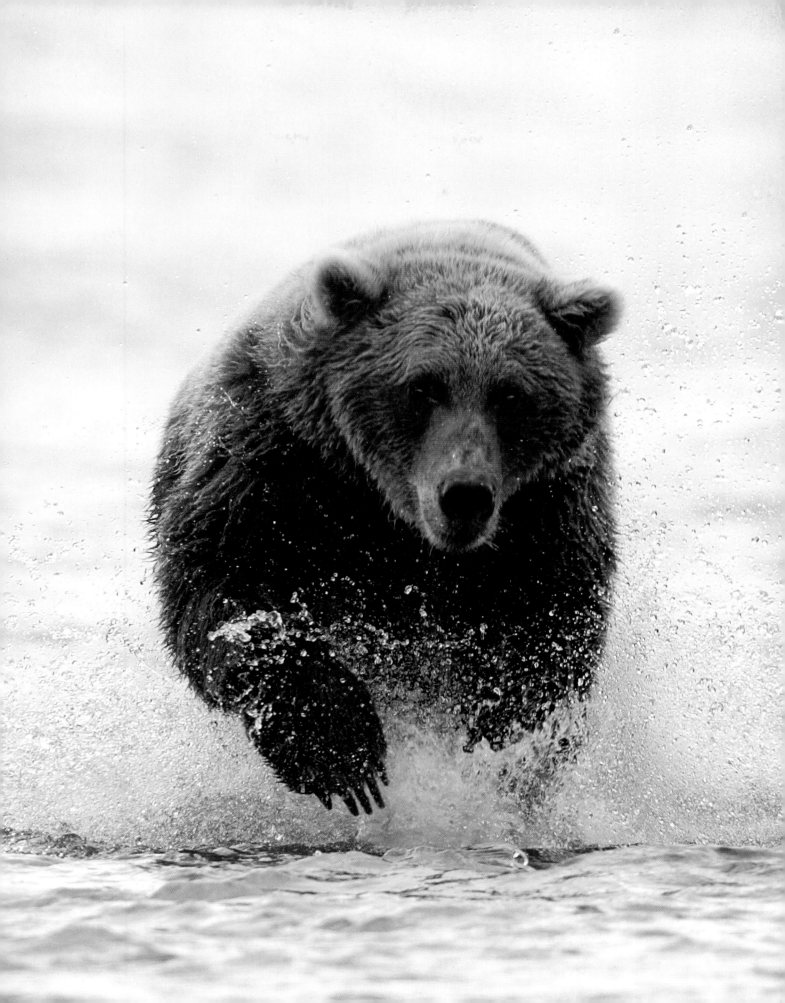

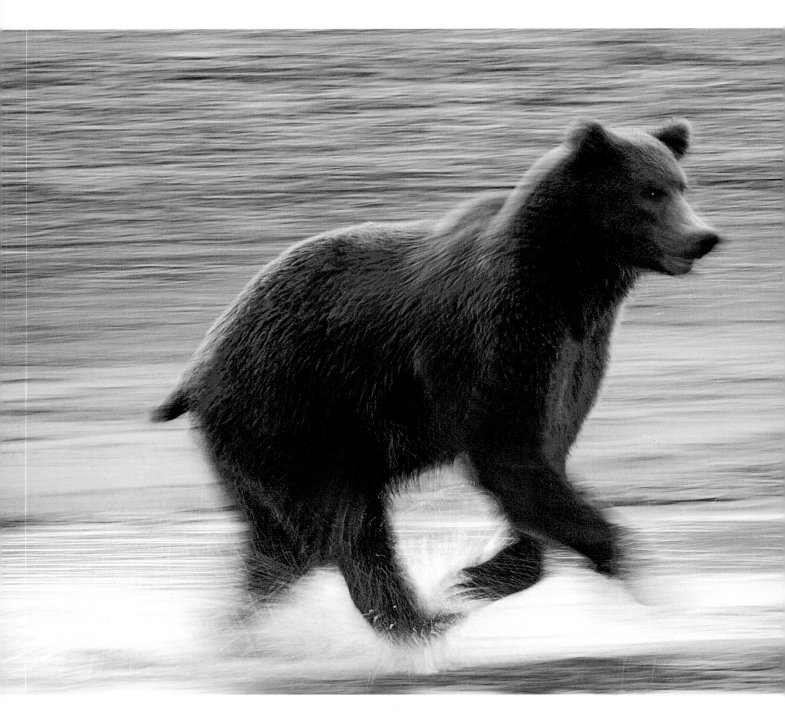

ABOVE For this photograph I used motion blur because of an unattractive background of pebbles and stones. After reviewing a couple of images of bears taken against this background using conventional shutter speeds, I found the pebbles and rocks too distracting. On my next visit to Katmai, I suddenly noticed a bear racing along the edge of the creek in pursuit of a salmon. Quickly, I set a shutter speed of 1/15 second, knowing that the background color would blur beautifully and the distractions would be turned into a pleasant gray wash. I kept my finger on the shutter as the bear raced pass, taking around 15 images, with the one above being the most successful. Wildlife photographers often have an overriding desire to freeze action or movement, and there is no doubt a variety of reasons for this. Perhaps one reason is the conditioning that comes from seeing the majority of published photographs depicting action frozen, with no sense of movement. To overcome this, blur is the most effective technique to use, particularly if your animal is moving slowly. Blur, at whatever degree you use, can introduce a sense of drama that might otherwise be absent.

*70–200mm zoom lens,
ISO 100, 1/15 second at f/16*

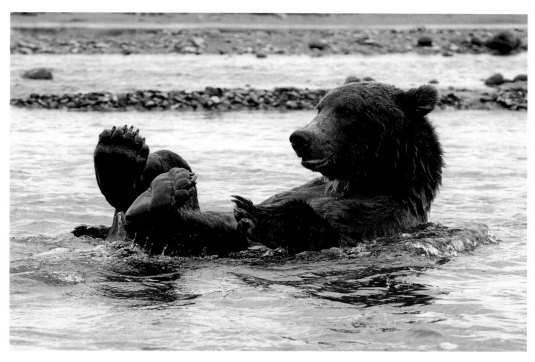

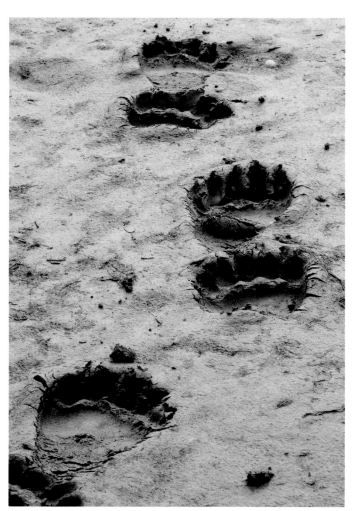

ABOVE Whenever I project this image at my talks on wildlife photography, I never fail to get a laugh; this bear seemed to be enjoying having a bath in the middle of the creek. As with the previous two images, I have placed some light in the eyes. I have captured thousands of images of bears over the years, but this one outsells nearly all of them put together. Pictures of wildlife that reflect human emotion and life tend to always sell best, and I am always on the lookout for such opportunities.

70–200mm zoom lens set at 150mm, ISO 200, 1/400 second at f/5.6

LEFT It is sometimes easy to forget the bigger picture when concentrating on a subject. This photograph of bear footprints in the mud of a coastal creek helps to tell the story. I used a medium-length telephoto lens to help isolate the prints, and a large depth of field in the region of f/14 to ensure that they all fell into focus.

70–200mm zoom set at 80mm, ISO 200, 1/60 second at f/14

RIGHT This is another image that helps to tell a story, and one that could be employed for a whole host of editorial uses. One of my aims during my days in Katmai was to try and illustrate humans sharing the wilderness with the bears. Here, a group of hikers is walking down the opposite bank of the creek to where I was. To make the picture effective, I needed the bear to be a reasonable size in the frame and, as I was unable to approach too close, I used my 500mm lens, which helped to throw the people walking behind out of focus. It helped that they were all wearing quite colorful clothing.

500mm lens, ISO 125,
1/640 second at f/5.6

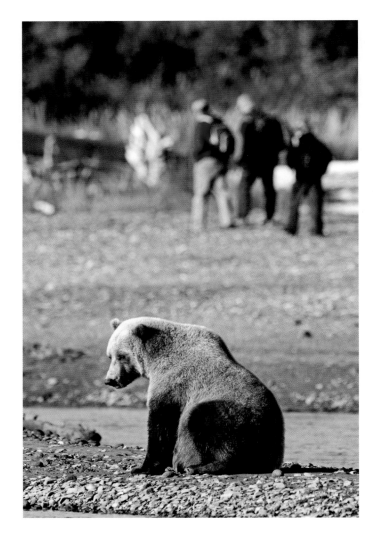

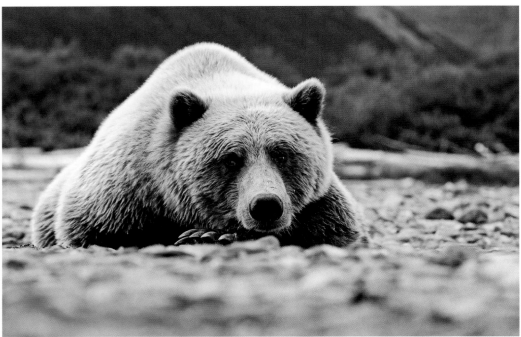

LEFT This image is one that I will never forget taking. I don't make a habit of taking unnecessary risks around potentially dangerous animals. For one thing, if you do so you are stressing the animal, and my aim is to capture images that create a mood and are as natural as possible. This bear is completely relaxed with me, as can be seen from the picture. She chose to come and lie just 15 feet (4.5 m) from where I was sitting; at first it was

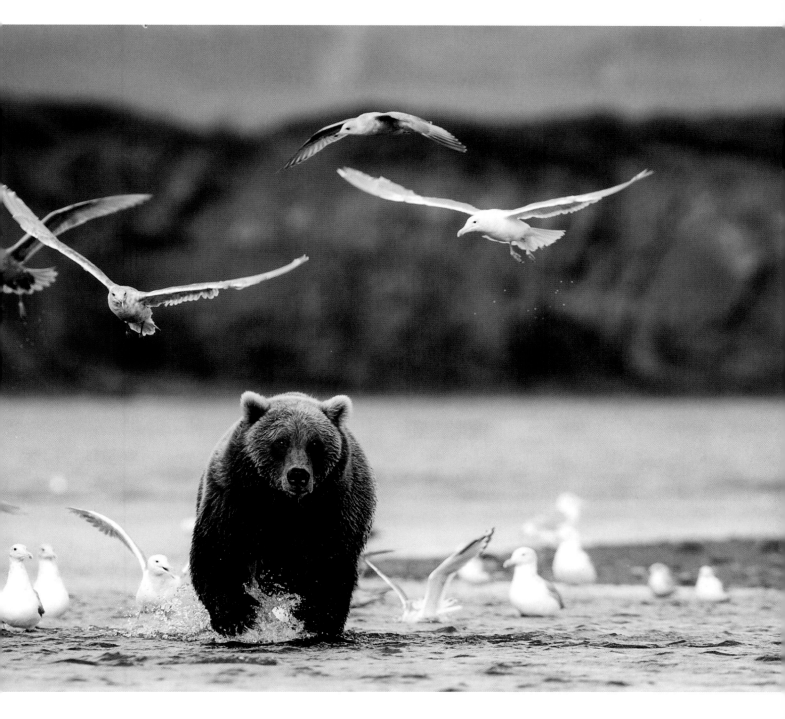

unnerving, but when I felt she posed no threat, I could enjoy what was an incredible experience. As I was already sitting, I quickly fixed my low-angle viewfinder so that I could lie on my front and take this intimate portrait with just a 70mm lens! I have purposely placed the out-of-focus foreground in the image so that the eye naturally leads to the bear's face, and this enhances the feeling of being at eye level. Other images I took in this series without the foreground do not have quite the same impact. The bear's face was in a little shadow because the weak sun was shining directly at me, so I have used the "Shadows and highlights" tool in Adobe Photoshop to lift the shadows around the face a little.

70-200mm zoom set at 70mm, ISO 125, 1/160 second at f/5

ABOVE Eye contact can be a strong ingredient for making a picture work, and in this photograph I feel that the fact that the bear is staring at me helps with this image. This is a bear that has been fishing and is returning back up the creek with the attendant glaucous-winged gulls hanging around in case another fish is caught. I laid low for this image, using an angled viewfinder, the low angle helping with the overall impact of the shot. I don't normally like placing my main subject within the center of the frame, but here it works as the gulls help to balance the picture. Again, as with the other photographs on the left, I have enhanced the catchlights in the eyes, which help to show that the animal is looking at the camera and, therefore, engaging with the viewer.

500mm lens, ISO 125, 1/640 second at f/6.3

Dolphins: Roatan, Honduras

APRIL

Lying in the Caribbean, the small island of Roatan off the coast of Honduras is the location for a group of habituated bottlenose dolphins. These dolphins live in an artificial coastal lagoon, and they are fed and exercised daily. The dolphins are trained but could leave for the open ocean if they so wished.

The dolphins on Roatan are used by the film and tourist diving industries, and they are part of a long-term research study. Photographing wild dolphins leaping is possible but it is unpredictable and time-consuming work. There are times when photographing a captive or habituated animal makes sense for many reasons. One of the most compelling reasons for me is that I can push the creative boundaries in a situation where I can control, to a certain extent, the animal's behavior, location and backdrops.

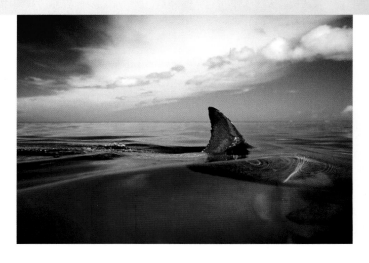

ABOVE Friend or foe? The appearance of a fin, such as in this photograph, slicing through the water hints at danger; a shark menacingly circling its prey. This is, of course, a dolphin's fin, but there is no friendly, smiling dolphin face in the image, only a feeling of menace. By isolating the fin, and shooting at a low angle to give the sky and clouds some impact, I have created a mood in the image that was not there in real life. In reality, the dolphin was cruising around waiting for its next instruction to leap!

Creating a mood by isolating a component in a picture or part of an animal can elevate an image from being just another portrait of a familiar subject to one that catches the eye and holds the viewer's attention.

17–35mm lens, ISO 100, 1/160 second at f/11 with angled viewfinder

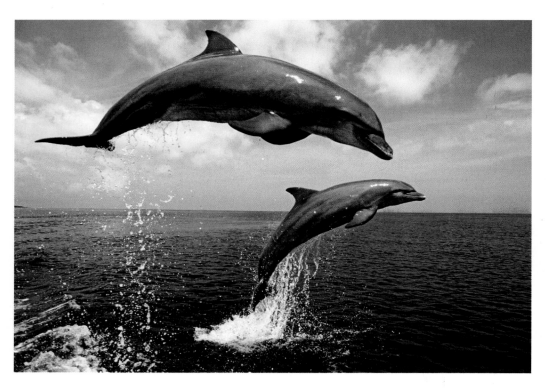

RIGHT This image of a dolphin leaping over the sun as it sinks to the horizon is my favourite image from my week with the dolphins. It illustrates best why working with captive animals can provide opportunities that are impossible to repeat in the wild. I conceived the composition of this shot in my mind, and then set out to take it. A pontoon, allowing me to lie just above the water surface, was anchored on the sea. I used a 17mm lens with an angled viewfinder. The low angle was used to enhance the oily feel of the sea and to gain the right perspective for the shot to work. I exposed for the scene by taking a reading off the sky just above the dolphin. Other than cloning out a water droplet coming off the back of the dolphin's dorsal fin that was distracting to the eye, no digital retouching has been made to this picture.

ABOVE This image is a bit of a cliché; we have all seen similar images of jumping dolphins, yet this proved to be a very commercial image. In its first year in the marketplace, my agent sold this image more than 50 times for a variety of uses. It is easy to see why it is so appealing to those buying photography; it shouts a number of concepts at you – freedom, fun, togetherness, movement, athleticism and so on. If you want to sell your work, you need to capture these anthropomorphic concepts to make good sales. The image was taken from a speedboat from which I was leaning over the side with a 17mm lens, getting quite wet in the process! The camera was protected with a plastic bag that I held in place with elastic bands. I chose to be as low to the water as possible to give a feeling that the dolphin was jumping high and to have the sky as a backdrop to the animal. If I had placed the leaping dolphins against the dark sea, much of the impact would have been lost as the dolphins would have blended into the water.

17–35mm zoom lens, ISO 100, 1/500 second at f/8

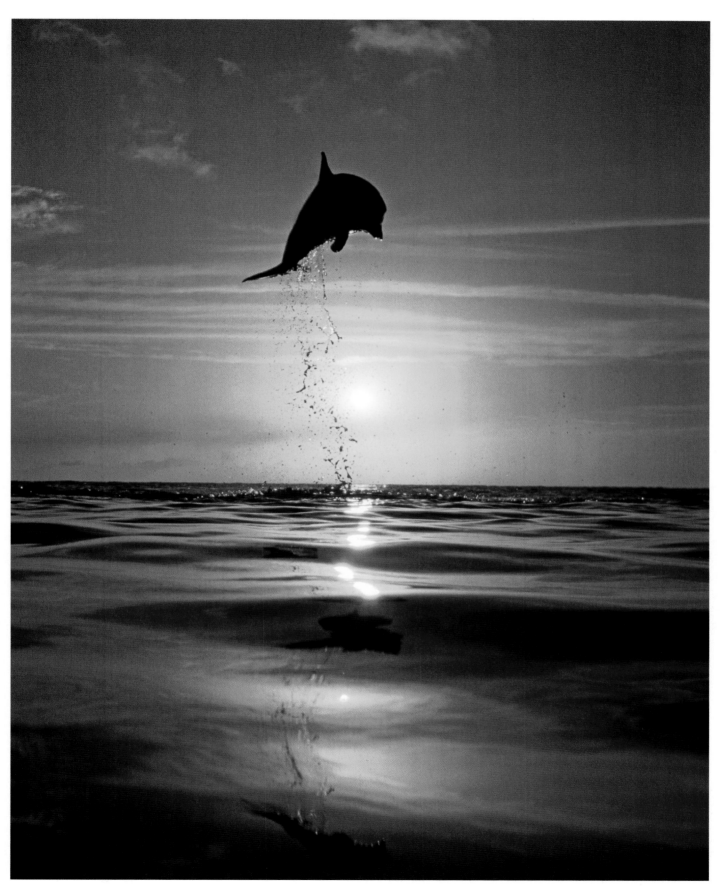

17–35mm lens at 17mm, ISO 100, 1/1000 second at f/11

Mara River crossing: Masai Mara, Kenya

JULY

Each year, the plains of the Masai Mara witness the arrival of more than a million wildebeest and zebra. This huge movement of animals is known as the "Great Migration." The animals have traveled from the southern Serengeti in Tanzania, where many of them will have given birth. By the time they arrive in the Mara, the young are around six months old.

There is one hurdle that most animals decide to cross in order to reach some of the best grazing in the Mara: the Mara River. Lying in wait are some of Africa's largest crocodiles, huge animals that for the previous eight months may have had little to eat; the arrival of the migration signals the start of a feast. To photograph this often gruesome trial of life and death had for many years been a burning ambition of mine. However, I knew it was not going to be easy: river crossings can be sporadic; the migration does not arrive in the Mara at the same time each year; the migration is rain dependent; and, if you get your timing wrong, you can arrive too late and find that the crocodiles have had their fill.

Most crossings are triggered by animals coming down to drink and then crossing; this means that most crossings take place during the heat of the day, when the animals need water most.

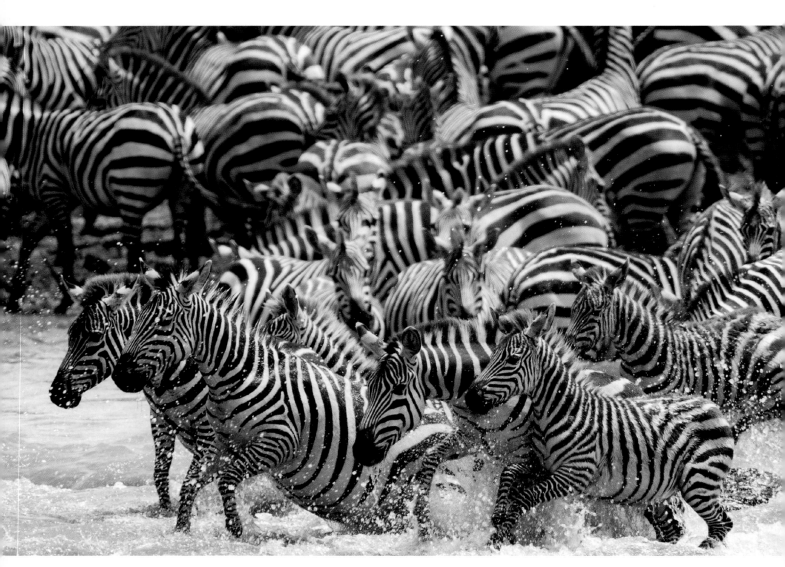

With all this in mind, when I at last experienced my first crossings, I knew it was imperative that I nailed the shot because I might not get another chance. But how do you know which animal the crocodiles will home in on when hundreds are crossing at a time? When will the crocodiles strike, and where will the animals cross and when? By scouting crossing points with Dave Richards, my expert guide, I was able to locate the ideal spots for photography. I watched the first few crossings closely, and I learned to identify the animals that the crocodiles would home in on.

It was soon apparent that large adult zebras are just too risky for a crocodile to tackle. Their powerful hind legs give a hard kick, and consequently the crocodiles take little interest in them. It was, however, the wildebeest and zebra foals that drew the most attention. Therefore, during each crossing, by concentrating my lens on the small vulnerable foals, I was ready when the crocodiles struck.

Another trick to photographing the images shown here was to be slightly downstream of the kill. Once the animal was caught, both animal and crocodile would drift downstream in the current as the struggle ensued; if I had been upstream, the kill would have slipped away.

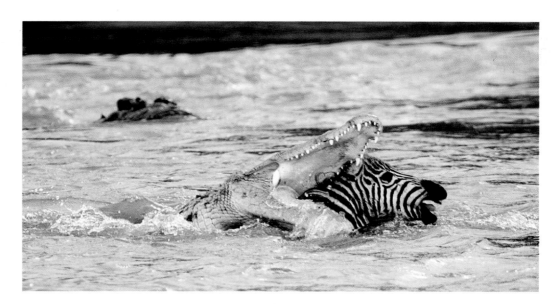

LEFT This image shows the start of a potentially fatal crossing. Crossings such as these make for some spectacular photography. When framing the zebras, I made sure I placed them toward the bottom of the frame in order to include the animals in the background, and to help to tell the story within the image.

500mm lens, ISO 200,
1/500 second at f/5.6

ABOVE RIGHT This image, as with the previous shot, relied on concentrating on the foal but, at the same time, using one eye to watch for the approaching crocodile. I have cropped the image to remove much of the featureless water in the bottom of the frame, keeping plenty of space in the top of the picture. Then, when your eye moves off the main action, it is drawn to the big crocodile that is moving in from the top left. This image has everything I wanted to capture in the life and death struggle of the river crossings. The foal's head and huge jaws of the crocodile give a sense of the size of these predators, and the look on the foal's face sums up the predicament it is in. In reality, this was a swift death – the capture took just a split second and the foal was dragged underwater to drown.

500mm lens, ISO 250,
1/500 second at f/5.6

RIGHT In this photograph, the end is both quick and violent. I had the option to use a medium telephoto zoom lens to show the overall scene depicting a number of crocodiles moving in to rip the animal apart. However, I stayed focused with my 500mm lens to try and add some impact to the scene. In particular, the large crocodile on the left has a really impressive head. I was also conscious of wanting to see the eye of at least one crocodile to add menace, and to form more of an attachment between the viewer and the picture.

500mm lens, ISO 250,
1/320 second at f/7.1

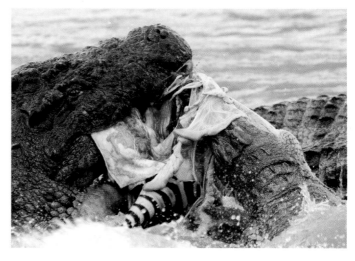

Dippers: Lathkill Dale, Derbyshire, U.K.

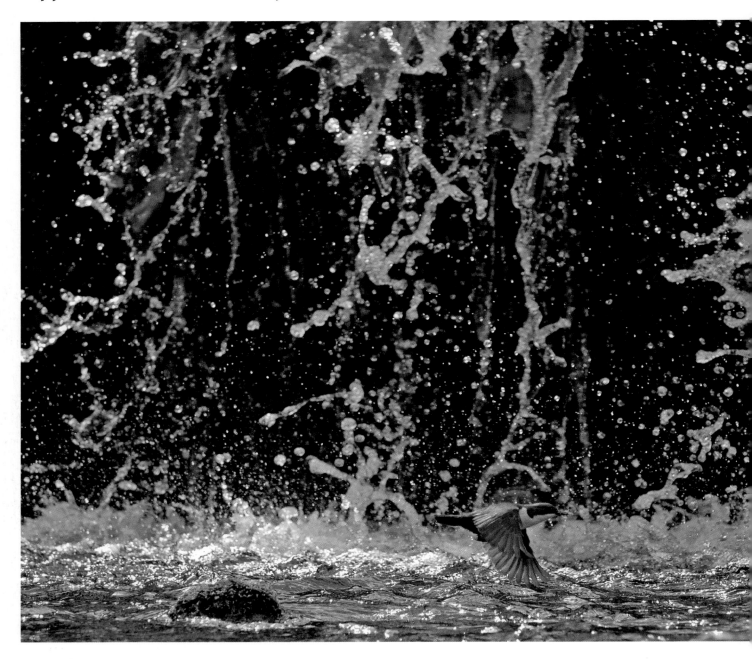

ABOVE During one of my visits to the Dale, I attempted to take flight shots as the birds flew past me en route to a nest by a waterfall. Due to their fast flight, this was proving very difficult. Occasionally, a bird would land on one side of the waterfall then fly across to the nest on the opposite side. This looked like a perfect chance to take images of the dipper in habitat, with the tumbling waterfall behind. It took two visits to capture the above image using a 70–200mm zoom set at 200mm. I used the lens wide open at f/2.8 as I needed a fast shutter speed to freeze both the flying bird and the waterfall. I consciously framed the bird at the bottom of the picture to show the waterfall to the best effect I could, and I used the moss covered rock to help balance the image. The bird is placed in the middle of the image because I wanted it to have some space to fly into and, with the mossy rock on the left, the bird needed to be far enough right so that the rock did not interfere with it. If the bird had been further to the right, a tension would have been created in the image. This is not necessarily a bad thing – I don't believe there should be any rules in composition, but out of the many images I took, I felt this shot worked best.

70–200mm lens set at 200mm, ISO 400, 1/2,000 second at f/2.8

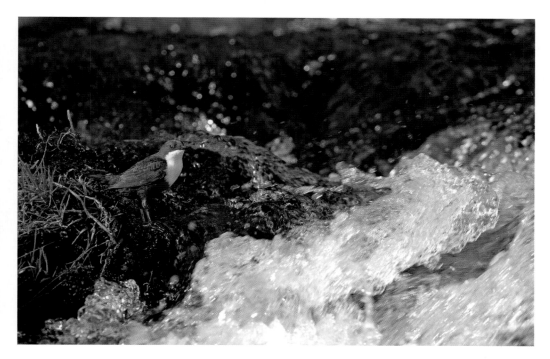

APRIL

Dippers live along fast-flowing streams and rivers in upland areas. In most localities, they are difficult to photograph without using a blind. Nevertheless, at Lathkill Dale in the Derbyshire Peak District in the United Kingdom, the situation is completely different. Here, the river that runs through the dale has a well-used footpath along its banks. On some days, hundreds of walkers use this stretch and so the birds have grown accustomed to humans and, as a result, they are very tame.

A large part of wildlife photography is not technique or computer knowledge, but opportunity. For nearly every subject you can think of, there is likely to be a locality that offers exceptional opportunities; often half the battle is tracking these down. I had long wanted to create images of dippers within their habitat, rather than simply capturing portraits. Finding these tame birds allowed me to do so.

ABOVE I had two options of how to illustrate the water with this image. I could have used a slow shutter speed to help blur the water, but I chose to use a relatively fast speed and shallow depth of field to both control the background and to blur the water a little, yet not too much.

There are two major elements to the composition of this image: the bird on the left and the raging water. The bird is looking into the picture, which gives the picture a certain calm. One of the keys of successful composition is the organization of the major elements within the frame. My aim was to illustrate the bird within its habitat – a fast-flowing watercourse. The riverbank and everything else around the bird is superfluous to the image, and if included could have detracted from both the feel and aim of the picture. The bird needed to be placed as close to the left-hand side of the frame as possible so that the image had some balance and harmony with the raging water.

300mm lens, ISO 100,
1/1,000 second at f/4

Otters: Shetland, Scotland

JUNE

Otters are one of my favorite subjects to photograph, not least because they offer a challenge afforded by few other mammals. The otters that live along the coasts of Shetland are diurnal, and they like to hunt for fish and crabs, although they will readily raid birds' nests for eggs and young. A falling tide is often good for finding feeding otters, and the best technique is to walk the coastline searching for animals offshore. When feeding, they dive repeatedly.

Otters eat small, easily managed items while lying on their backs, and they bring big fish and large crabs ashore. It is these shore visits that offer the best opportunities for photography.

My technique is simply to watch for an animal coming ashore. Then, while carefully keeping a low profile, I quickly move into position adjacent to the piece of shoreline to which the otter is heading, and make sure I am downwind. Otters have a great sense of smell and good hearing, but they have lousy eyesight, and so noise, movement and wind direction are the keys to success. Once ashore, otters will eat their catch before returning to the water to resume fishing.

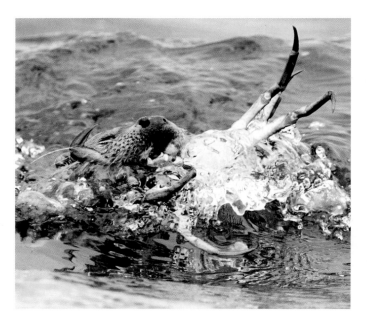

ABOVE I have enjoyed many encounters with wild otters, and many frustrations. One day, I was tracking a large dog otter in a bay off Sullom Voe on mainland Shetland, when he disappeared. I searched for over 30 minutes before deciding to give up for the day as it had started to rain. Just as I was climbing up the beach, out of the corner of my eye I noticed movement out at sea, and there was the otter bringing ashore a large crab. I quickly got into position close to the water's edge, and I was able to take a series of shots of the otter swimming ashore. Here, I have cropped the image to place emphasis on the otter clutching the crab. The original frame includes much of the animal's body, but far more impact is gained by this tight crop.

The digital darkroom allows you to play around with various crops to find pleasing compositions. I have used the "Dodge" tool simply to lighten the otter's eye a little and so make it more visible; this helps to give the picture a focal point other than the crab.

500mm lens, ISO 200, 1/500 second at f/7.1

RIGHT This picture of a female otter was taken from the top of a low cliff. A dog otter was close by, and the female repeatedly ducked under the bladder wrack (seaweed) on the shoreline, occasionally lifting her head to check where the male otter was. I have similar images of this female otter where she is looking at the camera, but they do not work as well as this image of her looking into the picture. Eye contact, although often desirable, was not wanted in this case. This can be especially true with shy animals such as otters that, when they do look at the camera, can look as if they are sensing danger. Consequently, they do not have the same engagement as a relaxed animal looking into the lens.

500mm lens, ISO 125, 1/250 second at f/5.6

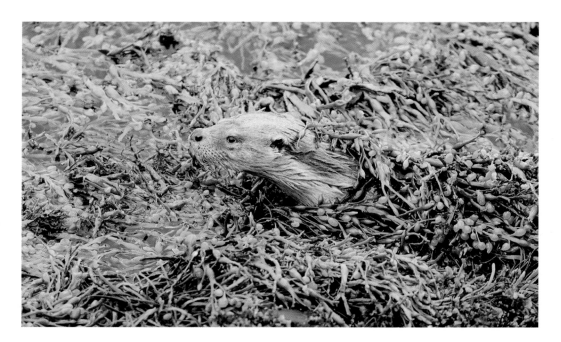

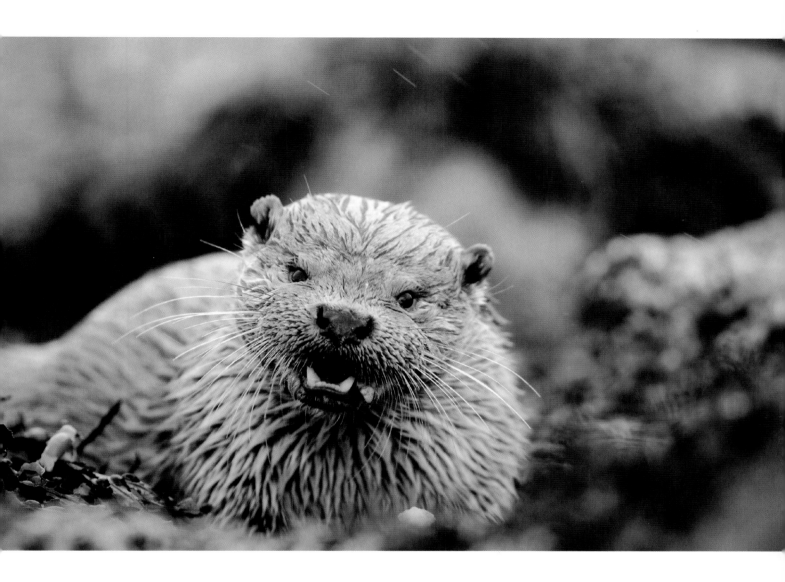

ABOVE The female otter in the photograph is eating a crab, and came ashore only feet from where I sat. She was aware I was present – she would regularly look up at me – yet she did not perceive me to be a threat. It is a wonderful experience to sit this close to a wild otter.

To isolate the otter against the weed-covered rocks and eradicate a very distracting background, I used a shallow depth of field and a long lens. For intimacy, I shot as low as I could, and this helped to bring into play a colorful out-of-focus foreground with which to frame the animal.

*500mm lens, ISO 200,
1/500 second at f /4*

RIGHT Animals regularly leave signs of their presence, whether footprints or feeding evidence, and in this photograph the sign was a finished meal. These signs can be a big help when looking for suitable sites to try for pictures. The photograph shows the remains of a crab left by an otter. Finding such remains will boost your confidence that you are in the right place and that you at least have a fighting chance of taking the photograph you are looking for.

I always try and photograph these scenes, and here I have used a wide-angle lens to encompass some of the animal's habitat, which helps to set the scene.

*17–35mm zoom set at 17mm,
ISO 200, 1/200 second at f/13*

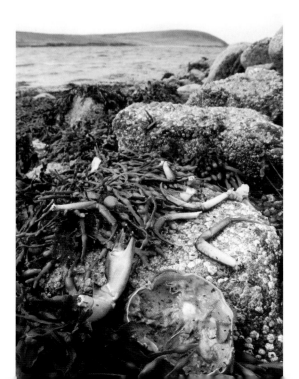

Bald Eagles: Homer, Alaska

FEBRUARY

Homer, a small town on Alaska's Kachemak Bay, is the place to photograph the bald eagle, one of the world's most symbolic birds. As the U.S. national bird, images of bald eagles, especially head shots, are used continuously in the media, in advertising and for many other uses. As a result, the bald eagle remains one of the most popular subjects for wildlife photographers. The images taken in Homer each year probably account for a large percentage of the images published worldwide.

The eagles flock to Homer largely through the efforts of one woman. Jean Keene lives on the spit and feeds the eagles from soon after Christmas through to the end of March. Over 400 eagles may be present on the spit, providing a photographic feast. Many of the eagles are extremely tame, allowing for some truly creative photography.

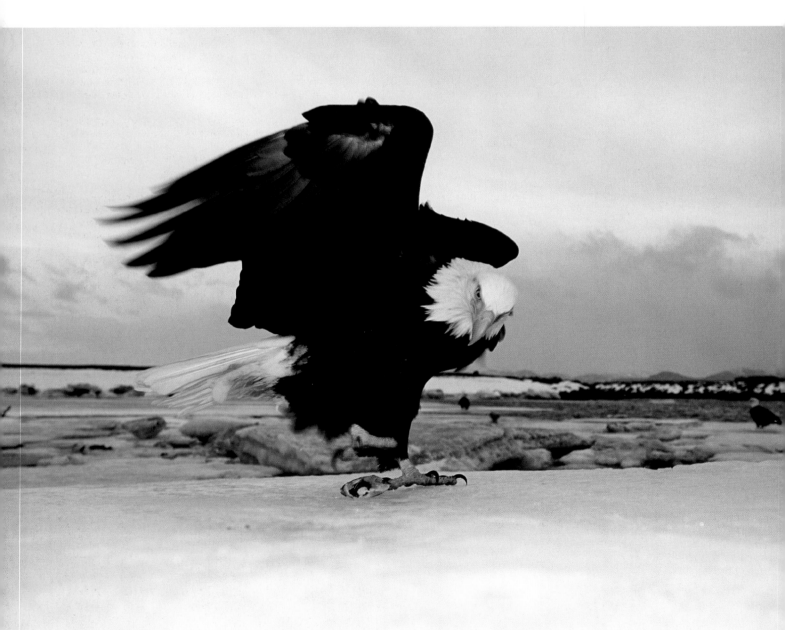

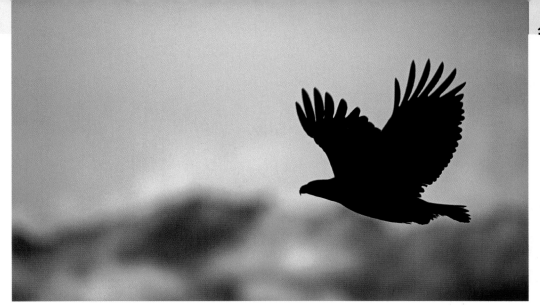

LEFT Snow and ice are features of most winters in Homer, and they are great ingredients for attractive wildlife images. This image was taken on a very dull, overcast day. To help illuminate the bird and to avoid too much shadow, I used a little fill-in flash. A wide-angle lens was employed, and I lay down on the edge of this block of ice on the shoreline with a chunk of fish as temptation for the birds.

A low angle was used to help isolate the bird against the sky, rather than end up with a messy background. I placed the bird slightly to the left of the frame in order to include the two distant birds on the right; this helps to balance the composition and, because they are facing left, stops your eye from straying off the page.

17–35mm lens used at 17mm, ISO 100, 1/125 second at f/4 with fill-flash set at −3 compensation

ABOVE Each evening, many of the eagles leave the spit and fly across to the spruce forests on the other side of Kachemak Bay to roost. By standing on the end of the spit in the early morning, you can photograph the birds returning against the rising sun. I made the above silhouetted image soon after dawn, and the snow-capped mountains behind are bathed in golden light. I have placed the bird so that it has plenty of space to fly into, giving the image visual harmony.

I particularly like the background colors in this image, and the position of the bird's wings in relation to the sky and mountains.

500mm lens, ISO 100, 1/750 second at f/5.6

BELOW Photographing birds in their habitat is a favorite technique of mine, and Homer's bald eagles lend themselves well to this. One of the tricks of the trade is to have a box of fish with you. I made this image by waiting for low tide and then, with a box of frozen fish, I lured the birds down on to the muddy shoreline. Positioning myself for the light and for the mountain backdrop, I got very wet as I lay flat on the mud for the low angle. I was fortuitous that the main bird in the scene called. The wet mud provided reflections, and the low evening sun helped me to expose for both the white head and dark chocolate brown of the bird's body without having to resort to the digital darkroom to balance the tones to try and bring out the true colors.

17–35mm zoom lens at 17mm, ISO 100, 1/250 second at f/8 with angled viewfinder

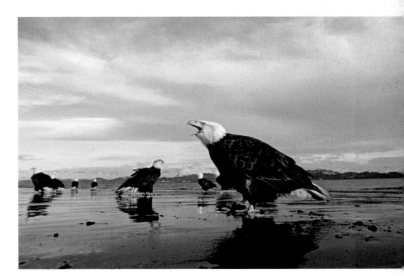

CHAPTER 11

The business of wildlife photography

Twenty-five years ago, I had a dream to become a professional wildlife photographer. Fifteen years ago, that dream came true – after a lot of hard work in both promoting myself and my work.

There are few professions harder to break into; the world is awash with great wildlife imagery, and the fees for wildlife images are some of the lowest in the stock photography business. Add to that the cost of travel, equipment and promotion, and you begin to realize how many images you need to sell to make a living.

There is one of two avenues that most successful wildlife photographers have chosen to take. There are those that have decided to concentrate on their home patch, and build a comprehensive archive of their native wildlife. These photographers are some of the most successful because home markets tend to want pictures of native wildlife more than any other. The alternative is to photograph the world's iconic wildlife, and to set off on a lifetime of world travel. This is a tough route to follow, but the rewards can be great. It all depends on how committed you are and, above all, whether your work is both commercial and different enough to sell consistently in the marketplace.

To be successful, you not only need to be a good photographer but a good businessperson too. You may produce exciting, beautiful and saleable imagery, but if you cannot sell yourself or your work, you will not succeed as a professional. Equally, you may be a good businessperson, yet if your work is not up to scratch, you will be unable to build a business.

Nearly all professional wildlife photographers rely to differing degrees on income from stock agencies. These are picture archives that market work on your behalf to the world's picture buyers. The stock agencies typically take a percentage for doing so – the norm is a 50/50 split, although this is continually being eroded, and some take as much as 70 percent.

RIGHT There are some images that have far more commercial potential than others. This emperor penguin image marketed by Getty Images ranks as one of my bestselling images. It is not hard to see why: its anthropomorphic qualities lend itself well to advertisers wanting to convey human emotions and traits such as love, protecting, caring, parental responsibility and so on. It has the "aah" factor too, which helps to sell it for other uses such as greetings cards and calendars.

300mm lens, ISO 100, 1/1,000 second at f/8

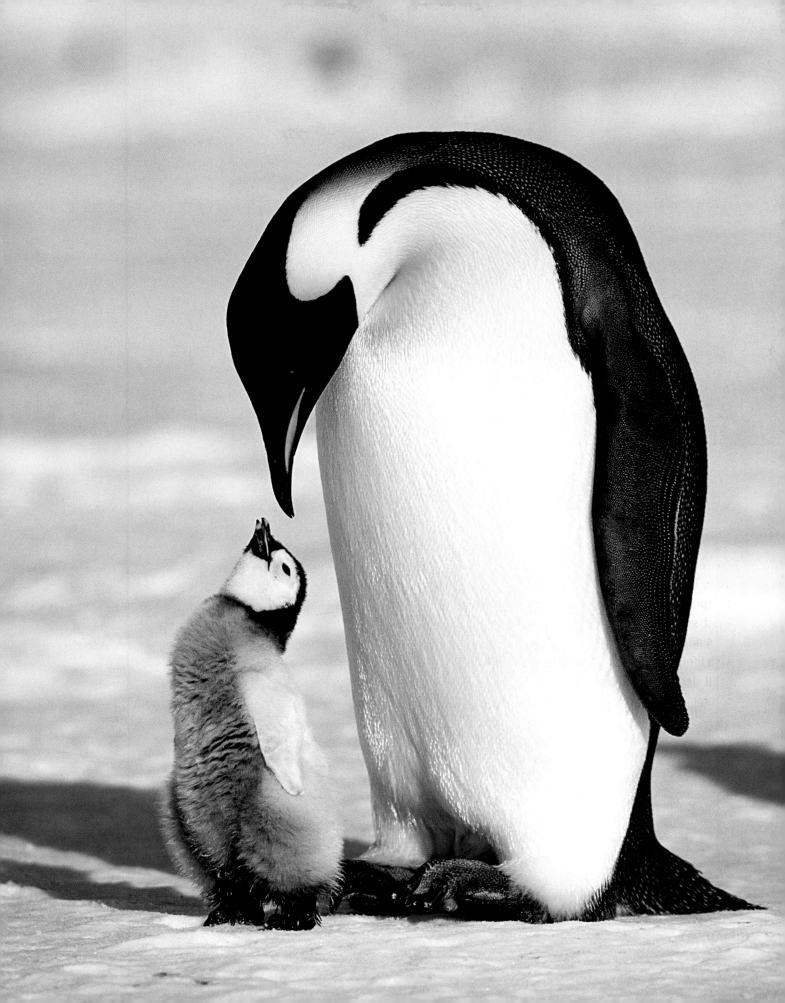

Choosing a stock agency

The stock photography business has gone through a major phase of consolidation in the past few years, and many small- and medium-sized businesses have been bought out by the two major players in the business: Corbis and Getty. The majority of successful professionals supply one of these two stock agencies, as they have quite a stranglehold on the marketplace. However, there are alternatives.

There are a number of small stock agencies that specialize in wildlife, including NHPA (Natural History Picture Agency), Seapics, Nature Picture Library and RSPB Images, and these, along with the general subject agents such as Alamy, are an obvious alternative choice. Nonetheless, even if the stock agencies take you on, do not expect to start making a lot of money overnight. You will be competing with many images out in the main market, and also within your own stock agency. You may, for example, have a wonderful variety of images of cheetahs, but the chances are that your stock agency will already have hundreds of images of that subject, and so your images will be diluted. For this reason, it is important to try and make your imagery stand out, while still retaining a commercial attraction – a difficult line to walk.

When choosing a stock agency, look at what imagery they have to offer. If your pictures complement what they already have, or even fill gaps in their coverage, this may be a big attraction. In what is now a very competitive market, it is pointless to join an agency that handles work similar to your own in subject matter and style. Indeed, if they are a good stock agency, they should be protecting their existing photographers' interests and not taking you on, although sadly this is rarely the case.

Some stock agencies do little selling of their own but act as distribution agents – sending pictures to a variety of overseas stock subagencies to sell on their behalf. Be wary of these arrangements; they never benefit the photographer and always benefit the stock agency. The deal is usually that your stock agency receives 50 percent of the sale which they then divide 50/50 with you. Sometimes the overseas stock sub-agency may only give your agency 40 percent, and you then receive 20 percent of the sale, which may not amount to much. Even worse, there are cases where the stock sub-agency passes on images to another agency, and the split can be 10 percent or less to you.

After reading this, you may wonder whether it is worth bothering with agencies at all. It is worth dealing with the good ones, and the more images you have in the marketplace, the better you will do. Much of your success as a stock photographer will depend upon your ability to be prolific with your output.

Marketing your own work

In addition, or as an alternative, to stock agencies, you can sell your own work. The internet has become a great leveler in this regard, and a large percentage of picture research is currently carried out by searching websites, and this includes photographers' websites. However, you need a good range of material, or to be a specialist offering images found nowhere else, to be able to attract buyers to your site regularly. A couple of visits where their searches fail may mean that customers will not return.

Fancy sites with graphics and pictures that take forever to load are a big turnoff. If offering images on the Web, remember to keep it simple and fast; picture buyers are always in a hurry and will not waste time on a site that is cumbersome to use.

There are many ways of promoting your site. One of the most effective ways is to produce color flyers that you can target to your potential clients. Remember that unsolicited e-mails are not always welcome.

Many photographers who also have the ability to write to a reasonable standard offer picture and word packages to magazines, and this is another route for making money from your photography.

If you have a deeply held belief that you can make it as a wildlife photographer, and if you have the talent and single-minded determination to put up with continuous

RIGHT Images of wildlife are used in many different ways. There are the obvious uses by book and magazine publishers, as with this example of my osprey image on a book cover. There are also more obscure uses, for instance, in recent times my images have been used on wine labels, a lottery ticket, and to advertise a sports performance drink, to name just three.

disappointment and setbacks in the early days, then you might just have what it takes. Nevertheless, you will not be entering a life of continual photography; I spend as much if not more time at my desk behind a computer as I do in the field taking pictures. For most people, wildlife photography offers a wonderful escape and a pastime, without the pressure of making a living from it.

If you do have the drive, determination and ability to both sell yourself and your images, then go for it – pursue your dream. Be prepared to persevere but, if you can overcome the many setbacks and establish yourself, you can look forward to a very rewarding way of life.

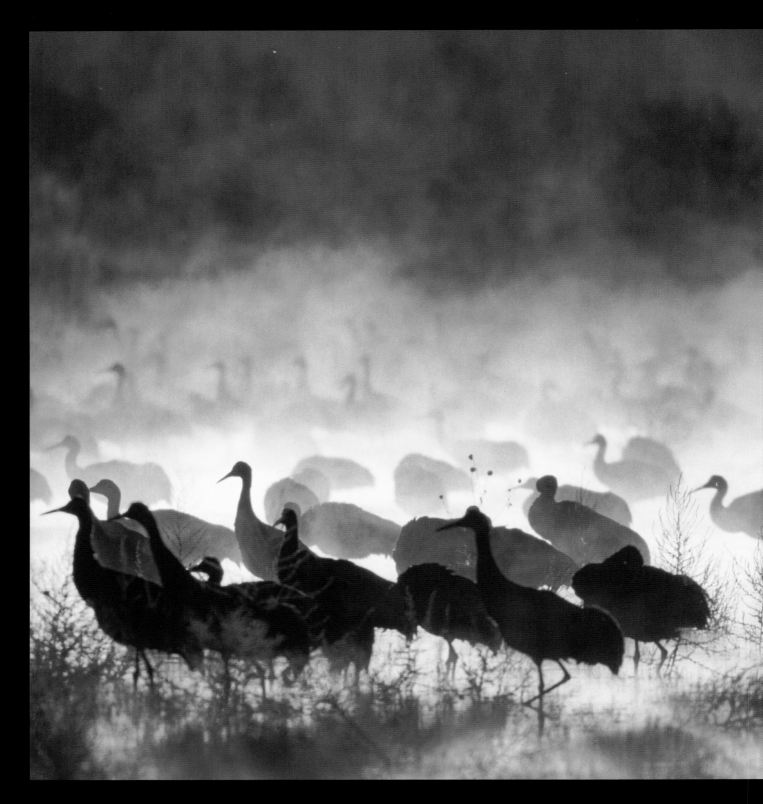

ABOVE I have witnessed few more spectacular scenes than this, a group of sandhill cranes on their roosting pond at dawn, at Bosque Del Apache in New Mexico. As the sun came up over a distant mountain range the rising mist turned orange. The scene lasted for no more than a couple of minutes. I varied my compositions of the standing cranes and framed the scene with the birds close to the bottom of the frame giving plenty of room at the top to illustrate the rising orange mist.

500mm lens, ISO 100, 1/500 second at f/5.6

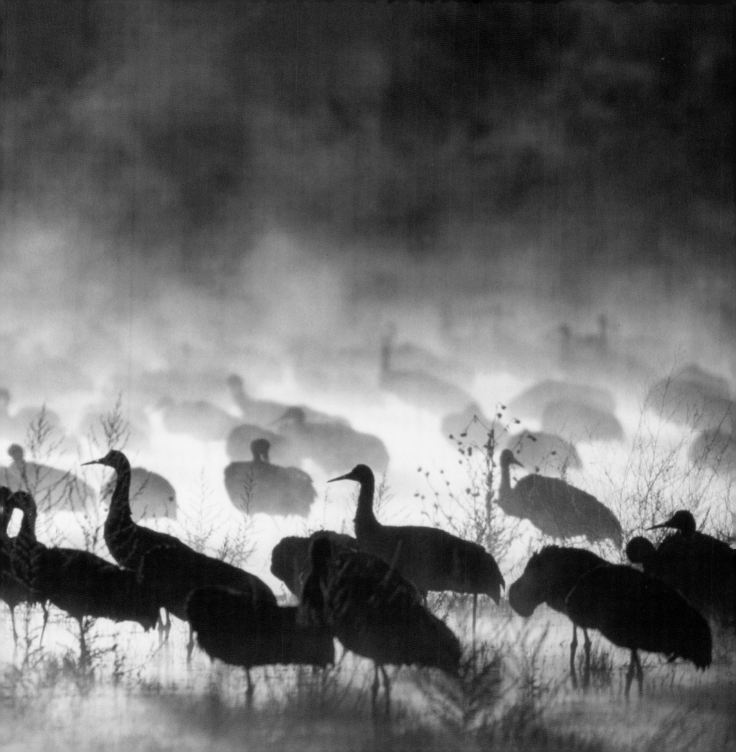

Useful websites and addresses

Tour Companies

Big Animals Photography Expeditions
2000 Broadway, Suite 1204
San Francisco, CA 94115
www.biganimals.com

Joseph Van Os Photo Safaris
PO Box 655
Vashon Island WA 98070
www.photosafaris.com

Travel Images
PO Box 2434
Eagle, ID 83616-9117
www.travelimages.com

Outdoor Photographer
12121 Wilshire Blvd., 12th Floor
Los Angeles, CA 90025-1176
www.outdoorphotographer.com/travelandworkshops/

National Audubon Society
700 Broadway
New York, NY 10003
www.audubon.org/bird_trails/

Equipment

FOR WIMBERLEY HEADS AND FLASH BRACKETS, ETC.

Wimberley Inc.
974 Baker Lane
Winchester, VA 22603
www.tripodhead.com

FOR THE DIETMAR NILL TRIPOD HEAD:
www.dietmar-nill.de

FOR BLINDS, BEANBAGS AND OTHER PERIPHERALS

L.L. Rue
138 Millbrook Road
Blairstown, NJ 07825-9534
www.rue.com

FOR BIRD FOOD AND FEEDERS

Wild Birdfeeders
1365 N. Orchard Street
Boise, ID 83706
www.wildbirdfeeders.com

To read about my latest photo trips and view more of my work you can visit my website at www.davidtipling.com

Acknowledgments

Although wildlife photography is often looked upon as a solo pursuit, securing good pictures frequently requires a great deal of assistance from others. Many of the pictures in this book are the result of such help, and many of those who helped are both fellow photographers and good friends. Special thanks go to Jari Peltomaki, Frederic Desmette, Dave Kjaer, Roger Tidman and Dave Richards.

A number of people have commented on and helped with the manuscript, notably Rod-wynne Powell of Solutions Photographic who, as author of *Photoshop Made Simple* and as an Alpha/Beta tester of Photoshop, has brought his immense technical expertise to bear on the relevant chapters in the book, ensuring their accuracy. My thanks too go to Tim Loseby for helpful comments and suggestions.

Nigel Redman and Mike Unwin at A&C Black greeted the idea for this book with enthusiasm, and encouraged me to pursue it. I am very grateful to my editor Julie Bailey for her help, suggestions and open mind as the book developed, and above all for her patience, and to Joanne Osborn for her editing skills. Thanks also to Rod Teasdale who has done a splendid job with the book's design.

Finally, last but not least, to my family: Jayne and James have to put up with the demands of a professional wildlife photographer – frequent periods away in far-flung corners of the world followed by long periods locked away in front of my computer. For their support and understanding I am forever grateful.

Index